ART & DESIGN

ACADEMY GROUP LTD
42 LEINSTER GARDENS, LONDON W2 3AN
TEL: 0171-402 2141 FAX: 0171-723 9540

EDITOR: Nicola Kearton
ASSISTANT EDITOR: Ramona Khambatta
ART EDITOR: Andrea Bettella
CHIEF DESIGNER: Mario Bettella
DESIGNER: Alistair Probert

SUBSCRIPTION OFFICES:
UK: ACADEMY GROUP LTD
42 LEINSTER GARDENS
LONDON W2 3AN
TEL: 0171 402 2141 FAX: 0171 723 9540

USA AND CANADA: JOHN WILEY & SON, INC
JOURNALS ADMINISTRATION DEPARTMENT
695 THIRD AVENUE
NEW YORK, NY 10158, USA
TEL: 212 850 6645 FAX: 212 850 6021
CABLE JONWILE TELEX: 12-7063
E-MAIL: SUBINFO@JWILEY.COM

ALL OTHER COUNTRIES:
VCH VERLAGSGESELLSCHAFT MBH
POSTFACH 101161
69451 WEINHEIM, GERMANY
TEL: 00 49 6201 606 148 FAX: 00 49 6201 606 184

Subscription rates for 1997 (incl p&p): *Annual subscription price*: UK only £68.00, World DM195 for regular subscribers. *Student rate*: UK only £53.00, World DM156 incl postage and handling charges. *Individual issues*: £19.95/DM45.00 (plus £2.30/DM5 for p&p, per issue ordered).
For the USA and Canada: *Art & Design* is published six times per year (Jan/Feb; Mar/Apr; May/Jun; Jul/Aug; Sept/Oct; and Nov/Dec) by Academy Group Ltd, 42 Leinster Gardens, London W2 3AN, England and distributed by John Wiley & Son, Inc, Journals Administration Department, 695 Third Avenue, New York, NY 10158, USA. Annual subscription price; US $142.00 including postage and handling charges; special student rates available at $105.00, single issue $29.95. Periodicals postage paid at Jamaica, NY 11431. Air freight and mailing in the USA by Publications Expediting Services Inc, 200 Meacham Ave, Elmont, NY 11003: Send address changes to: 'title', c/o Publications Expediting Services Inc, 200 Meacham Ave, Elmont, NY 11003.

Printed in Italy. All prices are subject to change without notice. [ISSN: 0267-3991]
The full text of *Art & Design* is also available in the electronic versions of the Art Index.

CONTENTS

ART & DESIGN **MAGAZINE**

Academy Highlights • Book Reviews by Peg Rawes

ART & DESIGN **PROFILE** No 52

CURATING The Contemporary Art Museum and Beyond

Guest-edited by Anna Harding

WHAT IS...?

This series introduces the reader to certain topics within the world of art and architecture. Each volume presents an analysis and exposition of the subject with the intent of heightening understanding and expanding knowledge. Clarifying the main points of each subject and providing numerous examples which illustrate the basic principles, each volume is a vital guide to the understanding of contemporary critical movements within art and architecture.

Each volume:
PB 240 x 225 mm
Fully illustrated
£8.95 DM26.00 $16.95

Forthcoming:
WHAT IS SUSTAINABILITY?
by James Steele

WHAT IS CONCEPTUAL ART?
by Peter Osborne

**Second Impression
WHAT IS DECONSTRUCTION?**
CHRISTOPHER NORRIS & ANDREW BENJAMIN

Christopher Norris provides a comprehensive documentation of the Deconstruction theory and its root in modern literature, while Andrew Benjamin produces a thorough and well justified explanation. Papers include: 'The Metaphysics of Presence: Plato, Rousseau, Saussure', and 'Framing the Text: Kant and Hegel'. This is a vital guide to understanding Deconstruction in contemporary art and architecture and its relationship to modern critical methods.

0 85670 961 1
56 pages
(Not available in Germany or Austria)
$16.00

*Further information can be obtained from:
(UK only) Academy Group Ltd, 42 Leinster Gardens, London W2 3AN, Tel: 0171 402 2141 Fax: 0171 723 9540*

(USA and Canada) National Book Network, 4720 Boston Way, Lanham, Maryland 20706, USA. Tel: (301) 459 3366 Fax: (301) 459 2118

(Rest of World) VCH, Postfach 101161, 69451 Weinheim, Federal Republic of Germany Tel: +49 6201 606 144 Fax: +49 6201 606 184

**Fourth Edition
WHAT IS POST-MODERNISM?**
CHARLES JENCKS

In this fourth edition of his successful book, Charles Jencks, the main definer of Post-Modern architecture, considers the concept as it relates to the arts and literature and offers a spirited defence of the movement against the growing Modernist reaction. This completely revised text presents the reader with numerous new examples of art and architecture appropriate to the theme and outlines the history which preceded Post-Modernism, facilitating a much clearer understanding of the overall concept.

1 85490 428 0
80 pages

WHAT IS ABSTRACTION?
ANDREW BENJAMIN

This text addresses the question of abstraction, one of the most significant and influential schools of contemporary art criticism, by looking at three interconnected projects. The first argues that developments within abstraction have rendered the traditional theoretical and philosophical understandings of abstraction inadequate. The second develops the theoretical and philosophical issues in relation to contemporary abstract work and the third shows in what way these theoretical innovations allow for the reinterpretation of the tradition of abstraction.

1 85490 434 5
68 pages

NEW
WHAT IS MODERNISM?
IAIN BOYD WHYTE

Modernism has dominated architectural theory and practice for most of this century. The International Style, which emerged partly as a reaction against Victorian high style, produced many sleek, elegant buildings. The architectural reaction to this incredible social movement which swept through all aspects of society was to provide good, low-cost public housing. Numerous examples are used to illustrate this movement, from large-scale public architecture to private housing, revealing the many masterpieces created during this period.

1 85490 389 6
68 pages

NEW
WHAT IS FENG SHUI?
DR EVELYN LIP

Feng Shui is the ancient art of placing a habitat, a house, a commercial complex, factory or multi-storey office block on to a site that is in harmony with other man-made structures and in balance with nature. Dr Evelyn Lip recognised authority on the subject, delves into the mysteries of Feng Shui – one of the five areas of influence that all Chinese believe determine one's success – and clearly outlines how it relates to architecture in the West. This is a book written for people from all walks of life on a subject that is rapidly gaining in popularity.

1 85490 491 4
64 pages
March 1997 £9.95

WHAT IS CLASSICISM?
MICHAEL GREENHALGH

This is a survey of Classicism from its beginnings to its recent developments, highlighting the continuity of the tradition with key illustrations. The text covers many aspects of history, art and architecture and guides the reader through time, explaining the complicated nuances that affect Classicism. *What is Classicism?* provides a thorough and excellent analysis of the subject.

0 85670 970 0
72 pages
$16.00

BLACKWELL JOURNALS

Museum International

Edited by Marcia Lord

Provides a vital clearing house for the exchange of viewpoints through case-studies, on-site reports, interviews, and informed editorial commentary.

- -

ORDER FORM

Subscription Rates, Volume 48, 1996

Institutional Rates, £55.00 (UK-Europe), $86.00 (N. America*), £55.00 (Rest of World)

Personal Rates, £29.00 (UK-Europe), $42.00 (N. America*), £29.00 (Rest of World)

Developing World, Institutions, $41.00, £25.00

Developing World, Individuals, $25.00, £15.00

ICOM Members, £15.00 (UK-Europe), $25.00 (N. America*), £15.00 (Rest of World)

Published in: January, March, June and September

MUSEUM INTERNATIONAL

ISSN 1350-0775

*Canadian customers please add 7% GST

❑ Please enter my subscription/send me a sample copy

❑ I enclose a cheque/money order payable to Blackwell Publishers

❑ Please charge my American Express/Diners Club/Mastercard/Visa account

Card Number . Expiry Date

Signature . Date .

Name .

Address .

. .

. Postcode .

Payment must accompany orders

Please return this form to: Journals Marketing, Blackwell Publishers, 108 Cowley Road, Oxford, OX4 1JF, UK.
Or to: Journals Marketing, MUSE, Blackwell Publishers, 238 Main Street, Cambridge, MA 02142, USA.

Internet

Full details of Blackwell Publishers books and journals are available on the Internet.
To access use a WWW browser such as Netscape or Mosaic, and the following URL:
http://www.blackwellpublishers.co.uk

SEARCH
NEWS & EVENTS
BOOKS
JOURNALS
RESOURCES
SERVICES

BLACKWELL *Publishers*

APPLY FOR YOUR FREE SAMPLE COPY BY E-MAIL!

jnlsamples@blackwellpublishers.co.uk

VISUAL DISPLAY Culture Beyond Appearances edited by Lynne Cooke and Peter Wollen, Dia Center for the Arts, Bay Press, Seattle, 1995, PB, £12.99, 351pp

Drawing together academics, cultural critics and curators, the 13 essays in this book document the multidisciplinary discussion at the Dia conference 'Visual Display' in New York in 1993. Situated in light of theories of 'Spectacle', this collection of essays suggests that techniques of display conceal diverse cultural experiences. However, against the attempt to produce understandings of the conventions of display which are either inside or outside the art institution, the anthology is concerned with the 'secret life of the spectacle'.

Like Malraux's *musée imaginaire* the book opens up the institutional hold on rhetoric, 'truth' and aesthetics which has come to characterise the dominant trends associated with visual art and culture. Here the boundaries between the art gallery and other forms of organising visual display are far less rigid than we might commonly suppose. Subjects which are perceived as distant or unrelated to the traditional concerns of the art museum are shown to inform and modify the institution beyond its traditional limits or position at the centre. Essays on science-fiction and the sublime, film-based and medical imaging of the body, the exaggerated display of identity in carnival, or techniques of display used in economic and political mapping demonstrate that Western visual culture is not produced from a central site of institutional meaning.

The book reflects artistic, cultural and critical contests which attempt to make messy the modern art museum's claims to notions of purity, exemplarity and authority. As its title suggests, the 20th-century art institution is not explained simply by what it chooses to make apparent to its audiences; there are hidden narratives, slippages of meaning, skirmishes and performance of culture. Many of the writers highlight the degree to which these more discontinuous discourses may be more productive realities of visual display.

However, the anthology is not a rejection of the role of the museum. Rather than visions of a single truth, the modern spectacle is constructed upon divergent and juxtaposed axes of understanding. Stephen Bann's 'Shrines, Curiosities, and the Rhetoric of Display' suggests how the 'axis of rhetoric' informs different historical moments of display from the holy shrine, the antique preserved in the cabinet to the artefact housed in the museum. Both Marina Warner's essay 'Waxworks and Wonderlands' and Susan Stewart's examination of Charles Willson Peale's fascination with taxonomy and collecting reflect specific historical and social attitudes toward mortality. In contrast to the now familiar cry that the museum can only be akin to a graveyard these writers nuance the generalised relationship between display and death to suggest how conventions of display are formed through experiences which may more commonly be excluded from institutional rhetoric. Thus, for Warner the populist waxworks of Madame Tussauds carry within them a sensibility of the social and cultural customs which surrounded the populism of reliquary in medieval Catholicism. Wax's own unstable material state (its fluidity and solidity) is both a metaphor for the way in which practices of display are in flux and a critical tool through which to examine the development of Western cultural preoccupations with the materiality of the body, touch, femininity and death in 'popular' visual forms. Susan Stewart reanimates the issues of display and 'arrested life' in relation to late 18th and early 19th-century experiences of mortality, health and interest in comprehensive systems. As such, Stewart argues that representation is intimately concerned with issues of memory, loss and the attempt to preserve life.

Lisa Cartwright and Ludmilla Jordanova project medical science into the arena of display. Medical science's claims for pragmatic recording and interpretation of images of the body – for example, the use of ultrasound to determine a foetus's gender – produces images of the body which are symptomatic of Western medical practice's own institutional limits.

Political, artistic and cultural claims for purity and truth are also considered in Wollen's examination of the body on display in the techniques of dance developed as part of Cabaret Voltaire's experimental practice during the 1910s and the idealisation of the body in the 1936 Berlin Olympics.

For Ralph Rugoff the museum is a virtual site, refreshingly not merely just in a digital form of computer-related technology, but as a pseudo-scientific, ethnographic museum. Whilst self-consciously operating within the codes of institutional rhetoric it is simultaneously an arena of fiction and simulacra. The Museum of Jurassic Technology in Los Angeles presents the museum as code, fiction or metaphor. The conventions of certainty, authority and knowledge which underpin ethnographic display are collapsed into a realm of the unknowable or virtual. Ralph Rugoff argues that the museum is not only an effect of science and knowledge but also intimately concerned with what might be more commonly associated with the affective, immanent or transient. Thus, it is an example of display which provides an alternative 'beyond' to the more common associations of the transcendent or 'sacred' object which operate in the institutional preservation and display of visual culture.

CIVILIZING RITUALS inside public art museums, Carol Duncan, Routledge, London, 1995, PB, £12.99, 178pp

Developing from her previous collaboration with artists and art critics in 1976 to produce an *anti-catalogue* and research on the concept of the museum as a site of ritual, Carol Duncan explores the culture of the art museum in relation to selected collections. The art museum provides a 'dramatic field' or 'script' through which to draw out its complex interpolation with art and architecture, rather than operating as a neutral space of display or product of architectural design. Through an anthropological analysis laid out in the first chapter the art museum in North America and Europe is conceived as a 'ritualised structure' or 'liminal' space; for example, the way in which it designs or structures experiences in time and space through conventions of architectural design, behaviour, geographical location, the role and visibility of the 'players' and display. Duncan reveals the particular ways in which the modern art institution performs its role to produce 'vivid and direct experiences' of social, sexual and political identities.

In contrast to preceding studies of art institutions, Duncan draws upon the approach not to distinguish the difference between Western and non-Western notions of display, but to ask how and in what ways the art museum works in contemporary Western culture; for example, she suggests that the museum viewed as either an educational or an aesthetic site are both ideals of certain kinds of ritual space and therefore both are restricted by ideological ends. Duncan's analysis enables a cultural discussion about the art museum which avoids falling into binary oppositions, such as education versus aesthetics, private versus public. Rather, it is an attempt to find a position *between* what the museum does and does not acknowledge.

Given the interdisciplinary ground of Duncan's argument it is not surprising that she also modifies both the anthropological and art historical understandings of objects. As a result objects which are presented in art museum are considered specific kinds of artefact – not in opposition to one another and so recuperated into classifications of high/low – in order that the way in which they are constructed within the ritual structure of the art museum can be made intelligible.

Chapters 2 to 4 explore specific examples of art museums in order to highlight some of the most dominant rituals which are played out. Situated within their political and historical contexts, Duncan suggests how the Louvre in Paris or the National Gallery in London provided a transformation of the private royal collections into accessible sites of cultural experience for the new bourgeoisie public. Chapter 3 explores how these rituals were appropriated and modi-

fied by the large public galleries in New York, Chicago and Boston, according to the political and social needs of the institutions and their public in the late 19th and early 20th century. The intimate relationship between the public gallery and the private donor is examined in Chapter 4, such as the Frick and Getty collections and the Dulwich Picture Gallery. In the final chapter Duncan argues that the specificity of the 20th-century art museum arises, in part, from the ways in which its gendered space has been put at stake. This argument incorporates discussions on how Picasso's *Demoiselles d'Avignon* and de Kooning's *Woman I* contribute to a masculinised museum space in MoMA and the art museum's negation of the moral-political self. For Duncan these issues remain persistent aspects of the ritual structure of the art museum which require further interrogation.

THINKING ABOUT EXHIBITIONS edited by Reesa Greenberg, Bruce W Ferguson, Sandy Nairne, Routledge, London, 1996, PB, £16.99, 487pp

The 'white cube' which characterises the institutionalised presentation of contemporary art in the modern art museum, has been shown to be hermetic, exclusive, masculine and therefore a severely restricted physical, conceptual and cultural arena. It is one of the constructs of the art institution which is placed under scrutiny in this collection of essays. Instead the idealised space of the art institution is shown to be perforated by cultural and artistic practices which, whilst figuring its spatial and aesthetic limits, also reveal experiences which have been negated or neglected by the traditional art institution.

This anthology is derived from Reesa Greenberg's teaching at Concordia University, Montréal in the 1980s and a two-part symposium organised in conjunction with Sandy Nairne and Bruce Ferguson held at The Tate, London and DIA, New York in 1990. Its brings together discussions from Britain, North America and Europe since the 1970s. Contributors include artists Daniel Buren, Judith Barry, Gerald MacMaster, Fred Wilson; academics Tony Bennett, Jean-François Lyotard, Rosalind Krauss, Martha Ward, Mieke Bal; and curators Lawrence Alloway, Clémentine Deliss and Ivan Karp.

Organised into six parts it examines the concept of exhibitions in relation to history, spectatorship, language and discourse, curatorship, space and the institution. In kind with current concerns about resisting totalised bodies of knowledge it reflects an engagement with the subject, both in exhibitions and related writing, which is more about process, dialogue, negotiation in discrete, yet varied, circumstances. Thus, although it presents an impressive breadth to its subject the anthology is also to be understood as a series of moments within the debate rather than having universal claims. As such its essays and bibliography represent a valuable resource for those involved in the visual arts.

For Johanne Lamoureux, the 'premier' spaces of the large-scale exhibition events in Europe – the biennials, triennials etc – have a counter-culture of interstitial spaces in the city through which the contemporary *flâneur* passes. As a result, the issues of public or private become, not opposite extremes, but complements to one another. Rosalind Krauss suggests that the postmodern condition of exhibition practice is commensurate with André Malraux's *musée imaginaire* from which Anglo-American museum practice has constructed a conceptual space for the imaginative and intellectual faculties. For Krauss this now encompasses the increasing number of publications which support and extend the reach of exhibitions beyond the gallery walls.

In two separate essays Sandy Nairne and Reesa Greenberg examine the degree to which the art gallery has shifted from its location in the political and cultural centre. Greenberg explores how the white cube has become mobile since the 1960s, reproduced as industrial warehouses, marginal urban locations, site-specific and domestic spaces. Now the static, appropriating and monumental notion of the art institution is redistributed into networks of relations in the international capitals of the art market. Nairne suggests that the development of the alternative artist-run spaces in the 1960s and 70s represent eruptions of alterity within the system. Although their claims for difference may be momentary, nevertheless they suggest that the contemporary institution of art is not as discrete or homogenous as might first be perceived; rather these installations, exhibitions, events, site-specific work are evidence of cultural and artistic strategies towards new relations and forms of visual culture. Thus, the institution becomes a system of different sites of cultural, artistic, social and power relations, or a shifting field of engagement and exchange between these concerns, rather than a single ground from which understandings of visual culture are made.

NON-PLACES Introduction to an Anthropology of Supermodernity Marc Augé, Translated by John Howe, Verso, London, 1995, PB, £9.95, HB £29.95, 122pp

Mapping a topography of social and physical spaces which construct contemporary Western culture, Marc Augé suggests that this 'supermodernity' is concerned with fluidity, instability and transience. In particular it is inscribed in the technological, digital and economic zones which construct our experiences of 'non-places' such as the airport lounge, the shopping precinct, motor ways and hotels.

The supermodern is characterised by its image of excess, for example the excess of time and space. Developments in technology have altered our attitudes towards our life expectancy and the co-existence of different generations have become multiple or extended. In addition the individual becomes part of a network of histories or genealogies, rather than an identity in History. Second, the extension of space, from the concerns with space exploration to the collapse of distance between different geographical points, or the division between public and private, have resulted from developments in communication and transportation systems. Third, the return of the ego has heightened the value given to the particular or the local experience and so brings with it new issues about how to think about the individual.

Negotiating a path through definitions of place as relational, historical and identity-based, Augé offers an interpretation of contemporary culture which is determined by networks of routes, clusters, intersections and cross-roads of relations. However anthropological place is also measured and permeated by 'non-place'. This is the zone of supermodernity which falls out of understandings of place and instead is classified as 'places of memory'. It is space as commensurate with the present (the temporary, 'frequented', fleeting) and produced by the double movement of both traveller and the environment itself. Drawing from Chateaubriand's accounts of pilgrimage, Augé goes on to explore the way in which the traveller experiences the immanence of the supermodern, rather than Baudelaire's *flâneur* who is content to remain a spectator.

Augé is also concerned with the degree to which Ethnography and Anthropology can engage with these phenomena which resist being encountered as empirical objects and so frustrate the rationale of objective explanation. Ethnography and Anthropology's concern with the Object (a phenomenon which can be identified by its otherness and which has most strongly been associated with the modernist exploration of non-Western culture) have now been brought to bear on the 'here' and 'now' of our own condition in late 20th century Western cultures. However, rather than rejecting the scope of Anthropology to explore these issues, Augé suggests that it remains a valuable discipline for producing meaningful understandings of contemporary experience in the 21st century.

This special selection of books chosen to tie-in with A&D's issue on Curating has been reviewed by **Peg Rawes**. *She has just completed an MA in Philosophy at the University of Warwick and lives and works in London.*

Art & Design *highlights*

NEXT ISSUE

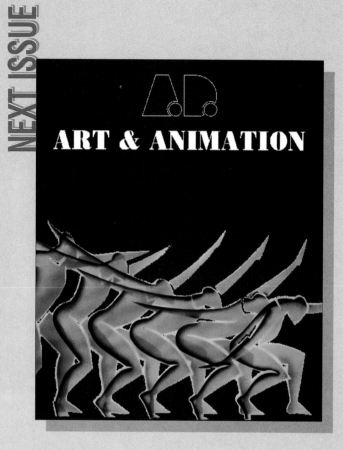

RECENT ISSUES

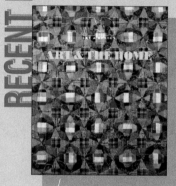

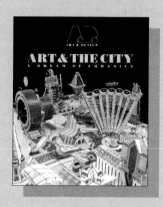

ART & ANIMATION
Guest Edited by Paul Wells
ART & DESIGN PROFILE 53

As a genre, animation is currently receiving serious attention from art, film and cultural critics. This profile addresses how fine art and the animated film interrelate. As witnessed by the recent huge success of the characters Wallace and Gromit in Oscar winner Nick Park's *The Wrong Trousers* and Disney's innovative and technologically masterful *Toy Story*, animation is now becoming a force to be reckoned with at the box office.

Art & Animation looks at subjects such as Walt Disney and Classical Art; the established tradition of European animators; the extraordinary success of Japanese Manga films; the connections between animation, dance, computer graphics and the puppet theatre together with the role of animation in art education. This is a particularly visual profile, combining stunning stills with contributions from a host of critics and features on animators such as Warner Brothers' Chuck Jones, Disney's Bob Godfrey, Nick Park, Terry Gilliam and many more . . .

Dr Paul Wells is Principal Lecturer and Subject Leader in media studies at De Montfort University, Leicester. He has made a number of film related series for BBC Radio and has written widely on aspects of comedy and animation.

1 85490 525 2 £19.95 $29.95
305 x 250 mm, 96 pages
Illustrated throughout, mainly in colour
March 1997

ART & THE HOME
Guest Edited by David A Greene
A&D PROFILE 51

The notion of 'home', both in theory and in practice is at the core of the human condition, traditionally viewed as a site of security and stability, yet also as a place of dysfunction and threat. *Art & the Home* seeks to address the contemporary conceptions of the home through the multifarious and rich body of artistic works in which it has been portrayed.

Contributions to this profile include projects by Uta Barth, Mark Bennett, Miles Coolidge, Sam Durant, Judy Fiskin, Jim Isermann, David Muller, Rubén Ortiz-Torres and Carrie May Weems, with writings by Luis Alfaro, Michael Darling, Dave Hickey and Janine Mileaf on the Stettheimer Doll's House of the 1920s.

1 85490 235 0 £17.95 $29.95

ART & THE CITY
A Dream Of Urbanity
Guest Edited by John Stathatos
A&D PROFILE 50

Art & the City presents a richly contrasting array of contemporary views of the city by artists, architects and writers who, through image and text, offer their own dreams of urbanity in an attempt to define the magnetic attraction – or for some hell – that is the city.

Contributions include projects by Elizabeth-Jane Grose, Will Alsop, Burattoni & Abrioux, Pat Kaufman, Joseph Ottewill & Ian Duncan and Graham Budgett, with essays by Jonathan Jones on Bodys Isek Kingelez's imaginary city of Kimbeville, Jack Sargeant & Stephanie Watson on the video game Sim City, Sarah Greenberg on Piranesi's utopian visions of Rome and Nikos Papastergiadis and Heather Rogers on parafunctional spaces.

1 85490 234 2 £17.95 $29.95

Further information can be obtained from:
(UK only) Academy Group Ltd, 42 Leinster Gardens, London W2 3AN, Tel: 0171 402 2141 Fax: 0171 723 9540

(USA and Canada) National Book Network, 4720 Boston Way, Lanham, Maryland 20706, USA. Tel: (301) 459 3366 Fax: (301) 459 2118

(Rest of World) VCH, Postfach 101161, 69451 Weinheim, Federal Republic of Germany Tel: +49 6201 606 144 Fax: +49 6201 606 184

Creative Curating

Creative Curating
MA in fine art administration
and curatorship

1 Year full time
2 Years part time

Application deadline 30/1/97
For a prospectus and application
form contact:

The Visual Arts Department
Goldsmiths College
University of London
New Cross
London SE14 6NW

Tel +44 (0) 171 919 7671
Fax +44 (0) 171 919 7403

Goldsmiths
UNIVERSITY
OF LONDON

Acknowledgements

We would like to thank Anna Harding for her hard work and enthusiasm in compiling this issue of *Art & Design* around new forms of curating.

Unless otherwise stated, all images are courtesy of the artists: p3 © Cornelia Hesse-Honegger and Locus+ Archive; **From Monologue to Conversation** *pp6-11* all photographs courtesy Mary Jane Jacob; **Everything** *pp12-17* p12, p15 (above left) with thanks to Selfridge's Department Store (London), p15 (above right and below), p17 (above) courtesy Transit Gallery (Leuven, Belgium), p17 (below right) with kind permission of Focal Point, Audio Visual (London); **The Spectator as Performer** *pp24-29* p24 installation at Chisenhale Gallery (London); **Mapping International Exhibitions** *pp30-37* This piece is an updated version of a paper first published in *On taking a normal situation and retranslating it into overlapping and multiple readings of conditions past and present*, MUKHA, Antwerp, 1993, pp135-152. A revised version was included in *L'Art Exposé*, Editions Cantz/Musée Cantonal des Beaux Arts, Sion, Switzerland, 1996; **Showtime** *pp38-43* p43 courtesy The Showroom (London); **Conceptual Living** *pp44-47* p44 (left) Collection Hans Schulte, p45 (above) courtesy Rhizome (Amsterdam) / Interim Art (London) / Lisson Gallery (London), p45 (below left) courtesy Rhizome (Amsterdam) / James van Damme (Brussels) / Victoria Miro Gallery (London); **Not Quite at Home** *pp60-65* photos courtesy Centre for Contemporary Art, Ujazdowski Castle, Warsaw; **Der Umbau Raum** *pp66-69* photos courtesy *Der Umbau Raum* (Stuttgart); **On Locus+** *pp70-76* © Locus+ (Newcastle upon Tyne); **Artist-Curators and the New British Art** *pp78-81* Cottage Industry was curated by Naomi Siderfin and produced by Beaconsfield; **Information, Education, Entertainment** *pp82-85* pp82, 84 (rows 1, 2, 3 [right], 5) © Planet/Bent Ryberg (Copenhagen), p84 (rows 3 [left], 4) © Mads Gamdrup (Copenhagen); **In the Midst of Things, At the Centre of Nothing** *pp86-90* p86 (centre left and below centre) courtesy museum in progress (Vienna). Front cover photo by Bent Ryberg.

Contributors' Biographies

Anna Harding, former Curator of Kettle's Yard, University of Cambridge, is Programme Director of the MA in Fine Art Administration and Curatorship in the Visual Arts Department, Goldsmiths College, University of London; **Neil Cummings** is an artist living in London. He has a long-standing interest in how practices of art fit into a wide sense of material culture; **Jeanne van Heeswijk** is an artist based in Holland who works in different cultural fields. Recent projects have included *Room with a View*, *I + the Other*, *State of Mind* and *NEsTWORK*; **Richard Layzell** is a performance and installation artist who lectures at Wimbledon School of Art and lives in London; **Bruce W Ferguson** is a curator and writer based in New York. He was recently Director of SITE *Santa Fe* in New Mexico, and is now the President of the New York Academy of Art; **Reesa Greenberg** is an art historian and writer. She is Associate Professor of Art History at Concordia University, Montreal; **Sandy Nairne** is Director of Public and Regional Services at the Tate Gallery, London and author of *State of the Art*, Chatto & Windus (London), 1987. Ferguson, Greenberg and Nairne are the co-editors of *Thinking About Exhibitions*, Routledge (London and New York), 1996; **Lois Keidan** is the Director of Live Arts at the Institute of Contemporary Art, London. She was formerly the Performance Art/Live Art Officer at the Arts Council of England; in 1994 **Macha Roesink** founded Rhizome for organising contemporary art exhibitions and advising on cultural projects which include a recent film and video screening series 'Timing' at the De Appel in Amsterdam. She also works at the Rietveld Academy; **Declan McGonagle** is Director of the Irish Museum of Modern Art, Dublin; **Siraj Izhar** is the artist-curator for the Strike project set up in spring 1992 at the Public Lavatory, Spitalfields, London E1; **Marysia Lewandowska** is an artist living in London whose exhibition *Point of View* at the CCA, Warsaw, was curated by Milada Ślizińska in 1993. Her conceptual photography-based practice includes recent contributions to *NowHere* at the Louisiana, Copenhagen, and to the book *Lost Property*, as well as her ongoing work as series editor of 'Sight Works'; **Milada Ślizińska** is Chief Curator of the International Programme at the Centre for Contemporary Art, Ujazdowski Castle, Warsaw; **Nicolaus Schafhausen** lives in Stuttgart and has been curating since 1989. He was Director of Gallery Lukas & Hoffman (Berlin/Cologne) from 1991-94 and has been the Director of Künstlerhaus in Stuttgart since 1995. He curated *Nach Weimar* at the Kunstsammlungen zu Weimar in 1996 and was a consultant for documenta X in 1995-96; **Liam Gillick** is an artist living in London. His new book *Discussion Island: A What If? Scenario Report* will be published next year; **Jon Bewley** and **Simon Herbert** are joint Directors of Locus+, Room 17, Floor 3, Wards Building, 31-39 High Bridge, Newcastle upon Tyne, NE1 1EW, e-mail:locusplus@newart.demon.co.uk www.locusplus.org.uk; **Julian Stallabrass** is Assistant Editor of *New Left Review*, Guest Lecturer at the Courtauld Institute, London and a regular contributor to *Art Monthly*; **Ute Meta Bauer** works as an independent curator. She is Guest Professor and Head of the Institute of Contemporary Art at the Academy of Fine Arts, Vienna. She was Programme Director of the Künstlerhaus, Stuttgart from 1990-94; **Fareed Armaly** is an American artist living and working in Europe. His projects combine a variety of mixed media to map out an interplay between architecture, media and society, for example: *Brea-kd-own*, 1993, Palais des Beaux-Arts, Brussels, and *Scale*, 1995, Forum Stadtpark, Prague; **Hans Ulrich Obrist** works and lives in London, Paris and Vienna. He regularly curates exhibitions for the museum in progress, Vienna and the Musée d'Art Moderne, Paris, where he is co-curator of *Life-Live* with L Bossé. He is also co-curating the 1997-98 Berlin Biennial.

FRONT COVER: View through the Sign System to the storage area where Louisiana's two histories overlap, revealing the work of both the Danish Lundstrøm and modern classics by artists such as Klein, Warhol, Ryman, Tapies and Bacon (from the exhibition NowHere, *Louisiana Museum of Modern Art, Denmark, 1996)*
BACK COVER: desperate optimists, Dedicated, The Showroom, March-April 1995
INSIDE FRONT COVER: DO IT, Converture du catalogue Islandaii, Municipal Art Museum, Reykjavik, March 1996
INSIDE BACK COVER: see p90

EDITOR: Nicola Kearton ASSISTANT EDITOR: Ramona Khambatta
ART EDITOR: Andrea Bettella CHIEF DESIGNER: Mario Bettella DESIGNER: Alistair Probert

First published in Great Britain in 1997 by *Art & Design* an imprint of
ACADEMY GROUP LTD, 42 LEINSTER GARDENS, LONDON W2 3AN
Member of the VCH Publishing Group
ISBN: 1 85490 236 9 (UK)

The Publishers and Editor do not hold themselves responsible for the opinions expressed by the
writers of articles or letters in this magazine
Copyright of articles and illustrations may belong to individual writers or artists
Art & Design Profile 52 is published as part of *Art & Design* Vol 12 1/2 1997
Art & Design Magazine is published six times a year and is available by subscription

Distributed to the trade in the United States of America by
NATIONAL BOOK NETWORK, INC, 4720 BOSTON WAY, LANHAM, MARYLAND 20706

Printed and bound in Italy

Art & Design

CURATING
THE CONTEMPORARY ART MUSEUM AND BEYOND

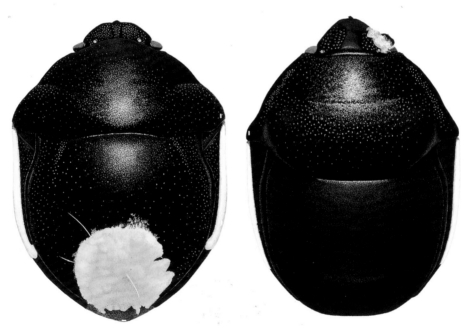

Cornelia Hesse-Honegger, Corimelaenidac, *watercolour, 1991,*
Swatara, Three Mile Island United States

ACADEMY EDITIONS • LONDON

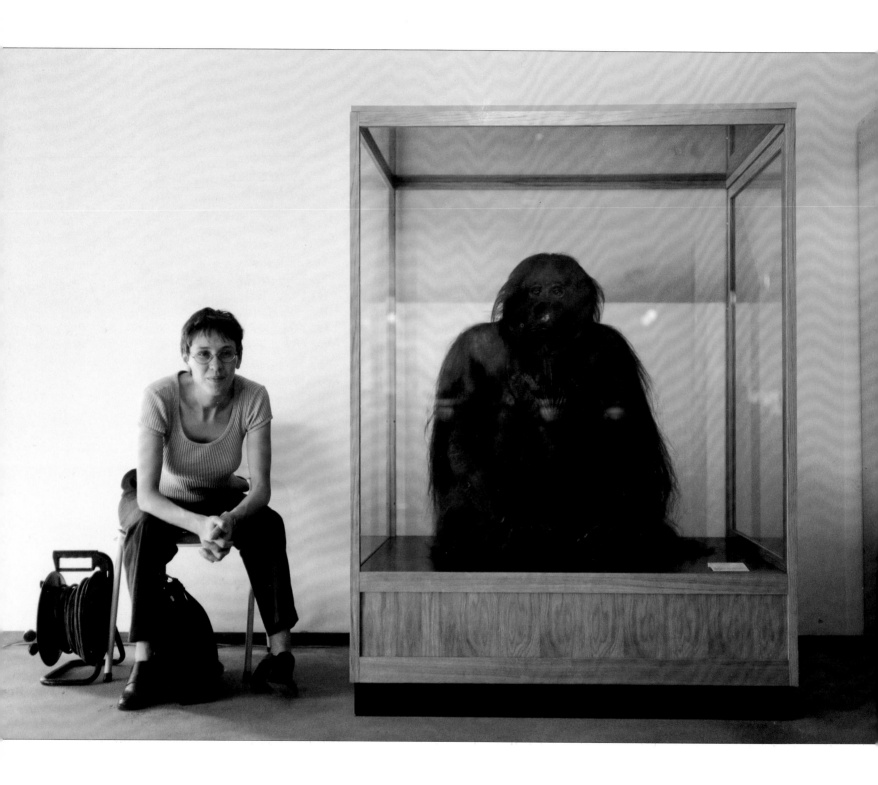

INTRODUCTION
ANNA HARDING

The responsibilities of curators have shifted enormously from museum-based practice where acquisition, classification and care of objects were the primary concerns. Curating now refers to a wider range of practices, both inside and outside the museum and in spaces in-between. Some of the possible in-between areas are presented by Hans Ulrich Obrist in-between the covers of this issue. This issue presents a range of projects from the last 10 years or so which may be alternatives or critiques of established curatorial practices of the contemporary art museum. While to provide a comprehensive range of practices would be impossible, I have chosen a personal selection of approaches.

From Peter Vergo's *The New Museology* in 1989 and *Art & Design*'s own special issue in 1992,[1] there is a wealth of recent literature which is forming a healthy critique of curatorial practice.

The essay 'Mapping International Exhibitions' by Bruce W Ferguson, Reesa Greenberg and Sandy Nairne, first published in 1993, sets an agenda to which many of the contributions in this issue respond. The recent book *Thinking About Exhibitions*, edited by the same authors, is also a valuable addition to the debate in this field. They describe how 'international exhibitions still invite a presumption that the curators have access to an illusory world view, and that spectators may follow in their wake'. This problematic is reflected in my report from Atlanta, where in the shadow of the Olympics I compare *Rings: Five Passions in World Art*, with an alternative curatorial approach in *Conversations at the Castle*.

Ferguson, Greenberg and Nairne call for different agendas and alternative international models. Two such projects are *Manifesta 1* in Rotterdam and *NowHere* in Copenhagen, both in 1996. In looking at *NowHere* and *Manifesta 1* I do not attempt any overview of curatorial intents but I have chosen from each an aspect which seemed of particular importance to current debates around curating. From *Manifesta 1* comes a report from *NEsTWORK* which examines the challenge taken up by this group of Rotterdam practitioners to attempt to ground *Manifesta* and give it meaning in the local community. From *NowHere* I include a report from Ute Meta Bauer, one of six curators who presented her personal section in collaboration with the artist Fareed Armaly.

The problematics of internationalism are reflected in two contributions which address particularities of context and audience. Reconsidering the reception of Antony Gormley's sculptures on the Derry walls, Declan McGonagle reminds us that public space is contested space, be it a highly emotive zone such as the Derry walls or the confines of the contemporary art museum. I am indebted to the suggestion of Marysia Lewandowska for her interview with Milada Ślizińska. Chief Curator of the International Programme at the CCA, Warsaw. This account illustrates how work which is highly regarded in the international art world may give different messages in the context of Poland. Just presenting yet another exhibition and doing what you always do will not suffice.

Many artists take on a significant curatorial role in determining the presentation of their own and others' work. Locus+ and Siraj Izhar offer alternatives to artists excluded from equal and integral participation. Richard Layzell recounts his experience of the complexity of occupying the dual roles of artist and curator in *Art Machine 95*. The significant growth in Britain of artist-run spaces and artist-curators has gained international acclaim in exhibitions such as *Brilliant!* (Walker Art Center, Minneapolis, 1995) and *Life-Live* (Musée d'Art Moderne, Paris, 1996). This phenomenon is examined by Julian Stallabrass.

In his essay 'Everything', Neil Cummings draws attention to taxonomies of display which have evolved for ordering the varieties of material culture around us, looking at the shop and home as sites for curating. Another curatorial practice taking the domestic as its starting point is *Conceptual Living*, a Rhizome project in the home of Macha Roesink, introduced to us by Gerrie van Noord.

Looking again beyond the contemporary art museum, Lois Keidan looks at Live Art where curating is one of the several possible approaches used for bringing together and presenting work. This is another example where curating is alive and responsive to the demands of the artwork without attempting to define or close down the possibilities for art or curating in the process. *Der Umbau Raum* in Stuttgart, introduced to us by Liam Gillick, is just such a project, where curating embraces offering support and space for new work and new forms to develop.

Note

1 *New Museology*, A&D profile no 22, Academy Editions, London, 1992.

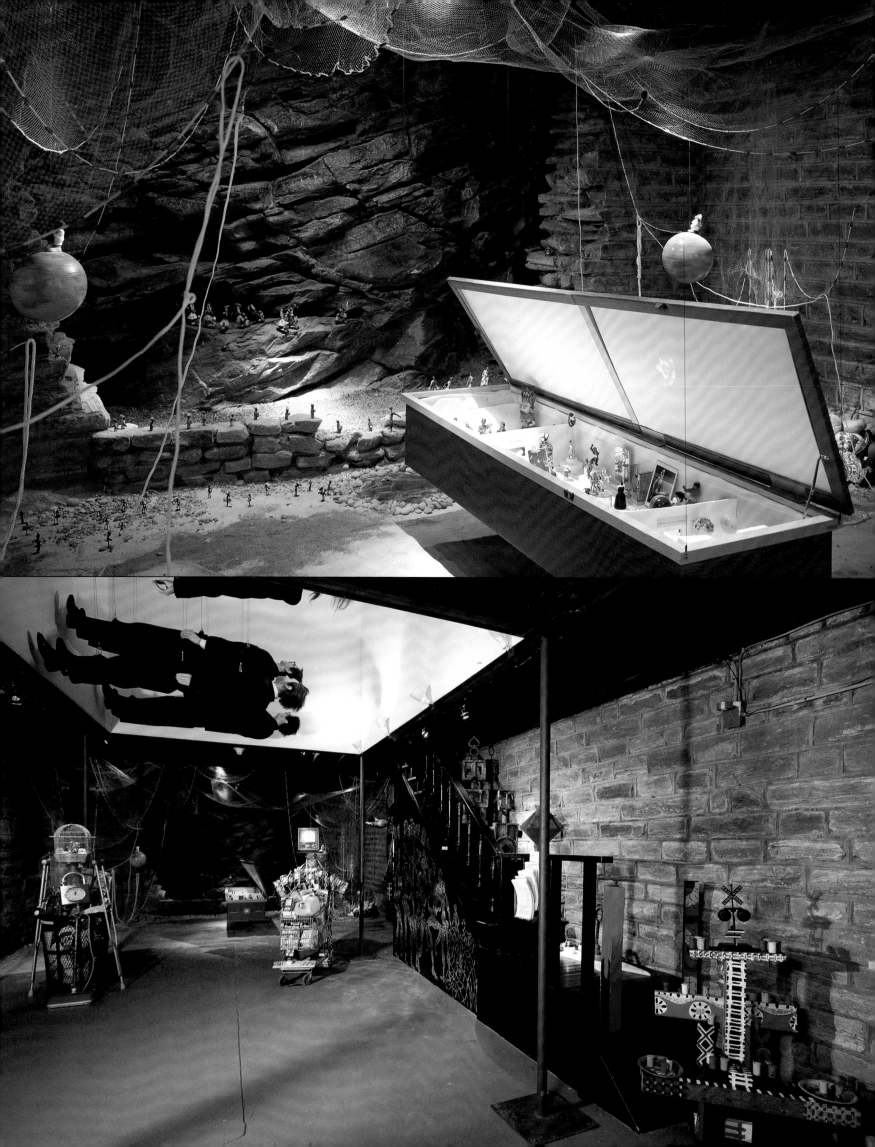

FROM MONOLOGUE TO CONVERSATION

A Report from Atlanta

ANNA HARDING

The biggest spectacle in Atlanta this summer has of course been the Centennial Olympics, brought to us by AT&T, the Coca-Cola kids and the Budweiser school of beer drinking. Education in brand affiliation starts in the cradle. The attractions beyond the games themselves are Coca-Cola World – the museum dedicated to the history of that famous syrup which started life in Atlanta – Swatch World and the water show – a fountain-filled park where you could walk under the spray for a refreshing experience. The key organisational factors behind an Olympic event would appear to be income generation through tourism, sponsorship, crowd control and security. I would argue that these are the same as those that determine a blockbuster art exhibition and would then like to take you across the road to consider an alternative.

In the shadow of the Olympics an extensive art programme has been scheduled to show the world that Atlanta is a 'high class city'. The centrepiece at the High Museum of Art is *Rings: Five Passions of World Art*, a blockbuster spectacle, selected by J Carter Brown, Director Emeritus of the National Gallery of Art in Washington, DC, co-founder and chairman of Ovation, a cable TV channel devoted to the arts. This 'innovative' exhibition is organised thematically around five interconnecting passions: love, anguish, awe, triumph and joy, echoing the five interlinking rings of the Olympic symbol. The impressive collection of 125 works spans seven millennia and has been amassed from five continents, presenting all the peoples from around the world, according to the aims of the founder of the Olympics, 'arching over differences'. The exhibition includes works by famous artists in Western art history: Picasso, Matisse, Rembrandt, Rubens, Poussin and Ingres as well as Bill Viola, along with ancient treasures from around the world: an eighth-century figure of Ganesha from Uttar Pradesh, a second-century Head of the Fasting Buddha, a Mexican monumental female effigy urn or a Romanian clay figure from around the fifth century BC are all subsumed under the curator's emotional canon, which all visitors are presumed to share. Artefacts of a traditional spiritual use are presented in this new context determined by the curator, in the same manner as paintings made for museums. This personal selection is brought to us by a highly renowned curator with years of experience, so we know we are in safe hands and that all the hand picked works can only be of the best quality. The thematic groupings suggest appropriate emotional responses and behaviour. In short, we are comforted that we are in expert hands.

To enter the exhibition, we queue in cordoned off rows. When the crowd levels are optimal we are herded into a goods lift. Inside, a recorded message goads us to hire headphones for the soundtrack tour, taken up by what seemed on my visit to be the majority of visitors. The soundtrack reassuringly brings us His Master's voice, like the 78 record label. J Carter Brown, curator, introduces soothingly: 'Greetings and welcome to *Rings* . . . walk with me now into the first room of the exhibition as I introduce you to a show that's unlike any other that you may have experienced. I've selected art, literature and music to evoke the interconnecting human emotions. *Rings*, I call them . . . This is Rodin's *The Kiss*, walk around the sculpture and enjoy it from every angle . . . Throughout the tour I want you to feel free to stop the tour at any time . . . I'd like you to view the *Rings* exhibition in a special way. Quite high above each work of art you'll notice a large number. As we continue through the exhibition it's important that you view the works in their numerical sequence . . . '

The soundtrack provided animates our experiences with instructions as to how to move through the exhibition, while the theatrical voice and musical selections create ambience for each emotion, with poetry on the gallery walls adding a further dimension to the experience. Alternatives again are to use the guide or catalogue or even CD-ROM, giving a semblance of multiple choice but, in fact, all providing varieties of the same one-way conversation. In short, we do not need to worry about how to respond to the work, nor do we need to think for ourselves as all our senses are satisfied.

Objects in vitrines, framed and on plinths, the museum kills the art and stifles its speech. In his essay 'The Show You Love to Hate', John Miller further critiques the ideology of the megaexhibition, where the private experience of the individual viewer is relegated and the promotion of the curatorial project as an artwork is foremost. The authority of the curator's viewpoint is reinforced by the dazzling white Richard Meier architecture of the museum with dramatic entrance ramp, the prime city centre location, uniformed guards, surveillance and security systems. Nicholas Serota, Director of the Tate Gallery, in his Walter Neurath Memorial lecture 'Experience or Interpretation: The Dilemma of the Museum of Modern Art', highlighted the critical curatorial dilemma: how far should art be left to direct experience and how far does it need to be interpreted and mediated? The presentation methods used in *Rings* would seem to reflect a fear of any kind of conversation or direct communica-

Ery Camara, From Monologue to Conversation, *from* Conversations at The Castle, *Arts Festival of Atlanta, 1996 (above: with IRWIN group, Transnacionala) (photos: John McWilliams)*

tion between artwork and audience, or at least a recognition of the need for multiple points of entry. However, by offering the multi-sensory route are we not just pandering to the desires of consumers to make the least possible effort?

Rings is good for business, states a local newspaper report on the subject of ticket sales for what may become Atlanta's most visited and popular art show, generating over 2,000 new museum members a month and admissions income of $3 million. The extensive display of *Rings* merchandise, which forms the last room of the exhibition, includes a catalogue autographed by the curator and even gets its own press release. As many museum directors across the world would say, they are just trying to run a business, but does this degree of packaging do any justice to the art on show and does it really help our understanding through art or just provide us with more visual source material for consumer product?

The day after the Centennial Park bombing, *Rings* is quiet, as a competing exhibit becomes the latest tourist spectacle.

A street away from *Rings* is *Conversations at The Castle*, an art project with a differing curatorial agenda, inspired by the concerns of many artists today who seek to bridge the gap between audience and contemporary art. International artists have been brought to Atlanta by curator Mary Jane Jacob, to carry out publicly interactive projects aimed to initiate 'conversation' between persons and across cultures. They have spent their summer in residence in Atlanta, enabling them to fully integrate specific communities in their work. They all have a common interest in conversation as an artistic tool, where the participants in the artwork are also one of its key audiences. Unlike *Rings*, the priority is not mass audiences for tourist dollars, but engagement with and involvement with community through contemporary conceptual art practices.

While *Conversations* benefits from none of the profile nor million-dollar budgets of the High Museum, the impact and influence of these artists' work will spread through the many personal and social networks which are brought to the project by its participants. The artists shift experience from one context to another and from the roots of their work in everyday life they hope that new understandings of cultural value might emerge. *Conversations* works on many levels: from intimate conversations between participants, in workshops and meetings, through street actions, discussion and meals round the table at the castle with critics, academics, curators and community figures joining the debate on art and culture, to the public aspect of a gallery-type presentation in a temporary space at the castle. The gallery presentation seems more of a secondary concern, a by-product of the process which has taken place over the past few months. The show itself is difficult to navigate, but thankfully a number of artists are available to make the connections back to the residencies and

interactive processes from which the display has emerged. The castle or gallery functioned more importantly as a meeting point than as a quiet exhibition. Equally important elements of display are a web site and e-mail which take the conversations to another level still, and finally a book which will document the artists' projects in Conversations at The Castle, with essays by Homi Bhabha, art critic Michael Brenson, and session leaders of the Conversations on Culture.

What happens when the artists leave town? Will the project have made an impact, and how can this impact on multiple levels be evaluated? Is a success on artistic or curatorial grounds necessarily satisfactory to participants, who may have a very different investment in it? Several of the artists would like to see their work in Atlanta continue and feel a responsibility, having begun something, not to abandon ship. The itinerant artists and curators, none of whom are from Atlanta, will move on to a new project, the next country, city and circus performance. They are only able to start a process or draw attention to needs. Perhaps by staying in one place they might become extinct. What seems crucial to the project is that the process is validated by a renowned curator and takes place on an international stage for these conversations to be heard. But what does this leave the residents and community leaders, beyond a notion that artists can make a contribution to the community? Or will the impact of the project have a long-term benefit? What will there be for museums to collect and what will become of museums if artists do not prioritise objects? Does this curatorial work which is directly engaged in process and community have a place in the museum? Will it help to redefine the art museum? Or will it remain on the periphery?

Participatory projects or community-based art projects have often been devised by artists as a way of making a living, as an aside from their 'serious' solitary studio practice. Possibly as a reaction to this absurd legacy whereby isolationism is to be sought after, *Conversations* demonstrates a desire by artists to bring processes of investigation and participation to centre stage. In this work there is no necessary privileging of the artist's production of art objects over the conversation itself and the intersection of art with a larger culture. At many levels the project heightens dialogue about public access and involvement in culture, rather than producing more artefacts. It is not primarily an educational or social exercise, but an artistic practice being recognised by curators as an area to which their work should be addressed.

Both *Rings* and *Conversations* seem to be preoccupied on a curatorial level with reawakening emotions, re-sensitising ourselves and demonstrating interconnectedness between people. Is this a sad reflection on a culture in which the ability to think for oneself and express emotion seems to have been largely discouraged, with artists brought in to rebuild the connections? Art is able to ask open-ended questions, to function at different levels within existing structures, to cross between

Maurice O'Connell, Brothers For Others: Surrogacy, Sports and Society, *from* Conversations at The Castle, *Arts Festival of Atlanta, 1996 (photos: John McWilliams)*

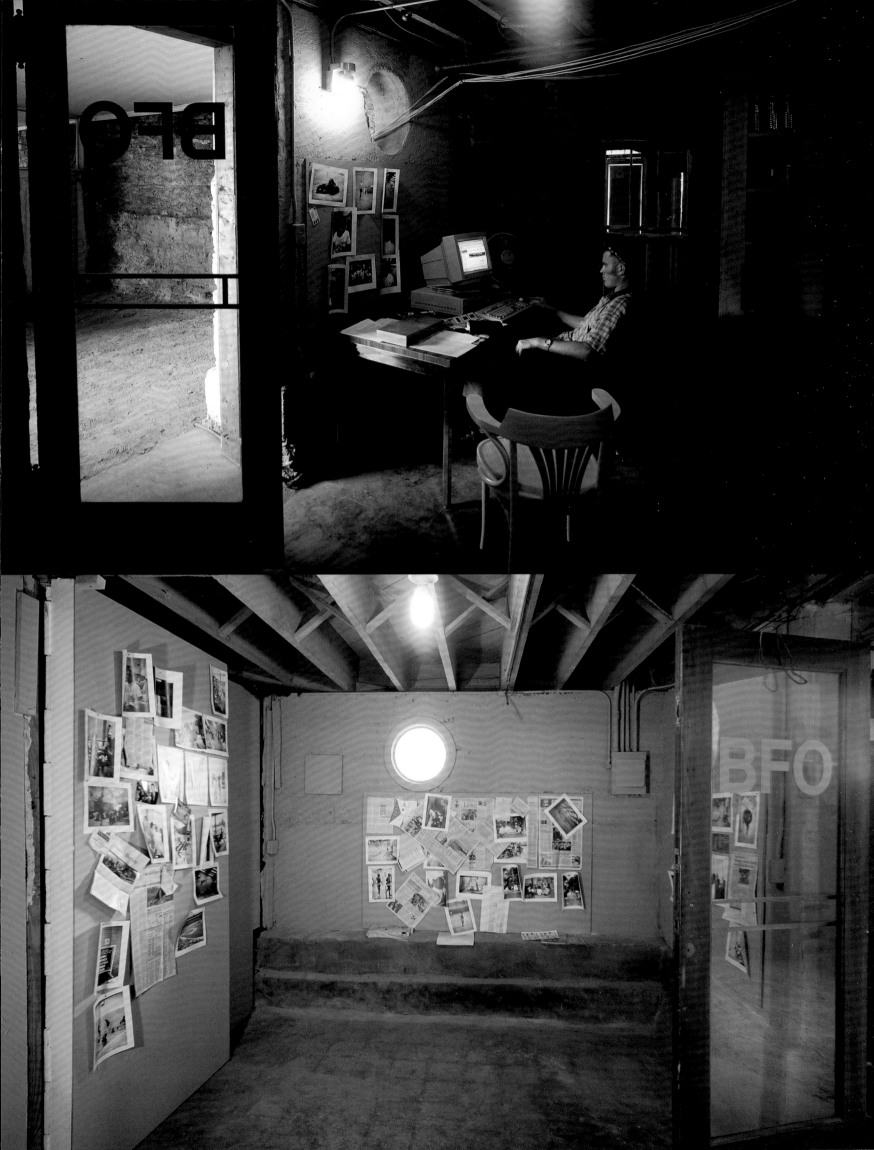

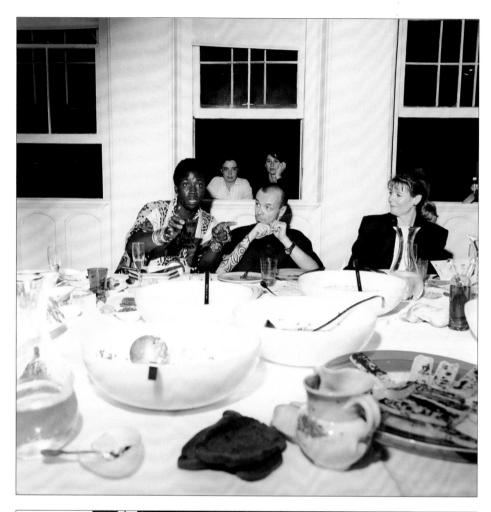

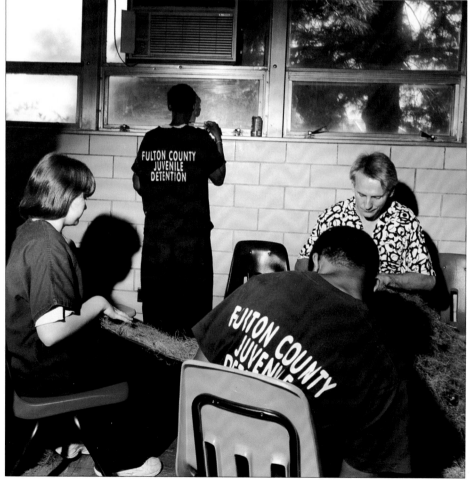

peoples and cultures, to allow people to ask questions about our world, and to encourage a questioning attitude as long as it is not stifled by conflicting needs of an institution.

The following brief descriptions are from the second part of the project, *Conversations as a Social Experience* and concerns the work of artists who I met during my visit. The previous part of the project, *Conversations as Visual Experience*, involved the artists Regina Frank, IRWIN and Yukinori Yanagi.

For Maurice O'Connell's project *Brothers for Others: Surrogacy, Sports and Society*, he based himself at the Jesse Draper Boys and Girls Club, an after-school club which aims to fill the gap for children who are not deemed to receive appropriate 'moral' education from school or family. His aim was to get a picture of the children's lives and those involved in the care organisation. How are the carers motivated? What is the philosophy behind their work? What is the relationship of this organisation to society and what is the relation of the child to corporate interests? His work involved discussion with the children, staff and the head of United Way, the charitable corporation which funds the clubs. The reconstructed office of the founder is kept as a permanent exhibit and reminder, which along with the founder's portraits and the organisation's corporate slogans, forms part of the institutional furniture. By the end of the three month project Maurice aimed to propose a possible future between himself, the children and others, based on what he had learned. He has also made an installation devoted to social service providers at the art gallery in downtown Atlanta which forms part of the Boys and Girls Club programme. During the final phase of *Conversations*, Maurice set up an office at the castle where he was available for conversations about his findings, while aiming to take his findings to others, principally Bill Clinton, via the internet.

Ery Camara's project *From Monologue to Conversation* took place in the African-American community of Reynoldstown and made use of the presence of the Olympics as a starting point for discussions and art making around self-image and involvement in community. (Inevitably, most residents experienced Olympics via TV even though it took place in their own city.) Camara established an atmosphere where history, awareness and imagination led to creation of artworks, where colours, shapes and movements involved the audience in a field of reflective thinking and creativity for the benefit of their community, by showing the inner values and subtleties that empower a neighbourhood.

The collaborative 'artway of thinking' (Federica Thiene and Stefania Mantovani) presented *Chow for Conversations on Culture*, in which they use the medium of food as an element of cultural identity and social gathering. Food, its preparation and the table setting are used to facilitate intercultural and interdisciplinary exchange. Their intervention is made into the series of eight round-table discussions planned by Michael Brenson and Mary Jane Jacob, transforming them into

conversation-dinners. The place settings and meals devised by 'artway of thinking' are the result of interactions between the artists, the guests and the chef, Massimo Frigatti, who came with them from Venice. While Federica and Stefania try to understand the chef's idea of art through food as a creative expression, he is trying to deal with the artistic concepts which they try to impose on it. The plates for the meals have been loaned by 16 individuals who the artists deem have made a significant change in the Italian cultural, social or political scene through their work. At the end of the series of dinners the plates will go back to their original owners, full of conversation. A typical *Chow* was that held at the headquarters of CARE, a food aid charity which distributes food parcels. The guests at the table, representing various sectors of the Atlanta community as well as invited guests from the United States and overseas, were each approached by the artists in advance and asked to choose a takeaway meal. The artists chose this format of meal as symbolic of American culture, with each guest exercising his/her right to be different through eating a different dish. The food arrived at the table in CARE food aid boxes. After the main course, coffee was served with a care box piled high with whipped cream. 'Artway of thinking' has previously worked with other élite communities, including bankers and politicians, to offer the experience of artists to pose questions and expose structures.

Mauricio Dias and Walter Riedweg devised *Question Marks*, a communication process through art between two groups of people in detention who usually do not have the opportunity to talk and listen to each other: youth offenders and victims at the Fulton County Child Treatment Centre (age 8 upwards) and 10 prisoners at the Atlanta US Federal Penitentiary. The project took the form of an exchange of questions through video tape, sensitising workshops and the making of a nest. The interaction aimed to benefit the younger residents of the children's facility by giving them an opportunity to consider their own future, and the older inmates at the penitentiary to reflect on their own experiences and take part in a dialogue that reaches beyond the prison and addresses the issue of people in detention still being part of society. The eight weeks of workshops were followed by an installation of video and slides at the castle and five street actions where the artists gave away car licence plates upon which the kids had marked many of their questions to society, to be fixed on cars and circulate on the streets.

Ironically, due to the Olympic furore and cultural jamboree, the Child Treatment Centre had its schooling programme cancelled because the crowded public transit system meant that teachers could not reliably reach class. Programmes at all detention centres were cut back because of potential security risks. While high art pulls in the gaping crowds at the High, those asking questions and with urgent questions to be addressed, are silenced.

Conversations at The Castle, *Arts Festival of Atlanta, 1996 (photos: Chris Verene) FROM ABOVE: artway of thinking,* Chow for Conversations on Culture; *Mauricio Dias and Walter Riedweg,* Question Marks

Interior displays, Selfridge's, London, 1996

EVERYTHING
NEIL CUMMINGS

Some Things

Implicit within contemporary institutions of display – galleries, shops or museums being the most common examples – is the idea of curation. Curation suggests the ability to define an ordered sequence of objects within a wider material economy, which we are encouraged to feel is excessive, chaotic and remorselessly accelerating.

A collection of curated artefacts – that is, a set of things selected as special, and sometimes displayed – may be called 'permanent'. This implies sets or sequences of objects being relatively slow moving in their passage through culture, for example, Roman glassware in relation to the speed of other material economies such as stainless steel saucepans. In opposition to this, a temporary collection represents a set of objects specifically assembled, perhaps momentarily, around a theme, event, fashion or season: 'Sculptors' Drawings from the 20th Century' or 'New Knitwear'.

The display of curated artefacts, whether permanent or temporary, defines a material space with *classification*. As such, the enclosed collection crystallises the structure of the singular and the serial; objects are either offered up as unique or displayed as a coherent set. The collection distils the multiple yet related taxonomic structures evolved to define and manipulate other, more diverse material economies. As a peculiar pattern of accumulation, the collection holds the promise of an imagined closure, and consequently is a well-known paradigm for perfection.

Objects which join collections through their display evolve as narrative elements, held in a material form. On an institutional level, objects can become a significant marker within a narrated history of Greek sculpture – imagine the Venus de Milo in the Louvre – and specified as singular. Equally my birthday present from Rachel, that strange teapot, now on my mantelpiece, is serially produced. The teapot becomes singular in my narration of it. I use the artefact to indicate a particular event, exchange or friendship; the teapot allows me to order experiences, and later to recount them. Susan Stewart's engaging book, *On Longing*, uncovers the particular qualities of relationships which adhere to the souvenir. Stewart detects nostalgia – an attempt to suture the felt lack between experience and its representation – at the heart of the manufactured souvenir, and eventually, through her narration, the souvenir collapses down into the drives that haunt the collected object.

Unfortunately, within institutional display, the artefact is condemned to a passive social and material relationship, dominated by the eye and a fashionable sense of order. Display is ideologically charged, it forces diverse behaviour into prescriptive patterns. Consequently, curation craves the authentic; ever more desperate tactics are deployed to mimic legitimate, perhaps more playful, material relations. Recently, amongst other things, galleries through their artists have invited you to take away old clothes (Christian Boltanski), read the books they suggest (Douglas Gordon), offer to be useful to you (Cesare Pietroiusti), plant Marram grass in your grounds (Maria Eichhorn), and hire the space out to local community groups for the duration of the exhibition (Renée Green). Galleries have opened in failed industrial or thriving retail spaces; they pretend to be restaurants, cafes or soup kitchens; they want to be museums, or even colonise domestic spaces. Less mobile institutions of display, museums and department stores routinely reach for complex theatrical devices – lighting, sound, smell, or major set-building – in an attempt to contextualise their depicted artefacts. It was Marcel Duchamp who alerted us some time ago to the power (or curse) of the institutions of display which simultaneously transform everything they contain to the level of the art object – an artefact manufactured almost exclusively for display – which nullifies everything valuable they might embrace. Unable to replicate a material behaviour which is – as we shall see – already the symptom of something else, institutional artefacts obey their prescribed syntactic forms; they rarely slide, slip or spill.

Everything Else

As our material culture becomes increasingly abundant, as we evolve into more discerning consumers, any thing, as part of a particular network of exchange is experienced in a subtle relationship to other extremely similar objects. Equally, rarefied economies exist for the appreciation of differences in paintings and antique furniture, as well as training shoes.

Increasingly, clothes, tools, art, bibelot, gifts, souvenirs and rubbish are seen as the markers without which social life would disintegrate. All economies of things are subject to a whole gamut of ideological constraints mediated through often competing ideas of correct and incorrect usage. This is to model the whole material world as an active participant in the configuration of social relations, rather than its passive reflection. Careful attention to material practices has made it possible to question lazy distinctions between art and tool, good and bad,

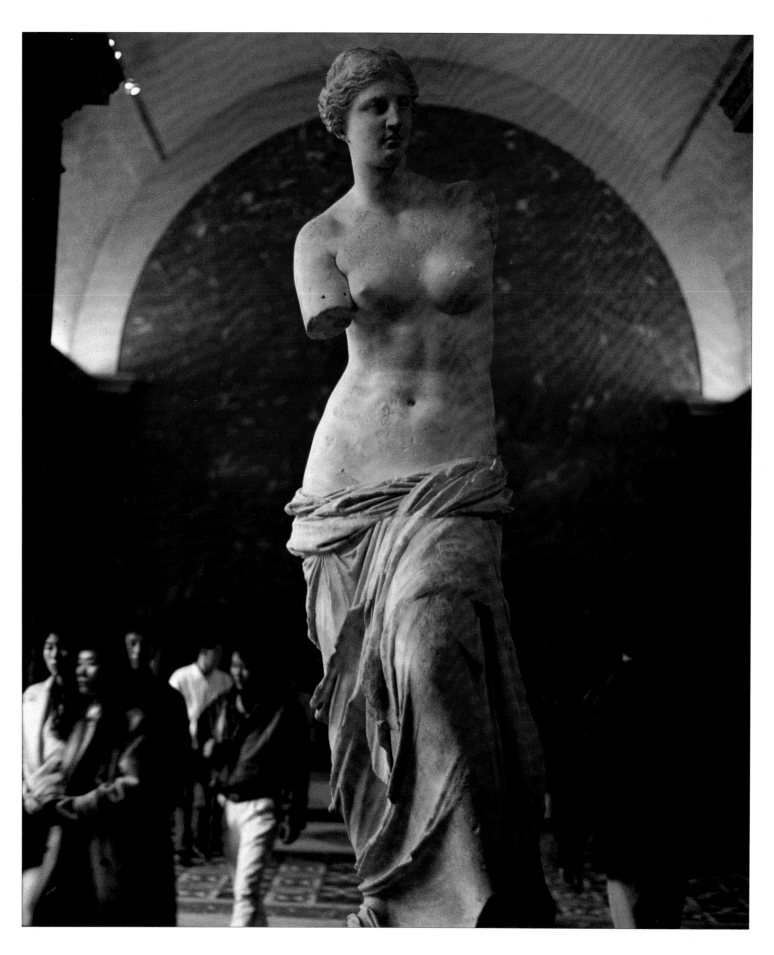

Venus de Milo, *Louvre, Paris*

ABOVE LEFT: Display, Selfridge's, London; ABOVE RIGHT and BELOW: Transit Gallery, Leuven, Belgium. In 1995 the gallery relocated to an Art Nouveau inspired townhouse which the owners had vacated, leaving behind nearly all their belongings. Transit moved all their accumulated possessions, as well as the gallery, into the building, leaving a part of the first floor, the physical core of the house, free of furniture, as the exhibition space.

or priceless and rubbish. In turn this exposes the means by which the play of difference and similarity within any defined set of artefacts allows the relativity of values to be extruded into being, and set to work: older, limited, cleaner, unique, smaller, valuable, faster, etc.

If, as many anthropologists and psychoanalysts believe, our intimate notions of self and the complex workings of society are constructed in our articulation of things, we become synonymous with our patterns of accumulation. From lovers' gifts to the GATT trade negotiations, we literally curate ourselves into being.

The sociologist, Pierre Bourdieu, has developed the term 'habitus' to describe the learned material practices appropriate to one's social aspirations. How a particular interest group – Bourdieu is able to slip between more inflexible 'class structures' – extends its influence over a given material terrain is often the fight for the dominant interpretation of the same thing. Using a close contextual method of interpreting material behaviour, Bourdieu shows how the struggle to accumulate, classify and display artefacts is a competitive process. The aggressive nature of this activity is the contest for 'symbolic capital', to which Bourdieu attributes all the actual cultural force of financial capital, which is why the conflict is so fierce.

Bourdieu intends the tussle for Symbolic Capital to extend – of course – through all levels of culture, to what is seen to be the appropriate use and interpretation of every image, text, object, sound and space. What, how, and with what should you cook, for instance? How should you store the utensils? In racks or drawers, from hooks, rails or magnetic strips, on shelves or stands? The kinds of fine classification and control that operate around seemingly slight domestic tasks cannot be contained by utility or notions of efficiency alone. Objects associated with activities cannot be lazily contrasted with things more habitually set aside for display.

In the lived space it is often the location (the mantelpiece, shelving, window sills or unfilled space on bookshelves) which empowers the *thing*, as an object of display, as opposed to any quality assigned to the artefact itself.

As much as objects help to define the context you find them in – you would not expect to find a carving knife kept with the toothbrushes, toothpaste, soap, or dental floss (unless it is a Hitchcock film) – they clearly influence the activities carried on around them. And yet the variety of situations in which we encounter objects often modifies the quality of attention we extend to them. The same object appears to change its symbolic potential as it moves through an assortment of contexts: that toothbrush may well appear in the Design Museum, a department store, in a friend's bathroom, a stall in a flea market, or a contemporary art exhibition.

The above are recognised as clearly defined places for encountering things, and in many respects authorise the behaviour they contain. In contrast, the lived space fractures and distorts all contexts. This seems to be where acquisition and display is most fluid and radical, where accumulation evolves into conscious curation, by setting aside artefacts in designated spaces as display, before returning and dissolving into the expected pattern of things. Things that are manufactured as symbolic ready-mades – paintings or their reproductions, souvenirs, silver or ceramic giftware, birthday or anniversary gifts – can be woven into relationships with temporarily symbolic artefacts, collected beer mats, driftwood from the beach or towelling robes. In the lived environment, things can engage in many of their social forms, as souvenir, art, gift, utensil or rubbish almost simultaneously. Any object can move effortlessly between these genres as circumstances arise: records rarely played may be fingered and admired by other enthusiasts, books can be bought but never read, crystal giftware can prop open the door, or washing up bottles can be transformed into desk-tidies; any thing could slide into pure display and return again. Perhaps the institutions of display are quoted as points of reference in this whirlpool of material practices, but they cannot contain them. More extraordinarily, we instantly recognise and interpret this shocking diversity of behaviour, and make judgements accordingly.

Objects that have the potential for display are often merely diverted from their prescribed patterns of use; the driftwood found walking on the beach with a lover, a beer mat from that Belgian bar, or a towelling robe stolen from an expensive hotel, are not where they belong. The narration, derived from Susan Stewart, weaves the object back into a sense of order. It is this relation to, and difference from, an expected material path that generates the potential for meaning and value.

Shocking and endlessly inventive are the fluid and diverse strategies by which people transform artefacts into lived environments, which both form and reflect their sense of self. There has been an enormous amount of recent work generated by Material Culture Studies – trying to determine the appropriate uses of things. Once established, the diversions, abuses and inventions can be compared and interpreted.[1] Inevitably, the diversity of material behaviour offers an infinite lexicon of variables. Attempts at linguistic definition tend to degenerate into crude marketing terminology. The subtlety of material culture slips through language; things resist translation. Clearly, as the institutions of display stifle the spontaneity which objects possess in their encounters in routine material life, the majority of curation, although experienced, remains unacknowledged and unrepresentable.

Note

1 For a fine example, see Daniel Miller 'Appropriating the State on the Council Estate', in *Reading Things*, edited by Neil Cummings, Chance Books (London), 1993.

16

ABOVE: Transit Gallery, Leuven, Belgium; BELOW, L to R: Egyptian glass, British Museum, London; Freud Museum, London

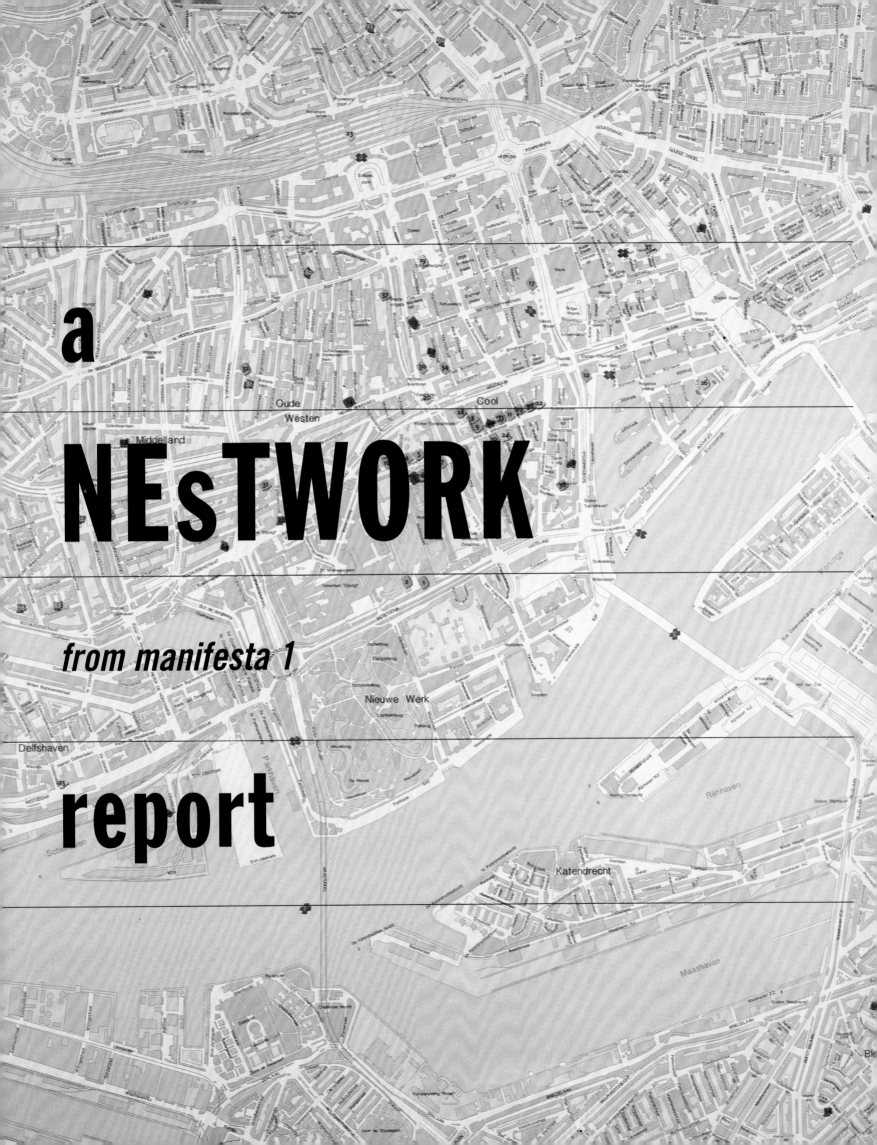

a
NEsTWORK

from manifesta 1

report

In May 1995 Manifesta held an open house meeting in Rotterdam presenting a daunting challenge for artists and curators: the organisation of an international platform with the objective of creating new means of communication in the visual arts. *'Manifesta is an exploration of the topographical and mental space of Europe. More than simply an exhibition, Manifesta will attempt ways of communication through art, philosophy and technology. The definition of Europe will not be found on a map, and the place of art today will not be found in objects or genres. The European boundaries are porous, and therefore the processes of discovery will take into account the multiple interjections of one land mass and another, one people and another'.* Manifesta's ideas include notions such as a new European identity, migration, translation, communication, community, politics and more. Faced with this ever-increasing flow of concepts, I wondered how this was all going to take place and what role would be reserved for the artists' community of Rotterdam. Rotterdam has its own history of art events. It is known as a city with an enormous number of festivals, such as Poetry International, R' festivals and Hoboken. In addition to this, it is open to every other festival that would like to put its tent

information /

reflection /

strategies /

hospitality /

NEsTWORK
creates
a space

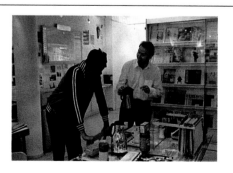

What impact did Manifesta 1 *have on Rotterdam?* After the open house meeting in May 1995 there was a period of silence that lasted four months. During that time the city waited in anticipation. By October the organisation publicly announced its first selection of official artists. Local artists, artists' initiatives and galleries could participate only as an independent side project, but they would be related to the main programme by a shared press campaign. Inner and outer circles were effectively created, with NEsTWORK caught in between. This was not what people expected when they heard Manifesta wanted to create a sense of community. Since

in the Museumpark. Rotterdam has one temporary event after another without having a clear idea about how to ground all this in the daily life of the city. Was *Manifesta 1* to become another travelling art-circus, another quickie? Apart from the Museumpark, our festival arena, Rotterdam has an intensive network of artists, artists' groups and studio-buildings. Artists have created their own basis in this city by means of exhibitions, exchanges, discussions and collaborative efforts in creating and maintaining spaces to work and think. How should this existing infrastructure relate to *Manifesta 1*? Would it be possible to give meaning to the idea of being the first host-city for Manifesta beyond merely satisfying the basic need for space and, of course, money? Big events like this put a tremendous claim on the energy and funds of a city. Certain questions arose in my mind: What is the position of the local host when receiving an international platform? How can the international group of artists participating in *Manifesta 1* be connected with their Rotterdam colleagues? And how can the city be more than just a few square metres around the Museumpark? After leaving the open house meeting it seemed logical to call another meeting to discuss the position of being a local host and the possibility of contributing collectively. Merely opening a Manifesta office in Rotterdam is not enough to ground the ideas involved. Real hosting can only be done by the people of Rotterdam itself. Motivated by this thought, I asked for an official 'artist place' in *Manifesta 1* and was given this by the curators. I use the expression 'artist place' because neither a side programme made by a curator nor the binary position of local community versus *Manifesta 1* would work. The position I wanted to investigate is that of deconstruction. Deconstruction can only happen from the inside, both belonging to here and there and constantly

information / NEsTWORK chose to house ourselves in four different locations of which the normal aims and activities were relevant to our projects. We activated and redefined the Documentation and Information Centre of the Rotterdam Centre for the Arts, the theatre space and Café Zaal De Unie, Boijmans Van Beuningen and the artists' initiative B.a.d., inserting our ideas into the existing structures in order to begin a dialogue. In these venues, all except Boijmans were added to the list of Manifesta 1 locations, we were a temporary though familiar guest confronting both the host and the visitors with our ideas, both in theory and practice. Supplying information is an essential aspect of the experience of contemporary art. We think the actual work of art does not exist and that we are a part of a network that attaches value and meaning to contemporary art. This means that the artist in a studio is as important as the curator, as the person who grants funding and as the one who gives information or passes quality judgements. The documentation and Information Centre of the Centre for the Arts has been reorganised and staffed daily by us. It served as the office for the co-ordination of / information

reflection / For NEsTWORK reflection includes discussion, thinking and confrontation with new ideas. We find reflection to be as important as the image, and stress the necessity for ongoing dialogue on the heteronomy of culture. We prefer the word heteronomy to heterogeneity because it counterbalances the term 'autonomy', and acts as a critique to the idea of artists as independent and self-determining. We are interested in constantly putting things into question, not in providing definite answers. In the theatre space and cafe of Zaal de Unie we organised an intensive programme of events, offering lectures, films, meetings, discussions and refreshments, creating the possibility of publicly questioning the idea of place. GOING PLACES is one part of the programme and consists of multidisciplinary shows which lure the public into places only existing as a mental construction or as a memory: they are shown the world through the eyes of others. STRATEGO is another part of the programme with the aim of questioning process, collaboration, femininity, displacement and identity as artists' strategies. Different artists and artists' groups were invited to create a / reflection

stategies / At the prestigious museum Boijmans Van Beuningen, NEsTWORK asked questions about art and its codes. How far can hospitality go if guest and host do not understand each others' rules or, more strongly, do not value each others' rules? On the opening day of Manifesta 1, the concert REPRESENTING THE ROTTERDAM DOCKS was organised by NEsTWORK in collaboration with the Rotterdam Hip Hop scene. The most important question underlying this concert was how far one subculture – art and the institutions representing it – can or would provide a space for another subculture – Hip Hop – and through that accept a strange element into its existing structure by temporarily abandoning its prevailing codes and rules to open up to the other; in this case the other inclusive of the inextricable connotations bound with Hip Hop, such as aggression (versus serenity), black (versus white) and street (versus salon). To open space for others and to be hospitable has not so much to do with space for the physical presence of the other, but is related to accepting the otherness of the other. And it is this feeling of confrontation that makes us / strategies

hospitality / Under the title NEsTWORK CREATES A SPACE we took the role of being a host ourselves. We offered space and funding given to us by Manifesta 1 to other artists and artists' initiatives. This included projects such as: distributing plastic carrier bags with the text Each day 40,000 people search for fresh content in contemporary art made by Omission; a photowall documenting all our activities by Noelle Cuppens; and a video installation by Geert Mul coinciding with the Hip Hop concert. During the installation and hanging of Manifesta 1, 17 of its participating artists were offered hospitality by artists' initiative B.a.d and NEsTWORK. The project entitled MY HOUSE: YOUR HOME offered the visiting artists the opportunity to live and work in and around the building of artists' initiative B.a.d. To this end each artist of B.a.d constructed a special home for his guest. The shape of the homes and their function reflected the maker's thoughts on hospitality and art. Apart from this, B.a.d. offered dinners, breakfasts and events where social exchanges generated artistic dialogue. They wanted to cause and visualise encounters between artists – both from abroad and those / hospitality

community and communication refer to meetings, exchange and collectivity the least one could have expected was an attitude of openness, curiosity and mutual interest from both sides. It has to be said *Manifesta 1* didn't give a lot of information on how to continue their process. One folder isn't much of a dialogue. But could it not also be that the artists of Rotterdam took their participation for granted, and waited too passively until they were invited and given specific instructions. My impression is that the local community defined the terms 'communication' and 'community' too narrowly. Communication is not only about conveying procedural information. Good intentions to provoke dialogue resulted in the magazine LOKAAL EUROPA, issued 4 times. This local initiative aimed to constitute a dialogue with *Manifesta 1* but merely gave voice to the negative feelings alive in the city towards *Manifesta 1*. There was a strong reaction to the exclusiveness of the official *Manifesta 1* programme which took the form of an enormous number of deliberate side programmes. One of them, Colorado, organised open studios and gallery visits to all parts of town and a large exhibition in a old sugar warehouse. It took the word 'participation' very literally, providing all local artists who were interested with a place to show their work, whether or not their work or ideas had any relation to the ideas involved in *Manifesta 1*. NEsTWORK dedicated one of the STRATEGO nights at De Unie to a discussion of these side programmes. The question was asked if participation for the sake of it is a constructive approach, or if connections should be made on the level of content. Was Rotterdam not focusing too much on the idea of inner and outer circles? In some sense you could say *Manifesta 1* incited the local art community to critically think about its own context. A lot of work needs to be done in our own backyard.

moving back and forth, fostering connections between the local and the international. Letting the home team play, so to speak. Internationalism is a popular concept but is empty unless it takes the local community on board. I invited people who work within different areas in the field of culture in Rotterdam, such as visual arts, philosophy, criticism, music, dance and even administration. They were invited on the basis of affinity and all showed a strong engagement with the city and the ideas involved in *Manifesta 1*. Furthermore they needed to be willing to work collaboratively in a non-hierarchical, self-structuring group,

on a process of putting the ideas 'local' and 'place' into question during the eight months preceding the opening of *Manifesta 1*; a process in which there would be no hierarchy that privileges the artwork, text, place or even the generation of money and creation of a publicity framework. The intention was not to fully represent the city of Rotterdam – an impossible task – but, by interweaving the different narratives and connections of the people involved, to make it present. NEsTWORK was born. 'The name indicates what it is, the nest and the network cannot be separated from each other. NEsTWORK sees itself as an

entity integrated in the friendships and networks already existing in our city and its professional field. NEsTWORK wants to explore the meaning and implications of the notion 'local'. In a time when internationalism seems to be the magic word, NEsTWORK wants to focus on the place where work is done. Art always takes up space. This space is never a blank page; the framework of the host determines the functions and the importance of all activities. But when receiving a guest, the host must in some ways open up to different ideas as well. NEsTWORK asked itself questions about the function of place. How does art relate to the place

information /

all NEsTWORK activities, and information about art in Rotterdam was available there. The already extensive archive, normally made up of work by individually working artists of the CBK, was expanded with information on artists' run spaces and special projects and activities made by Rotterdam artists and projects created in relation to Manifesta 1. To complete the information given on all

Rotterdam activities, we made a special city plan showing all sites of cultural activity in Rotterdam. We did this knowing that Manifesta 1 would only provide a map of the area around the Museumpark. Exhibitions normally make maps showing the centre of cultural activities, leaving out the periphery which constitutes the actual artistic life in a city.

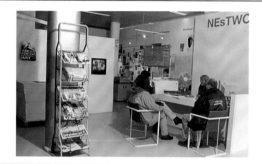

reflection /

special night around their point of view. Furthermore, the open manifesto PORTABLE ART LOCAL ART serves as a starting point for discussion and reactions to the meaning of 'local' and 'image'. The terms 'Portable Art' and 'Local Art' were used to coin two notions of art that seem to rule each other out. 'Like every other form of human expression, art occupies space. The sculpture in the park, the

painting on the wall, the exhibition or installation in the museum all demand their place in the world. The studio, where art is made, also always occupies space. How does art relate to its place? There are two possible answers which at first appear mutually exclusive – two views of art, which I shall term Portable Art and Local Art. I shall differentiate between them and examine the

ways in which they relate to each other. It is important to point out that these are not two separate species of art. And, it might seem natural to conclude that art at times works according to the first notion and others according to the second. But this dichotomy is not based upon empirical views of random art works or styles. Here we are looking for the origins of art'. (Ruud Welten, Rotterdam 1996)

strategies /

create borders, codes and rules as a way to secure and define. To be a guest is not easy. Within their press campaign Manifesta 1 advertised that they offered: 'no paintings, no sculptures: take a walk on the art side'. NEsTWORK, however, added one painting to the permanent collection of Boijmans Van Beuningen and infiltrated the information bulletin system of Boijmans Van Beuningen

with a text entitled GAMES PEOPLE PLAY. These were the most difficult tasks for us to complete. Museums seem to be more willing to take in something that they clearly frame as different (for example a Hip Hop Concert) than to include something close to home, like an additional painting.

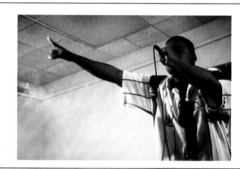

hospitality /

working in Rotterdam – in a very direct and personal way. This is to give identity and significance to the period Manifesta 1 artists stayed in Rotterdam. By connecting different working and living conditions, the city of Rotterdam became a true host rather than a short port of call.

NEsTWORK creates a space

And the exhibition Manifesta 1 *itself? Manifesta 1* set itself up to be a platform for new means of communication but in my view it only accomplished this during the ten days for construction and hanging and the opening days. The big tent in the Museumpark that served as a meeting point for all the artists and the public involved in *Manifesta 1* was taken down immediately after the successful opening events, which included: the Pavlov Dog, the crowded and lively bar and cinema of Douglas Gordon and Rirkrit Tiravanija and the possibilities of having a talk with Joseph Grigely or Tracy Mackenna at the laboratory of contemporary studies. After

the intensive atmosphere of the opening, visiting *Manifesta 1* again gave me a shock. Could what I saw, or rather did not see, be true? Of the activities from the opening there was almost nothing left and the marginalised position of most of the works in the institution became painfully clear. This had nothing to do with the sometimes marginalised or non-prominent locations the artists in *Manifesta 1* chose to show their work. The marginalized position came through the lack of public support by Rotterdam institutions such as Boijmans Van Beuningen, CBK Exhibitions' Villa Alckmaer and De Kunsthal. All they provided was an exhibition space in its

narrow sense, treating *Manifesta 1* as just another festival, another quickie. One institution even forgot to mention it in its biannual programme. A chance to participate in a new European platform was neglected by Rotterdam's art institutions. They were all too busy with their own positions. Without their support *Manifesta 1* was nothing more than a carcass.

And NEsTWORK? A month later when the Pavlov dog and the people of the laboratory of contemporary studies had left for other destinations, NEsTWORK was left alone to continue the

where it is made or exhibited? What is the current status of visual images? What part does locality play in contemporary art?'

NEsTWORK as a group developed its own concepts that are shaped by the concrete, daily practices of giving *information,* encouraging *reflection,* unravelling *strategies* and offering *hospitality.*

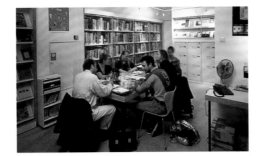
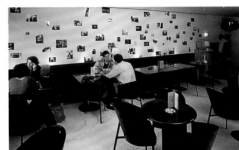

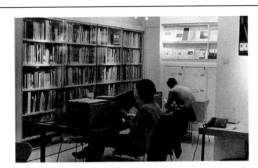

/ information

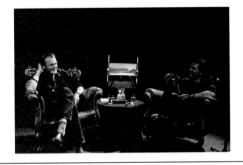
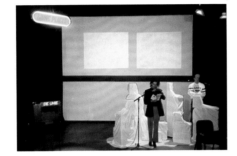

/ reflection

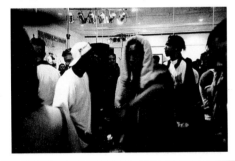

text: Jeanne van Heeswijk, special thanks to Susan Kozel design: Simon Davies

photos: Noëlle Cuppens, Bob Goedewaagen, Janine Schrijver, D.J. Wooldrik posters: Edwin Janssen, Wim Salki, Marc Vleugels city plan: Bart Oppenheimer, Kamiel Verschuren

NEsTWORK: Karin Arink, Wapke Feenstra, Jeanne van Heeswijk, Edwin Janssen, Menna Laura Meyer, Kamiel Verschuren, Ruud Welten

/ strategies

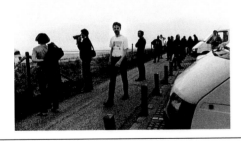

/ hospitality

process. At the Documentation Information Centre of the CBK, where NEsTWORK gave all artists and side projects the possibility to publicise themselves, every day artists came by to renew their documentation in the archive or to bring additional information. They often spent time with us drinking coffee and discussing how they perceived *Manifesta 1* and the work of the artists involved. NEsTWORK functioned as a sounding-board. At the theatre space and Café Zaal De Unie the discussion programme was well attended; NEsTWORK succeeded in bringing different groups in the city together to exchange ideas. In these ways NEsTWORK created a new platform for communication in Rotterdam and even in The Netherlands. But what NEsTWORK also aimed to do was to foster connections between the local and the international — this hardly happened. We attempted this, but given the situation it was nearly impossible. How interesting and challenging it could have been if the artist, curators and institutions of *Manifesta 1* had been involved in the programme as well. Perhaps then it would have been possible to extend the administrative network we shared with Manifesta to a level of content. Today I received an invitation to the festival R'96 in September. . .

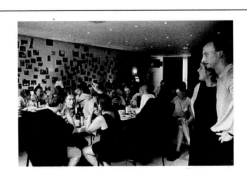

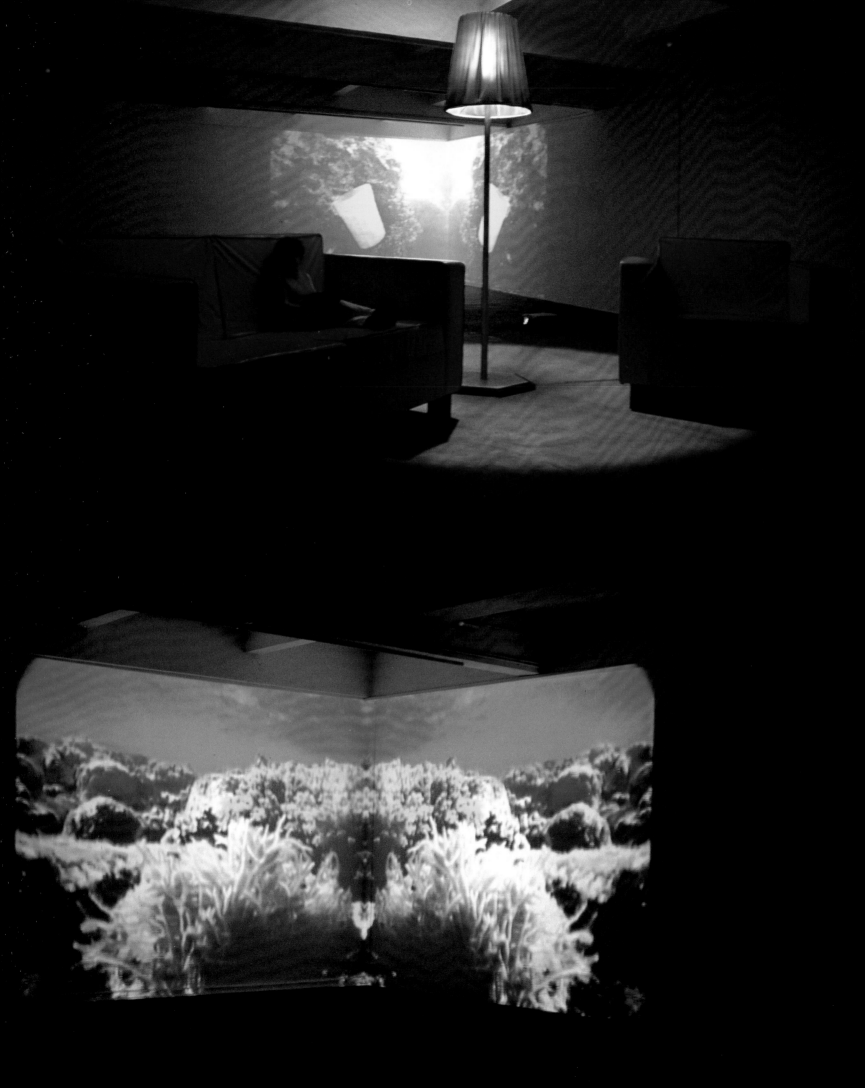

THE SPECTATOR AS PERFORMER
RICHARD LAYZELL

The Fear and Tyranny of Bill

I'm not having my men lift that, it's too big. There's people at the back trying to unload and nobody told me. We're supposed to have 24 hours warning for deliveries so we can tell the police. This place is like a builder's yard, I'm not having it. There's too many of your people working late, we'll have to put a stop to it. None of this is art if you ask me, I like a nice painting. You people are not showing a proper respect for my building.

Bill is the Gallery Manager. He's not a curator. He has 20 or so people reporting to him. He becomes our main point of contact with Glasgow Museums. We are freelance. Kathleen O'Neill is curating a museum-scale interactive exhibition at the McLellan Galleries in Sauchiehall Street, called *Art Machine 95*. She has invited me to be a participating artist and subsequently, a co-curator.

I gradually came to understand that when people spoke of *Glasgow Museums* it was not a descriptive title but the name of the organisation. To avoid the confusion I subsequently refer to it here as the *organisation*. It is a large bureaucracy employing probably 200 people. The McLellan Galleries (referred to in the singular) is one amongst many major museums in the city which are administered by *Glasgow Museums*. The Burrell Collection, Kelvingrove Museum and Art Gallery, the Museum of Religion and the recently opened Gallery of Modern Art are others. The McLellan Galleries, six very large elegant interlinked galleries, is their one major venue for temporary and contemporary exhibitions.

There is one marketing and publicity department serving the *organisation*. It is based underneath the McLellan Galleries but there is no obvious overlap; employees have their own side entrance and rarely venture into the galleries. Technical assistance is located in many different buildings throughout the city. Electricians tend to float. Finance is somewhere else altogether. It is logistically complex to order basic materials and make payments. There is also a strict demarcation of jobs – this group of people can move things for you but they cannot nail anything or put a plug on anything and you will need to consult Bill first, so that he can ask them to move the stuff on your behalf.

This is not an untypical situation within the museums network nationally, but the ambition and scale of this project accentuated the frustrations. Ultimately, there was the sense of being part of a museum structure where the permanent collection and the public's 'enjoyment' were the key issues. Within this environment a contemporary interactive exhibition was likely to make ripples. There were key people within the organisation who were pleased to see the waves but we were the ones making them.

In addition, there were several curatorial agendas. In 1990, Glasgow's year as European City of Culture, the McLellan Galleries hosted *Art Machine*. This was a family oriented, hands-on exhibition which attracted large audience numbers. The *organisation* wanted *Art Machine 95* to achieve a similar effect – ie, making art a popular, fun, educational experience. There was an insistence that we adopt the same name. We, however, had a considerably broader vision for *Art Machine 95* and saw 'interaction' as a contemporary concern via technology. We were interested in extending collaboration in the art-making process by creating partnerships with organisations working in mental health, disability, homelessness, particular communities, drugs and education. Audience numbers were not the primary issue. Kathleen O'Neill also planned to extend the exhibition through the normally closed-off ground floor of the McLellan Galleries, opening up the building completely, doubling the available space, bringing artwork into corridors and stairwells.

This hit Bill very hard indeed. 'You'll never do it. There's too much stuff in the crate store to be shifted and you can't let the public in there, it's a hazard. And the public are entitled to come in here off Sauchiehall Street and use the toilet (on the ground floor), it's a regulation. So how are you going to stop them coming in to the exhibition without paying?'

The other main funder for the exhibition was Strathclyde Regional Council. They were keen on extended community involvement.

During the planning stages Kathleen held artists' meetings at the Museum of Religion. We met to pool ideas, make requests and get acquainted. Despite the complex range of agendas inherent in *Art Machine 95*, these excellent meetings began to build a sense of collaboration between artists at an early stage. This unusual process was extremely valuable but it forced me to see the potential complexity of occupying the dual roles of artist and curator.

It is common enough for artists to curate themselves into their group exhibitions. In this instance it came the other way round. I was an invited artist before becoming involved as co-curator. To continually explain this to people felt like a justifi-

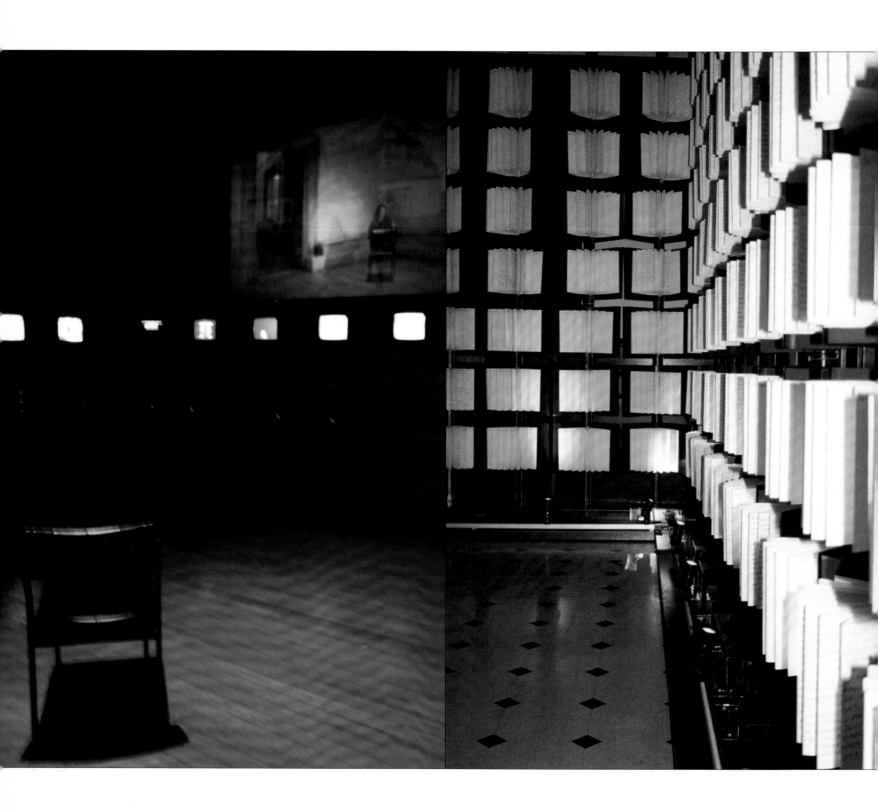

PAGE 24: Pipilotti Rist, I'm Not the Girl who Misses Much, *video installation, Chisenhale Gallery, London, April-May 1996; THIS PAGE, from* Art Machine 95, *May-Sept 1995, McLellan Galleries, Glasgow, 1995, L to R: Brian Connolly,* Ingress-Egress, *mixed media, video installation; Nicola Atkinson-Griffith,* Captured, *installation*

cation. The role of curator evolved into something of a provider and on a psychological level it was hard for the other artists to see me as one of them, perhaps understandably, given the complexities of the *organisation* and the demands of the exhibition. The two roles began to polarise in my mind, the one with an overview and assistance, the other with obsessional focus and requests. It was harder to switch between the two than I had predicted. The artist only surfaced in the evening, like a badger. I think Bill saw me as some kind of a boss, a flaky Londoner who he could complain to about the rubbish in his burrows. His constant presence and curious agendas became much more than an irritant. It began to feel as if we were bringing art into hostile terrain, a listed building which would be better off empty, keeping the public safer.

Technology was to play a central role in the majority of the installations. *Interaction* became a theme, a buzz word, a concern, a hook. We started calling it *Scotland's biggest interactive event.* Artists worked with communities and groups across the Strathclyde Region, from Glasgow to Campbeltown, from the Gorbals Addiction Service to the Fernan Street Disability Resource Centre. All the works were specially commissioned for the exhibition. Most were site specific. I watched them evolve from the curator's perspective, remembering how spaces and resources had been allocated. Inevitably, size did not equate to effectiveness any more than interaction did.

The Irish artist, Brian Connolly, opted for the smallest space. He collaborated with Glasgow's Trongate Studios, which provides working space for artists with mental health problems. In *Ingress-Egress*, his first video installation, he gave the spectator a profoundly moving experience. We sat in a chair where our own image was mixed with the ghosts of his seven collaborators through video projection. We were surrounded by monitors which told their individual stories of journeys to 'safe places' of their past. We listened to them on headphones. The intimate space provided the intimate experience. This work still resonates strongly with me, remembering the processes of risk and uncertainty the artist undertook, the simplicity of the concept, how successful it was as a collaboration, the depth of the experience for the viewer. We were participating in the work before we knew it.

Nicola Atkinson-Griffith produced recollections of people from across the Strathclyde region encapsulated in walls of flapping books. In the collation of these memories and stories she travelled extensively and interviewed over 300 people. Their words were reproduced in 266 handmade books which surrounded the spectator from floor to ceiling. In the physical realisation of the installation *Captured* she collaborated with architects, engineers and local artists. The pages flapped intermittently, words were silently animated, individuals' voices were poignantly trapped.

Stephen Hurrell's three video projections beamed onto walls at the top of the imposing staircase, normally dead space.

Physically they formed a link between the two floors. Aesthetically they were a play of colour and fast edits. Emotionally they explored the memories of older people and the aspirations of younger people living within Darnley, a colourless housing estate.

Simon Biggs made the most technological demands. His huge video projections in *Presence* were activated into sequences depending on where the spectator stood. A direct conversation could develop between the work and the audience. This was most literally an interactive work. One walked towards a wall, influencing the projected images. The figures moved towards us, they moved away as we moved away. The physical environment was clinically bare, four white walls with a complete blackout. It was a cool, uninviting experience. Perhaps his reluctance to work with local people as video subjects in the work added to this sense of detachment. Perhaps it relied too strongly on the 'interactive' tag.

The issue raised here is the quality of the interactive experience. Interaction in itself does not make exciting art. A couple of decades ago the mention of 'video' produced a reverential hush. 'Interactive' may currently invite a similar reverence but it is only a means to an end. It is a word which, like video, has become part of popular culture and is open to interpretation, from virtual reality to automatic bank teller machines. Here, in *Art Machine 95*, it offered inroads into communities, technologies, emotions, sensations, issues and audiences. Spectators 'performed' their way through the exhibition, participating aesthetically, unwittingly. Interaction opened doors to art. The politics of seeing an installation from a wheelchair, as with Andy McKinnon's *Dreamspace*, did not obscure the profundity of the experience. Rationally we may stand back and question what light this may shed on disability. Physically and emotionally we enter into it and cannot doubt its integrity. Reassuringly, *Art Machine 95* achieved the popularity of its 1990 predecessor without sacrificing a high level of innovation and integrity in the artworks.

Once the exhibition had opened, Bill's role, response and opinions became, on the surface, less important. In an unseen way, however, his influence was strong. His team of 20 or so were now acting as invigilators. They had been briefed by Kathleen and myself to adopt a new role in this interactive show. They were encouraged to be as interactive in their dealings with visitors as the exhibition required, stepping out of their normal passive, security roles. Without Bill's support in this it quickly deteriorated to the point where invigilators huddled and quietly scoffed at the level of interaction going on, in almost complete detachment. Bill's view of the public was as some amorphous respectable mass who, like himself, wanted to see the place clean and tidy. When a group of grieving women from the Gorbals came in to see the memorial quilt dedicated to their young people who had died from drug abuse he was heard to say, 'These people shouldn't be in here!' The

emotional response was not welcome. But it was not just Bill who was uncomfortable.

At this time I briefly joined the team commissioning work for the Interactive Gallery of the new Gallery of Modern Art. The curatorial team included scientists, educationalists, historians and designers, all with strong views on 'interactives'. Contemporary art did not play a significant part in their thinking; in fact, one or more of the group actively disliked it. Julian Spalding's highly personal selection of work for the new gallery caused great controversy. He was quoted as saying that Duchamp's influence on modern art began its decline. So, where was the logic in his highly conservative collection of painting and sculpture including interactive work? The answer lies in a view of interactives as hands-on educational tools, the 'soft' end of contemporary art.

On one level this sounds reasonable enough, interaction does often lead to greater accessibility. Similarly, Bill's concern for 'the public' is shared by many contemporary artists. The confusion and problems arise when the level of experience for the audience deepens to a significant aesthetic, sensory or emotional level. If they truly become involved in an art experience then the waves break, as they should.

The Nice Goals of Pipilotti

It is important to me to be comprehensible. My art shouldn't work only on an intellectual level; it should also provoke emotions, invoke strength and give pleasure. Nice goals, don't you think?

Pipilotti Rist, *Bohren #2*, 1994, Kunsterhaus Bethanien

Tap, Ruffle and Shave is the interactive installation I produced with a group of other artists for *Art Machine 95*. In 1996 it took a new form at the South Bank Centre in London. There were distinct differences in working with this organisation. Here it was presented as the flagship of a new curatorial policy, an audience-friendly sensory work for a very public exhibition space. It was commissioned by David Sefton, a music specialist, who was looking for overlaps between art forms and ways in which to broaden audiences.

The installation was designed particularly for sensory impaired people and then opened up to be very inclusive. Discovering how the visually impaired experience the world had a strong influence: 'My body can recollect the narrow little strip of ground over which I have passed, and it consists of tiny details . . . here the footpath goes up slightly, there is a nick in the kerb, this telephone pole has a metal plate screwed to it but this other one is smooth'. (John Hull, *Touching the Rock*)

This is close to an art-attuned experience. It draws out the sense of touch and of mapping without vision. Dominated as we are by the visual, we tend to associate touch with smut. Allowing touch to be the driving force brought the visual flowing gently behind. And the audience, being driven by the sensory impaired, explored the work freely. There was no touch taboo. Many were far more uninhibited than the British are supposed to be. They crawled on the tactile carpet, wrapped themselves in the silk drapes, resonated the wood and steel, made sounds. They became the performers, the interactors, the collaborators. It was their space, their zone. Wheelchair users, babies, concert goers, businessmen came and tinkered, not always knowing it was art they were in. This level of outright enjoyment did not match my programmed picture of a gallery space. Then I got used to it and something shifted.

The Swiss pop star and video artist Pipilotti Rist consciously plays with any programmed views of a gallery space we may have. Outright enjoyment is absolutely intended, but her work is far from vacuous. And do we tend to assume that emotional, sensory or sensual enjoyment in art is somehow lower on a scale of aesthetic experiences?

Her relationship to technology is celebratory and unintimidated. She generates passionate highly-coloured video imagery, sometimes of her own body. Through elaborate editing and post production she manipulates, condenses and intensifies the images further. This is her second level of intervention. The third level relates to how the video interacts with the audience. She conceals video monitors so that they are only visible if one inserts one's head into a vertical tube. She creates a chandelier of monitors surrounded with crystals. She constructs domestic environments where video projections become kinetic wallpaper.

The TV tube is the flame thrower

The room is the maelstrom

And you are the pearl inside (Pipilotti Rist)

In *I'm Not the Girl Who Misses Much*, Pipilotti's first London showing, we were invited to sit on an outsize sofa, playing the videotapes from a giant remote control. Or we could experience it at the next remove by being around the people in the armchair, like waiting for a free seat at a party. From this position the interaction with the work was just as rich. The walls shimmered with video projections. An outsize armchair and standard lamp were nearby. It became a place to inhabit more than a gallery, an inviting, colourful, aural space where the viewers became the participants and had control over their experience. The divisions between home, art and TV were deliberately blurred. People stayed around as willing consumers. They wanted to be there, in the work, in some cases unaware that it was art they were in. The gallery's visitor numbers went way up.

Audiences who may be intimidated by the idea of contemporary art are familiar with the notion of interaction. They are willing to enter into a total experience that may affect them deeply. Sensation and emotion can be freely embraced. And their absolute enjoyment need not threaten the integrity or complexity of the art work. It is a bonus.

Richard Layzell, *Tap, Ruffle and Shave (an installation to meddle with)*, South Bank Centre, London, May-July 1996 (photo: Amy Robins)

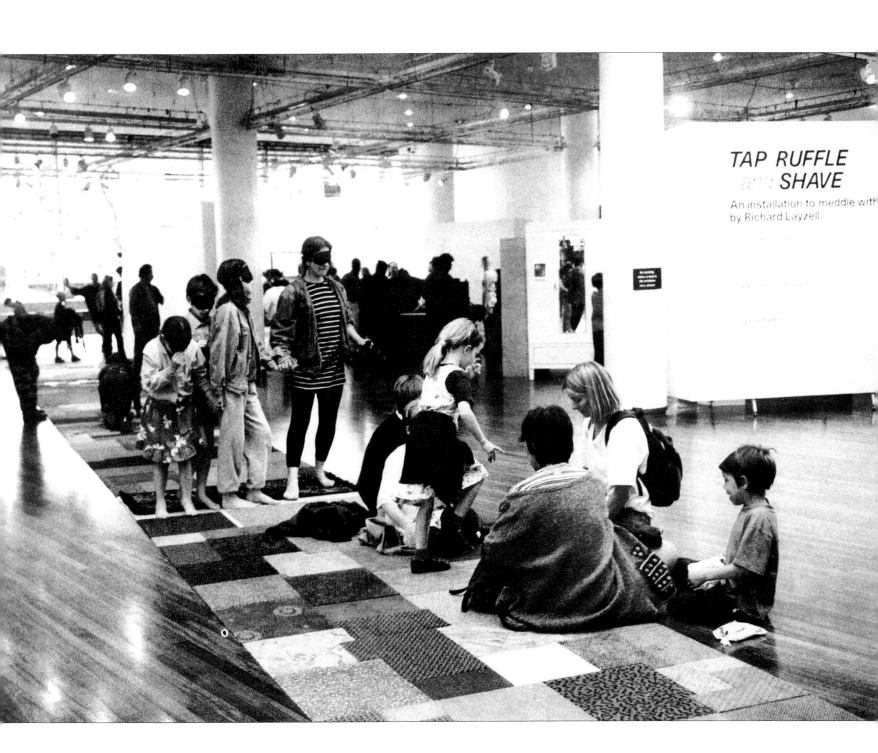

TAP RUFFLE
and SHAVE

An installation to meddle with
by Richard Layzell

MAPPING INTERNATIONAL EXHIBITIONS
BRUCE W FERGUSON, REESA GREENBERG AND SANDY NAIRNE

Every exhibition is a map. As such, it not only separates, defines and describes a certain terrain, marking out its salient features and significant points, omitting and simplifying others, but it also depicts the ground according to a method of projection: a set of conventions and rules under which the map is constructed . . . The problem is . . . that, in exhibitions as in maps, the conventional nature of the representation tends to be hidden in use. The laws of projection become invisible.

John Tagg, 'A Socialist Perspective on Photographic Practice', *Three Perspectives on Photography*, Hayward Gallery (London), 1979, p70.

John Tagg's mapping metaphor has become a much-used trope for postmodern writing, especially writing about art. We are aware that in recent years the continuing usefulness of this metaphor has been questioned but wish to use it specifically in relation to international exhibitions to unravel some of their strategies of projection.[1]

One of these strategies is the link between the location of an exhibition and its politics. *Where* an exhibition is staged, particularly an international exhibition, is a key determinant regarding which artists are included as participants and the exhibition's likely range of viewers. The very name of a location can determine how an exhibition is positioned historically and read critically. Exhibitions depend upon the rich and various connotative benefits associated with their chosen locations, for sites are always signifiers of stability and history or, conversely, of the exotic, of the new, or even of art itself.

Often, the location is included in an exhibition's title. As authorisation is the fundamental and lasting act of possession in a colonising activity, the name of an international exhibition helps to construct a position and a viewpoint; from an inside which looks out, from a site with an oversight, a temporary centre of the world from which to inscribe the new map and possibly a new world. To title is to entitle.

With exhibitions that purport to be 'international', it is clear why the location is often included in the title. The locale of an exhibition is embraced in its title as a rhetorical manoeuvre to appropriate the cultural status, the meanings and the myths that attend the collective imagination attached to the city, region or country named. The geographical and political reputation, as well as the social and historical esteem of the name are coupled and recoupled in linguistic unions which multiply

in status. Naming as a form of claiming is a manifestation of imperial desire, one which is not often openly acknowledged.

The Venice Biennale (whose romantic cultural echoes in the visual arts, opera, film and literature are many) is the largest and consistently best attended of the periodic international exhibitions, but rivals now regularly vie for their share of the same attention. City and country names are further augmented with numbers to contend for an equal or different authority. These include the Sao Paulo Biennale (the 22nd presented in 1994), the Indian Triennale in New Delhi (the eighth in 1994), the Sydney Biennale (the ninth in December 1992), the Istanbul Biennale (the third in 1992) and the first Dakar Biennial held in 1993 in Senegal. Each exhibition makes different claims on the idea of the 'international' and each represents a different negotiation between, first, contemporary political factors; secondly, artistic partialities; thirdly, local, national and international funding sources and policies, as well as old architectures and new exhibiting spaces, curatorial or governmental selection processes and the wider factors of critical expectations and, lastly, market influence. As complex representations, or as images and narrations of 'the world', each exhibition competes for worldwide cultural influence.

Centrality and regionality are in nervous and unstable play. There are the assertive and conflicting claims of each of the countries involved, the host capital's local interests, and implicitly enacted artistic and market concerns to be negotiated. As a result, the logic and originating assumptions of 'international' exhibitions are now increasingly vulnerable and precarious. One example is the 1993 Venice Biennale, which expanded the number of countries from which artists were represented in the form of add-on East and South African, Irish and Turkish delegations, which are among others that do not, and will not, have permanent pavilions on the already crowded site.

However, given constantly shifting nation state identities, merely increasing the number of countries represented so as to attain some 'truer' form of internationalism is, and will always be, a less than satisfactory solution, a tokenism at best.

The choice of 'cultural nomadism' as the Biennale's theme by the overseeing curator, Achille Bonito Oliva, was another much commented upon attempt at recognising the need for change. Oliva might have been responding to Austrian curator Peter Weibel's decision, even before the Biennale theme was proposed, to acknowledge the complex identity of 'nationals'

by selecting three artists, only one of whom was Austrian.[2] Official sanctioning reinforced the decision of a small number of countries to select artists whose hybrid citizenship status questions the achievement or maintainance of cultural hegemony through definitions based on a nationalistic agenda. The most discussed selection was Germany's choice of Hans Haacke, German-born, now living in the United States, and Nam June Paik, an expatriate Korean with an international working history that includes Germany and the United States. Conflicts, contradictions and frozen traditions were obvious and disturbing at this, the most venerable of the aristocratic expositions. Try as it did, however, the Venice Biennale could not, and probably never will escape the connotations of its name and its associated histories.

II

The exhibition is a tool of a thousand-and-one purposes, and half of them have not yet been discovered.
Kenneth Luckhurst, *The Story of Exhibitions*, The Studio Publications (London/New York), 1951, p216.

There is a long history of international exhibitions which encompass three interrelated parts: the promotion of art in support of cultural and national identity; the growing development of commercial world traffic in art; and an expansion of the modernist doctrine in which art is a 'universal' language as well as an instrument of exchange. This 'unconscious' of modernist art – its own universalist beliefs and claims – and the deliberately hierarchic policies of dominant political forces have complicitly joined together to anchor an era of cultural politics and political cultures in which modern art often acts as logo for the enterprises of Western governments and capital.

The Great Exhibition in London in 1851 provided a spectacular model for the international expositions of the second half of the 19th century. These were stage managed forms of national rivalry, set within universalist assumptions and 'international' pretension. They were public and popular devices within the ideology of modernity where art had an important place alongside manufacture, one which supported the 'civilizing' tendencies of imperial modernisation. Paris provided the peak of achievement with its three exhibitions between 1867 and 1889, when the Eiffel Tower was erected. Others, such as the Great Exhibition of 1873 in Vienna, also decisively marked the spirit of a new age in an old capital, another

FROM ABOVE: Pavilions at the Venice Biennale (before 1988); Plan of the Exposition Universelle of 1900, Paris (detail)

official excuse for the advancement of radical urban planning and redistribution of neighbourhood populations. For other, newer cities the international expositions asserted a place on the map, enlarged commercial possibilities, and frequently originated or expanded the processes of introducing modern civic architecture and transport. Such grand expositions were essentially utopian, and quintessentially didactic, liberally deploying sensation and pleasure to unifying ends.

Chicago's 1893 Worlds Columbian Exposition exemplified the imperial dream of the 'white city': huge temporary edifices sheltered national displays as well as thematic conglomerates of industry, communication and the famous Women's Building with its murals designed by Mary Cassatt. The fairs of this era were 'triumphs of hegemony as well as symbolic edifices' as Robert Rydell puts it.[3] In Chicago, the White City and the Midway (the other section of the exposition where 'ethnic' groups were located next to the funfair and displayed anthropologically) were 'two sides of the same coin – a coin minted in the tradition of American racism, in which the forbidden desires of whites were projected onto the dark-skinned peoples, who subsequently had to be degraded so that white purity could be maintained'.[4] This imperialist and hegemonic story of the cultures of the world was also told in Paris, where African and other colonial villages were on display under the all-seeing eye of Eiffel's tower in the huge Exposition Universelle of 1900. The debased form of these exhibitions today is Disneyland or EuroDisney where each nationality or ethnicity is reduced to its most cliched cultural form for facile and fast (visual and edible) consumption. Even though there may be no national pavilions in the majority of international art exhibitions, it is the same history and the same assumptions about the rivalry of nations and hierarchies of race that stand behind the creation of other early examples such as the Carnegie International in Pittsburgh (founded 1896). And till today, World Fairs themselves have continued to further an implicit racism and particular assumptions of a hierarchy of culture.[5]

The legacy of this history even continued to inform those attempts which tried to reformulate the model. The trauma of the Second World War and the exclusions of 'degenerate art' during the Nazi era provided the immediate backdrop for the founding by Arnold Bode of the *documenta* exhibition series, the first of which took place in Kassel in 1955. *Documenta's* lack of location name gives it a different flavour, a different tone from the other periodic exhibitions discussed above. *Documenta's* title emphasises the factual, the objective and, above all, the neutral because it was deliberately created as the antithesis of the propagandist exhibitions and national rivalries all too evident in the years before 1939. Here was a renewal of the humanist ideal specifically to be expressed through an exhibition of Western contemporary art but here too was a symbol of post-war renewal in Germany and Western cold-war cultural dominance.[6] Bode's exhibitions were

precursors of the new museums and galleries devoted almost exclusively to white, Western and predominantly male avant-garde art which were to become such a feature of urban life in post-war Western countries and of many international exhibitions held since.

III

Ideas such as humanism and universalism, which are intertwined with the history of locations and which bolster the link between national identity and an esteemed intellectual heritage, are proven upon continued examination of the empirical sort, to be inadequate.

Renée Green, *On taking a normal situation and retranslating it into overlapping and multiple readings of conditions past and present*, Antwerp: MUKHA, Antwerp 93, catalogue brochure, np.

Revised political concepts of internationalism would seem to offer the possibility of revisions in the structures and structuring of international exhibitions. With the formation of the European Community there has been a new version of the city exhibition. Each year, a city in Europe is chosen to be Cultural Capital and several cities have given the idea differing importance and resources, with Glasgow undertaking the largest year-round programme in 1990. This celebratory programme of Cultural Capitals in Europe may be one of the few parts of European Community cultural policy to have any public impact to date. Some of the exhibitions of contemporary art created for this context such as *On taking a normal situation and retranslating it into overlapping and multiple readings and conditions past and present* held in Antwerp in September 1993, acknowledge that cultural politics have been displaced from previously identifiable national registers by more complex and contradictory understandings of artistic and social identities. The exhibition comprised a local component consisting of a partial history of the avant-garde in Antwerp, and the larger, more prominent, international show. Artist selection in both, however, was still restricted to Western Europe and the United States. There, and at the highest formal levels of intergovernmental agreements, 'cultural capital' in Bourdieu's sense remains extremely narrowly defined.

Since the founding of the 1957 Treaty of Rome, the European Community official culture has treated culture schizophrenically, either as economic goods to be traded freely like furniture or vegetables, or conversely as national treasures which should be cherished and protected at any cost. The 1991 Maastricht Treaty promises that 'The Community shall contribute to the flowering of the cultures of the Member States, while respecting their national and regional diversity, and at the same time bringing the common cultural heritage to the fore'. This is a small move towards recognising cultural com-

plexity and commonality within the Community and a Europe with no single culture, other perhaps than being a spectator-participant in the global media network. It fails to identify both the continuing place and impact of the so-called cultural minorities – aside from those defined in terms of terrain – and to distinguish new, hybrid cultural forces within Europe.

The North American situation is somewhat different. Both Canada and Mexico remain adamant that protection of their cultural industries be written into the North American Free Trade Agreement to safeguard against unlimited US access to their markets. The arguments focus on economics and national heritage with little discussion of common culture. In the visual arts, with the exception of the too little discussed exhibitions of art by indigenous peoples, such as *Land, Spirit, Power* at The National Gallery of Canada, 1992, there have been few 'North American' or cross-border exhibitions. Instead, 'showcase', highly nationalistic exhibitions of Mexican art (of which *Mexico: The Splendours of Thirty Centuries*, 1990, and *Latin American Artists of the Twentieth Century*, 1993, both held in New York are the most blatant) are designed to portray 'Americanised' images of a future trading partner's culture. What gets lost in the unilinear time line format and rigid classification categories within such historical extravaganzas is any sense of past or of current cultural diversity and complexity let alone any revised concept of 'internationalism'. NAFTA's focus on the migration of goods, its unstated restrictions on the free movement of people within and into the trading zone and its myopic, pre-mapped cultural orientations only reinforce narrow nationalisms.

International exhibitions formed within official auspices are meant to be nice affairs, not disposed to the wide variety of contradictions that exist today. In war-torn, refactionalised and hyper-racist Europe, or recession-hit, unemployment plagued, media-oligopolised North America, international exhibitions cling to the narrow goals of an earlier era. They have, at the very least, the triple intention of improving diplomatic relations with other political allies, boosting trade and contributing to the urban regeneration of their locality. Ironically, the art in international exhibitions increasingly addresses issues which the exhibition itself may prefer not to acknowledge. However, what the art actually *is* seems to be mostly of little matter to those who fund it, other than it must command the attention of the art world, lead to wider media coverage and give the right expansive signals of cultural and, by implication, economic progress.

Of equal consequence are both the changes in the public acceptability of certain types of images (previously restricted to specialised aspects of popular or reproductive culture, particularly from advertising and pornography) and the inculcation of technological and telematic systems into the practices of the art world. The result is that the illusion of a space of art separated from the social space of everyday experience is one which is difficult and unacceptable to maintain. Those former distinctions between art and life are less coherent due to the efforts of artists who foreground the conflicts and problems of common experience, and due to the intensifying aestheticisation of social and political life through mutual interdependencies of communications networks. As the museum and the exhibition, two structuring devices of information management in the aesthetic realm, become mass media, or at least act in an similarly supervisory manner, the crisis of representation which frequents all vernacular imagery and texts becomes ever more central to both the production and reception of art.

Such sensitive issues become even more complex when the art exhibited addresses questions of urban, national or subjective identity, or when art posits questions of power, domination, subjugation and fantasy which are critical of, or alternative to, the behaviour seen in many corporate executives or political leaders. By example, in the exhibition *La Reconquista: A Post Columbian New World* organised by Patricio Chavez, which became the USA offering to the 1992 Istanbul Biennale, a postcolonial curatorial position was in direct conflict with the official sponsoring body, the United States Information Agency. This was the second in a recent series of forceful attempts by the USIA to quieten a representation of the United States which did not fit its own political agenda for that region.

Exhibitions are fictions of a particular kind and they can be both celebratory and critical by turn. Who is participating, why and on what terms should be the subject of careful examination by audiences, artists and funders. Shifts in both form and content have altered the certainties in international exhibitions, symbolised perhaps by the simple but profound fact that the art museum is no longer the assumed haven of a desocialised art.

IV

. . . even in the sixties, artists were already beginning to become allergic to the idea of cooperating with museums, seeking to escape from the static atmosphere of the museum by organising their happenings and concerts. Today, in 1971, their preoccupations have a more social aim. Artists are no longer interested in getting into the museum but want to conduct their activities on a wider stage; for example the municipality.

Harald Szeemann edited from group discussion, Special Issue of Museum, Paris, XXIV, No1, 1972, p14.

If Robert Rauschenberg's 1964 victory prize at the Venice Biennale symbolised the change in the balances of power between Europe and America, the disruption in 1968 represented other shifts worldwide whose echoes are still heard. Euro-American disaffection with government and state institutions reverberated in widespread political and educational

upheavals while fundamental shifts in relations between artist, curator and spectator revealed deep social and cultural frictions. These were commonly signalled by artistic projects which invited audience response through new kinds of physical perceptual and intellectual participation. The artistic ideals of the *art informel* – kinetic and happenings movements together with the new technological advances, such as video – transgressed the museological supposition of the passive spectator. Allan Kaprow in his events, Claes Oldenburg in his store, Lygia Clark and Helio Oiticica in their constructions and environments, Iain and Ingrid Baxter's wide range of projects by the NEThing Co, Joseph Beuys in his seminars and performance events and Carolee Schneeman's activities had, at the very least, a shared purpose of disrupting the conventions of behaviour within an exhibition by blurring the edges both of what might be looked at, where it might be seen, how often, and by whom.

The continuing tension and oscillation between the artist and gallery, both public and private, is indicated by radical shifts *within* the space and shape of the traditional exhibition. It also occurs in the creation of non-gallery exhibitions in the form of earthworks and environmental projects, the use of television and radio airwaves as studio/ gallery 'spaces' and the establishment of single-issue exhibition venues (women's galleries, photography galleries, video galleries). An uneasy vacillation amongst artists between the museum, gallery and vernacular locations emerged and to some extent was supported by those whose interests were not even immediately or obviously served by such waywardness. The late 60s were years of tremendous growth in the art market and in dealers' galleries, together with a huge expansion of independent, artist-based institutions. Surprisingly, perhaps, it was dealers who frequently offered artists the spaces of greatest 'freedom' where the absence of an overt institutional or curatorial 'voice' allowed them total control of the space. But as Adorno said of these official institutions, ' . . . indeed, art is dependent upon such support if it is to be produced at all and to find its way to an audience. Yet, at the same time, art denounces everything institutional and official'.[7]

Many of these contradictions were born out in *documenta V* in 1972, which Harald Szeemann curated with Jean-Christophe Ammann and others. They presented a thematic structure which introduced comic-strip, film and devotional religious materials in order to indicate some of the parallels for new artistic activity and Szeemann invented the oxymoronic category of 'individual mythologies'. He also invited Bazon Brock, a philosopher, art historian and artist, to re-stage the 'visitor school', first made in 1968 as a vehicle for analysis and popular debate within the exhibition itself. Yet, these so-called radical approaches infuriated many selected artists such as Robert Morris and Robert Smithson who protested vigorously against the lack of consultation in the thematic approach.

More important still were the protests from women artists, newly organised but still ignored. And no less problematic was the narrow base of countries represented. In Szeeman's *documenta*, the East German participation, proposed for the photo-realist section, was subject to much debate. In this exhibition were introduced all the contemporary tensions of medium, culture, nation, gender, race and class which face us on every front more acutely today. Its problematics, hidden and barely acknowledged then, are the very content and structuring devices of the artistic discourse of exhibitions today.

A whole series of 'alternative' exhibitions and projects in the 70s extended the questions of place, audience and culture. From the A Space project in Toronto of the mid-70s in local apartments, through Stephen Willats's participatory art projects in West London, to the 1976 *Rooms* exhibition which drew upon the social qualities of PS1 in New York, artists were challenging the assumptions of the gallery exhibition by creating viable and complex options outside gallery constraints. At the same time, artists were in the forefront of opening up the hinterland between nightclub, music and art activity through the introduction of everyday activities into the privileged realm of art, a spirit much guided by the earlier and continuing activites of Andy Warhol. But it was also in the early 80s that the art world reinstated the idea of promoting a 'proper realm' of and for art through the polemic of a 'return to painting' which surrounded exhibitions like *A New Spirit in Painting* (1981) and *Zeitgeist* (1982).

By the late 80s and early 90s, however, the use of new and multiple exhibition locations became the norm in certain 'counter' international exhibitions in which painting was less emphasised, such as the Ghent *Chambres d'Amis*, the 1987 and 1991 TSWA projects across the United Kingdom and *Places with a Past* in Charleston (1991). This now mainstream movement which Mary Jane Jacob refers to as the 'scattered site' exhibition[8] has once again problematised the self-contained gallery exhibition, undermining the last lingering ideals of the translucence of the pure, white cube and the primacy of painting. The flight from the gallery (from the temple to the grotto) and the utilisation of spaces of immediate and strong connotation, as opposed to spaces masking their denotation through a supposed neutrality, bears out many of the current contradictions in the seeking of new audiences.

In her critical analysis of the new 'non-exhibition exhibition' Johanne Lamoureux has referred to its relation with the leisure industry and tourist promotion. She identifies a common characteristic in such exhibitions as the creation of a 'local exoticism'.

Abandoned office blocks, public buildings, or monuments of industrial archaeology are often the urban counterpart of the deserts sought by land artists. They have the cumulative advantage of a dual experience of space, for the 'ghostly' presence grazing the surface here (in the

contiguous overlap between place and trace) is intensified by the fact that the here is never fully integrated as such, never fully familiar. It is often off circuit. It is always from the outset, an elsewhere.[9]

The ironies of this development are manifold: audiences, un-intentional in their encounter with art, are also unprepared. Being forced to search through parts of a city requires an engaged commitment in contrast to the equivalent, structured and more passive experience in a museum. On the other hand, for an increasing number of specialist installation and itinerant transnational artists, the discovery and public exposition of spaces to be made 'extraordinary' can produce results of exceptional poignancy and make infinitely more subtle a new exchange between histories and images, and between participating viewers/readers, local and otherwise.

V

Whose voice is heard when a curator works through an established genre of exhibition? . . . How can the voice of an exhibition honestly reflect the evolving understandings of current scholarship and the multiple voices within any discipline? . . . Can an exhibition contain more than one voice, or can a voice exhibit more than one message?
Stephen D Levine, 'Museum Practices' in *Exhibiting Cultures*, Smithsonian Institution Press (Washington, DC/London), 1991, p151.

For some 20 years now, since the eclipse of the fundamentalist principles underlying modernism itself, questions of sexuality, class, race, nationality, gender and other identity affiliations or disaffiliations have been a general feature of much artistic practice and are slowly reformulating local, national and international exhibitions.

One of the most discussed recent examples is Fred Wilson's highly provocative revisioning of the collection, *Mining the Museum*, at the Maryland Historical Society in Baltimore in 1992 where, using the visual language of museological display practices, Wilson's installations underscored the absence of Afro-Americans in this and, by implication, all museums' presentation of history. In a similar vein, Maud Sulter's curating of *Echo: Works by Women Artists 1850-1940*, the first exhibition of paintings by women artists in the collection of the Tate Gallery held at the Tate Gallery Liverpool in 1990, coupled with an adjacent exhibition of her own work, *Hysteria*, used pink walls and background jazz to emphasise the historical absences of women, lesbians and blacks in European collections and exhibitions.

On the national front, questions of peoples and place have been explored assiduously in Australia and Canada. Issues concerning the segregation of supposedly Western and non-Western work came to the fore through political and artistic protest. This was exemplified in the development of the

Plan of Charleston, Places with a Past, *1991*

Australian Perspecta survey exhibitions[10] and the Sydney Biennales, and the elaboration of conflicts in the support and exhibition of Inuit and other First Nations' artistic work in Canada in exhibitions such as *Indigena* and *Land, Spirit, Power*, both 1992. It is clearly no longer possible for curators to characterise aboriginal art as an unchanging and 'timeless' set of conventions which can then be written off as fundamentally less creative than Western, artist-centred contemporary art.

The European mainland has allowed itself to remain more aloof from many of these concerns. Regional issues and their tensions have been used as substitutes for the more complex cultural debate of post-colonialism. Even where more attentive, there are difficulties in the purported interest that a post-modernist art world has in issues of 'difference'. Artist and critic, Rasheed Araeen, has consistently pointed out the dangers of producing new 'ethnic' ghettoes rather than recognising cultural and racial difference already lying in the heart of modernism.[11] Against this background and an emerging ambivalence about how to address such concerns in international exhibitions, in 1989 Jean-Hubert Martin produced *Magiciens de la Terre* at the Centre Pompidou in Paris as a self-conscious attempt to realign internationalism by basing the selection of 100 artists on a quota of 50 per cent 'centre' and 50 per cent 'periphery'.

Gavin Jantjes commented in the same year that ' . . . *Magiciens de la Terre* laid open the Western/Eurocentric consciousness like a surgeon dissecting his own body without an anaesthetic. It revealed that the Eurocentric gaze has distinct and daunting problems when fixed upon the "cultural other", its achievements and methodologies. To imply that equality in the cultural arena is signified by everyone exhibiting together is both illusionistic and historically unsound'.[12] *Magiciens de la Terre*, as an exhibition, and some of the juxtapositions within it, gave fuel to further debate on both sides of the Atlantic, arguments reflected again in the critical disputes around the 1992 *documenta IX*.

The fact that questions of identity or cultural diversity are central to contemporary art, culture and politics does not mean that their exposure is guaranteed nor considered to be of importance to traditional exhibition practices and practitioners. A look at the list of the last *documenta* artists shows clearly that neither feminist concerns nor the aesthetic production from developing countries is as yet visible to many powerful curators.[13] This type of selection process is still the standard rather than the exception in Western European curatorial practices, practices which lag far behind contemporary audiences and artists in their understanding of contemporary social relations.

A different type of project which has grown out of these debates is the Institute of International Visual Arts in Britain. Arts Council funding has been provided for a conglomerate of exhibition, research and publishing activities, now directed by Gilane Tawadros, based on a 'different' international agenda: one which starts from a postcolonial perspective. The importance of such a project lies in the structural change that it engenders: seeking new international models alongside the present institutions. Equally the recent international exhibition at the Louisiana in Denmark, entitled *NowHere* and produced for Copenhagen's participation as European City of Culture through the summer of 1996, offered six curators (Laura Cottingham, Bruce W Ferguson, Anneli Fuchs and Lars Grambye, Iwona Blazwick, and Ute Meta Bauer) the unusual opportunity to explore different themes in parallel in adjacent parts of the museum. A colour-coded map was the key document which deliberately led the visitor on in a circular route from one set of choices to the next.

The very *idea* of the international survey exhibition is now questioned at its most fundamental level. However progressive the political or economic intentions behind them, international exhibitions still invite a presumption that the curators have access to an illusory worldview, and that spectators may follow in their wake. In this context, a more specific and sustained engagement with communities and audiences, creating meanings beyond the spectacular effects and mere festivalising of such occasions, may well produce a new genre of exhibition. It seems that in order to accommodate both artists' needs and audience demands, the new international exhibition must have reciprocity and dialogue built into its structure. To what degree this is possible remains to be seen. What is clear is that both the internal and external maps of international exhibitions are in some degree of flux and that, in this process, mapping is being reconstituted within what Homi Bhabha calls a parallax view where shifting positions alter objects in relation to the observer's moving eye.[14]

Notes

1 This is an updated version of a paper first published in *On taking a normal situation and retranslating it into overlapping and multiple readings of conditions past and present*, Antwerp: MUKHA, Antwerp 93, 1993, pp135-152. A revised version was included in *L'Art Exposé*, Editions Cantz/Musée Cantonal des Beaux Arts, Sion, Switzerland, 1996. See also Greenberg, Ferguson and Nairne, eds *Thinking About Exhibitions*, Routledge, London, 1996.

2 The Austrian was Gerwald Rockenschaub. Andrea Fraser is American, Christian Philipp Müller is Swiss, living in New York; cf *Stellvertreter/Representatives/Rappresentanti, Austrian Contribution to the 45th Biennale di Venezia 1993*, Vienna, Bundesministerium für Unterricht und Kunst, 1993.

3 Robert W Rydell, *All the World's a Fair: Visions of Empire at the American International Expositions, 1876 -1916*, University of Chicago Press, Chicago, 1984.

4 Robert W Rydell, *op cit*.

5 See Maurice Berger, 'Word Fairness' in *How Art Becomes History*, Harper/Collins, New York, 1992, pp46-62.

6 For recent discussions of the first *documenta* exhibitions, see Walter Grasskamp. For example, *documenta*, or, 'How is Art History Produced' in *Thinking About Exhibitions*, Ferguson, Greenberg, Nairne (eds), Routledge London, 1996, pp67-78; and 'documenta, kunst des XX, jahrhunderts: internationale austellung im museum fridericianum

in kassel, 15 Juli bis 18, September 1955' in *Die Kunst der Austellung: Eine Dokumentation dreissig exemplarischer Kunstausstellungen dieses Jahrhunderts*, Bernd Kluser and Katherina Hegewisch (eds), Frankfurt am Main and Leipzig: Insel Verlag, 1991, pp116-125 and Kurt Winkler, II. documenta 59 – Kunst nach 1945, *Stationen der Moderne Die beudeutenden Kunstausstellungen des 20. Jahrhunderts in Deutschland*, Berlin, 1989, pp427-435.

7 Theodor W Adorno, 'Culture and Administration', *Telos* 37, Fall 1978.

8 Mary Jane Jacob, 'Making History in Charleston' in *Places with a Past*, Rizzoli, 1991, p5.

9 Johanne Lamoureux, 'The Museum Flat', *Public*, Winter 1988, p78.

10 Bernice Murphy, 'Introduction', *Australia Perspecta*, Art Gallery of New South Wales, 1981, pp11-33.

11 See issues of *Third Text* and *The Other Story*, The Hayward Gallery, London, 1989.

12 'Red Rags to a Bull' in *The Other Story*, The Hayward Gallery, London, 1989.

13 A 'counter' or parallel *documenta*, *Begegnung mit den Andern*, curated by Hamdi el Attar exhibited 110 'non-European' artists in Kassel and Hannoversch Munden during the same time period. See Paulo Bianchi, 'Vom Anderssein der Anderen', *Kunstforum* 11, 1993, pp526-540.

14 Homi K Bhabha, 'Double Visions', *Artforum*, January 1992, pp85-89.

Ground floor plan of the Fridericianum, documenta IX, *1992*

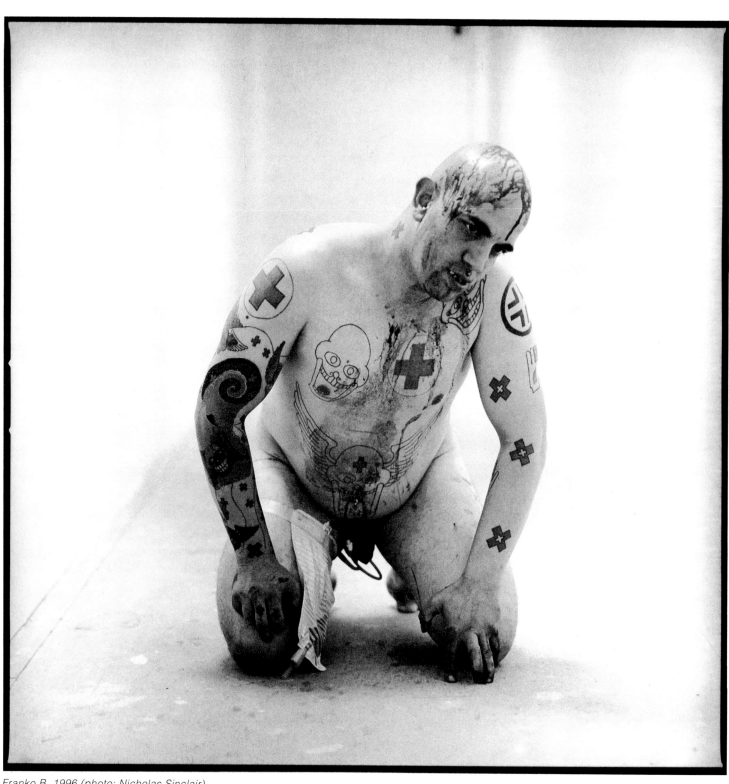

Franko B, 1996 (photo: Nicholas Sinclair)

SHOWTIME

Curating Live Art in the 90s

LOIS KEIDAN

It seems that there are almost as many terminologies for presenting Live Art and related new performance practices in Britain in the 90s as the Eskimo people have words for snow. 'Programming', 'producing', 'presenting', 'promoting', 'commissioning', 'platforming', 'showcasing' and 'curating' litter contemporary performance speak and funding guidelines but often confuse the representational relationship to current practices as much as define them.

What do some of these terms actually mean and what distinctions are there between them within current infrastructures? In relation to other fields, what does 'curating' mean here? Is 'Curating Live Art' a genuine intention or a pretentious affectation for 'booking shows'? What relationship does Live Art bear to the Visual Arts and why do these two worlds still seem to overlap so infrequently, given the fluidity of contemporary artistic practices? Before discussing issues of framework I should, however, suggest what I understand 'Live Art' to be and in the process suggest why it might need to be curated and what might be at stake in these debates.

As a glance through any recent publication or funding guidelines will reveal, Live Art tends to defy definition or received conventions. Not recognised as an artistic discipline *per se*, Live Art touches upon a broad church of forms, ideas and contexts – it is an ever evolving and shifting area of live cultural practice in pursuit of, and being pursued by, increasingly diverse and hungry audiences.

The global cultural arena has opened up over the last decade in exciting and eclectic ways as artists pursue new ways of representing and responding to our shifting times. The 90s in particular have witnessed the emergence of significant new ideas that are helping to shape and define broader cultural landscapes. These ideas are both challenging the nature and role of contemporary performance and questioning received ways of reading the world. A diversity of artists and practices, from theatre to installation, film to music, visual art to dance, have crossed each others' paths and blurred each others' edges, and in the process have opened up possibilities of time-based forms unrestrained by tradition or convention.

This process of developing new creative languages, coupled with the politicisation of the arts arena, has also opened up the possibilities of new agendas being addressed through cultural practice. The performance space has come to represent one of the few 'safe' sites left for enquiries into different ways of being, seeing, thinking and doing. It offers artists, particularly those disenfranchised and marginalised within the dominant culture, new forms to interrogate how we might negotiate the world at the end of the 20th century. The explosion of ideas and activities in new time-based practices have contributed to an energy and sense of enquiry in contemporary culture that is proving to be highly influential and extremely refreshing. Live Art is at the centre of this process.

With its antecedents in experimental theatre, the plastic arts, performance art, actions and developments in new media, Live Art is a terminology for a broad range of interrelated time-based practices. These are practices which are conceptual in nature, driven by ideas rather than form, that draw on the artist as the primary material or metaphor and are rooted in notions of presence, process and context.

To approach the particularity of 'Curating Live Art' it might be useful to unpick some of the distinctions in representational relationships, and examine a range of intentions, objectives and 'partnerships' in presenting contemporary time-based practices. Inevitably, producing, programming and curating are subject to enormous crossovers and are by no means mutually exclusive, but what I will attempt to define is their primary representational relationship.

Put simply, showcases and platforms are self-explanatory strategies for introducing work – new artists, new practices, new contexts. Who the work might actually be addresing is as various as the nature of the practice – new audiences, new spaces, the academy, potential programmers, the field itself. The representational relationship here is primarily as facilitator. Compared to international colleagues, Britain is well resourced in recognised platforms and showcases. The ICA's own ongoing commitment to these areas include the monthly 'Ripple Effect' platform for new artists and new work and an annual Summer Exhibitionist's showcase, a national open submissions event for artists fresh out of college or just beginning to engage with Live Art practice. Glasgow's National Review of Live Art Platform programme, Manchester's Savage Club, Nottingham's EXPO, Chisenhale Dance Space's performance platforms and the lively performance/club scene are just a few other examples of formal and informal infrastructures which continue to be influential in thrusting a new generation of artists onto the national cultural landscape. In many ways these are the performance equivalents of the Whitechapel Open or the British Art Show – letters of introduction to the constituency more than a considered cultural polemic.

'Producing' suggests a different and more complicated relationship to the process and realisation of performance-based practices. Producing is a responsibility to the whole journey of a piece or project as much as a responsibility to its ultimate shape in the public domain. Producing involves everything from R&D to fundraising to project development to negotiating deals, to the terms and conditions of presentation, wherever that may be, and a thousand other conceptual and practical details in-between. Many venues and festivals throughout Britain act as much as producers as programmers – developing and facilitating new work for their own programmes and spaces, and often for touring. Increasingly, artist-led initiatives are independently producing projects. This is particularly true of those whose terms and conditions cannot be accommodated in existing infrastructures and organisations for reasons related to the nature of the practice or the realities of cultural politics. Platform, Beaconsfield, Earthworks and Strike in London are just a few of the artist-run initiatives that self-determine the formation, creation and realisation of major time-based projects that exist outside the parameters of existing infrastructures. (Indeed the Arts Council of England's new Combined Arts Projects Fund is exclusively for artist-led projects and initiatives.)

Other illustrious examples of producers engaged with Live Art practice in Britain include Artangel, Arts Admin, shinkansen, Digital Diaspora and Cultural Industry. All are producers, independent of any organisation or inherited infrastructure, who span sound, visual and live art in their work and have been instrumental in steering projects and artists through complex and demanding processes, leaving significant traces in our cultural legacy in the process. The representational relationship with producing is primarily a partnership built on shared conceptual, aesthetic and cultural objectives.

Programming is an ambiguous terrain that can be as basic as considerations about place, date and time and as complex as strategies for social engineering. At its worst it is local authority calendar filling, international festival shopping lists, *pro forma* administrators paying the rent – a bit of jazz, a bit of dance, some household names from theatreland, a few community projects and a smattering of new performance to keep us on our toes. It is quantity not quality that is at stake in this scenario. At its best, programming is a well rounded, neatly collated and executed menu of events meeting a diversity of needs with intelligence and integrity, be it a festival or a venue's autumn season. Britain is again well resourced (if desperately underfunded) in quality and informed venue-based programmers and programmes, many of whom are engaged on different levels with Live Art practice. CCA in Glasgow, Manchester's Green Room, the ICA, The Bluecoat in Liverpool and Bristol's Arnolfini are just a few examples of venues which balance their continuing commitment to Live Art with meeting the needs of their broader communities.

Taken as a given that any engagement with Live Art practice, with all its complexities, necessitates a particular form of commitment and passion, the representational relationship with programming is essentially a functional one. A relationship that meets the operational needs of both artist and organisation in presenting appropriate work to relevant audiences in accessible ways. Although not always the case with the examples given above, there is not necessarily a curatorial role in programming – it is as much the structuring of events within a policy as the structuring of a position or polemic.

Perhaps it is the demands of diversification, the appalling lack of funds, the scarcity of suitable venues and the pressure on sympathetic ones, that prevents other programmers nationally and internationally who could seriously, rather than superficially, engage with Live Art from interrogating what they put on and how they do it. In what context does this work exist, how does it relate to our audiences and their experiences, how does it relate to other practices, how can it be read, what ideas does it provoke about our times and how is it best framed? Given space, resources and mandates, these are the questions programmers should be asking when engaging with the representation of Live Art. If they do not this area of practice will continue to remain in the cultural margins as 'weird shit', a freak show adrift from a critical mass and cultural context. If they do, then this form of representation can be seen as shifting towards a curatorial position.

Through their commissioning policies, programming concepts and representational frameworks, many performance programmes and festivals in Britain undertake a curatorial role, sometimes as discrete strands within a broader body of work. CCA and the Green Room frequently present programmes curated around issues and ideas. The National Review of Live Art and Hull Time Based Art's ROOT are informed and considered festival programmes taking a clear position on contemporary practices, the biannual London International Festival of Theatre's programmes provokes debates around the extremities of contemporary performance practices, Nottingham's NOW festival pushes the boundaries between performance and club spaces and the Video Positive festival in Liverpool continues to explore the performative dimension to new technologies.

The representational relationship with 'Curating Live Art' is primarily discursive. It is a programming strategy for provoking discourse around issues in the *zeitgeist* amongst artists, audiences, the academy and the critical and cultural mass. It is the drawing of a map to navigate the relationships between artists, art and society, and a structured consideration of interconnected ideas that test the nature of contemporary practices and negotiate complex concerns. A curatorial position is the creation of a context, an increasing necessity given the difficult terrain covered by much contemporary practice.

Contemporary performance is in a unique position to articulate problematic issues through alternative strategies. As a

form insisting on notions of 'presence', with the body, that highly contested site of meaning, at its centre, it is an immediate, multi-layered and emotionally charged concept providing a space, unlike any other, for the creative expression of ideas and new experiences of art.

For artists fronting issues of identity and cultural difference, Live Art has proved to be an articulate and persuasive platform to challenge the dominant narratives of the modern world. Recent years have seen the emergence, particularly in Britain and the USA, of a new generation of culturally diverse and politicised artists whose work is lending a powerful voice to broader social and political debates about identity formation, assimilation, hybridity and the transcendence of archaic notions of nationality and nationalism. This process has not only contributed to the representation and negotiation of cultural difference in our society but has also been instrumental in shaping perceptions that there are no such things as homogeneous or essentialised cultural experiences. For many artists engaged with issues of identity in relation to race, sexuality, gender or physical ability, contexts of representation are critical to the impact and influence of their work.

No single artist, for example, should be expected to represent the 'black experience' or bring with them received responsibilities to some idealised notion of a black community. Many artists whose work is decontextualised fall prey to carrying such dangerous baggage – particularly when the unofficial quota systems that operate in many venues persist in seeing them as 'this years' model'.

Respect (1993) and *More Respect* (1994) were two ICA seasons whose curatorial strategy was to address such problems and issues in relation to contemporary black cultural practice. Both seasons fronted a broad range of time-based work engaged with issues of identity formation and gave equal voice to a diversity of experiences, positions and sensibilities. By creating such a framework, both *Respect* and *More Respect* contributed to more informed and progressive debates amongst artists, audiences and the critical mass about the hybridity of experience, the conflicts of identity and the complicated and elaborate factors which influence the formation of the self in the late 20th century. Our curatorial position in both these seasons, and in other seasons concerned with identity formation in relation to sexuality (*It's Not Unusual*, 1994) or gender (*Jezebel*, 1995), has been to problematise an issue by reflecting the extremities of positions, possibilities and concerns across a range of interconnected ideas and practices.

The body, taboo, mortality and death are hot topics in the cultural arena and nowhere more so than in Live Art. Taking a similar line to the Tate Gallery's *Rites of Passage* (1995), the ICA's *Way To Go* (1994) was a season for All Souls curated around the ways Live Art practice can inform the negotiation of death and dying in the modern world. Like all recent ICA seasons, composed of new and commissioned work, emerg-ing and established artists, *Way To Go* was a framework. It was a body of intensely personal and delicate work concerned with concepts of death, dying and remembrance; work which used the languages offered by new performance practices to 'say' things which it might not be possible to convey through other means. Embracing a range of disciplines, from interactive and time-based installations to movement-based work and a 'performative panel' debate, *Way To Go* was a way of provoking a dialogue about something perceived as the unspeakable.

Curating is also a strategy not only for problematising issues or opening up discourse but for creating a safe space for the appreciation and consideration of seemingly extreme and subversive practices. If taken out of context, Ron Athey's ritualistic theatre of blood letting, scarification and piercing, Franko B's objectified body and fluids, Orlan's plastic surgery and Annie Sprinkle's sex as sacred ritual, run the danger of being perceived simply in terms of their shock value – obscenities and freaks from the margins of society lacking in any cultural currency or intellectual value. Without considering or representing the history and legacy of body art, the many sexual cultures of the modern world, the extraordinary forces that shape sensibilities and beliefs beyond the dominant culture and the implications of accelerations in science and technology, it is impossible to represent artists such as these in the ways that their practices demand and deserve. If, however, they are represented effectively, artists that delve into the deeper and darker areas of the human condition can, as Antony Everitt once said of Damien Hirst,

> open up paths for the viewer into areas of experience which are not anti-moral or amoral, but extra-moral . . . a world where bad taste is driven to the point of elegance and disgust filtered into delight.

The ICA tried to find a way to map out some of these provocative issues and contextualise a range of controversial work in relation to the body in *Rapture* and *Totally Wired*. These were two recent seasons looking at ideas of ritual and sacred practice in the post-industrial world and the nature of the body in relation to developments in science, society and technology. As we reach the end of the century many things that were once held up as 'truths' are up for grabs and the modern world is being deconstructed and reconstructed in significant ways. As science takes the body into yet another dimension, as Western religious orthodoxies lose their role and relevance, as new technologies revolutionise our relationships to others, as the national media explores *fin de siècle* spirituality, and as individuals embark on personal searches for contemporary rituals, questions around the body in society and society in the body, acquire an urgency and a potency. The Live Art arena is again uniquely positioned to pose these questions and consider a range of responses.

Rapture and *Totally Wired* created frameworks which not

only suggested the continuum of the body as the central metaphor of artistic enquiry but also reflected the ways in which performance is a potent medium to investigate the narrow boundary between 'lived' and 'performed' experience, to connect conflicting ideas about the evolution of the human condition, to appropriate developments in science and technology for creative means and ultimately to transcend conventional ways of being and seeing.

By framing and curating programmes in some of the above ways, we hope we are contributing to debates about the nature and role of contemporary artistic practices in relationship to critical frameworks and cultural developments. Inevitably issues of representation inform audience awareness, engagement and understanding and we also hope that our curatorial approaches are encouraging a new generation of audiences to pursue other ways of considering Live Art and its ability to navigate some more difficult terrain in our society.

With all these shifts in form, shifts in the sphere of operation of artists and shifts in critical discourse, one would suspect that the walls between Live and Fine Art would be breaking down, or at least getting thinner. However, apart from some exceptions this does not appear to be the case and we must ask why? Are the curatorial policies of gallery spaces rejecting the possibilities offered by time-based practices that are now as vital and vibrant as ever? Or are artists choosing to reject the confines of the gallery and operate outside institutionalised or formal contexts?

Is the 'messiness' of Live Art, as David Hughes once put it, off-putting, particularly given the pressures of effecting any work at all in these hard times? By messy he, of course, means the whole gamut – from the need to accommodate a live presence and shifting audience relationships, to inherent technical demands and the ability to represent effectively the hybrid nature of much Live Art practice through conventional single artform channels. Perhaps it seems like an activity that is simply too different to make room for, or, as a 'second cousin twice removed' of Visual Arts, Live Art practice is simply not seen as 'family'. Or worse, perhaps it is perceived as lacking the gravitas or discipline of a Fine Art tradition. For curators whose policies span object-based and live practices, such as Beaconsfield, Hull Time-Based Arts or Locus+, this is not an issue or a problem. But for many it is – have Brian Catling or Tilda Swinton really been the only flesh and blood in the Serpentine since the demise of *Heatwave*? Where was the live presence in the 1996 British Art Show?

Thankfully, the exceptions are many, but they seem to remain exceptions rather than indicators of shifts or trends in our cultural landscape. desperate optimists at The Showroom, Forced Entertainment at Leeds City Art Gallery, Ronald Fraser-Munro at Camerawork and Rona Lee at The Minories in Colchester are but a few recent examples. What connects these projects as much as the location of presence within a gallery space, is that each piece was conceived and executed for that space and its particular context and in collaboration with that space's curators. They were not, as in some other notable examples, projects 'booked in' in an attempt to transform a gallery into a makeshift theatre – an exercise that tends to be misconceived and doomed to failure, particularly in relationship to critical expectations and audience experiences. I believe that unless work is conceived for a gallery space, desired by a gallery space and presented within the contexts of that space's ongoing policy and programme we will again be back to the freak show scenario – a weird and unrelated programming aberration that simply confuses all concerned.

This is to say nothing of the restrictive and often ridiculous licensing rules and archaic legislation that distinguish gallery and theatre practices and often ties artists and curators' hands behind their back. Health and Safety restrictions are often minor obstacles compared to the discrepancies between what and how issues of representation are approached in different contexts, particularly in relation to current Obscenity Laws and practices that fall under the small print of the, often bizarre, Theatres Act. Annie Sprinkle would possibly not warrant as much attention from the Vice Squad if she were an installation rather than performance artist.

However, perhaps the resistance of the Art World is met in equal measure with artists' resistance to The Gallery and all the baggage and 'institutionalisation' that this context suggests and involves. Increasingly, artists seem to state their position as existing outside the parameters of existing structures, be they gallery or indeed conventional theatre spaces. For many practitioners a public domain, unfiltered by received codes of cultural conventions, is the most immediate, direct and uncontaminated space to be in. For others, the world of the gallery is perhaps too clinical a terrain to accommodate their practice effectively – sometimes those clean white walls sanitise and limit the chaotic possibilities of the live act.

Whatever the reasons and resistances, if we are to represent and contribute to the development and appreciation of contemporary culture, we must acknowledge the shifts in practice that have taken place between gallery and theatre spaces, we must recognise the evolution of our audiences' experiences and expectations and we must continue to engage as much with the ideas as the forms of current practices.

desperate optimists, Dedicated, *The Showroom, London, March-April 1995*

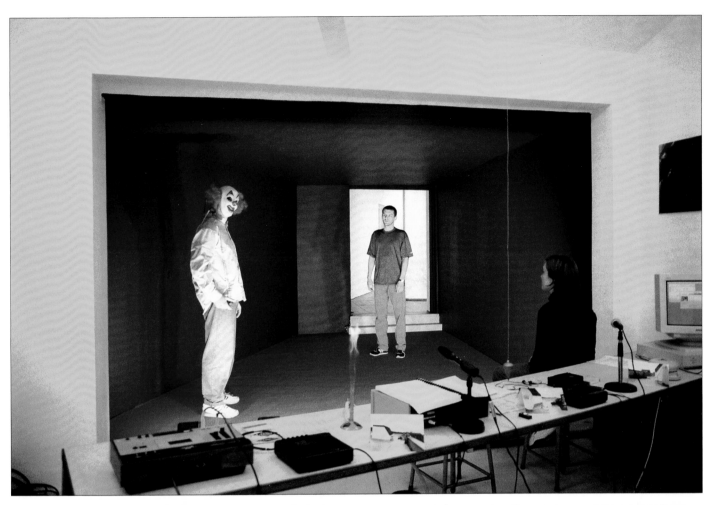

CONCEPTUAL LIVING
MACHA ROESINK

After having purchased art for company collections for several years, Macha Roesink felt the need to create a situation in which art could be experienced in a more intimate, direct way. Under the name Rhizome, she decided to initiate her own projects, of which *Conceptual Living* was the first.

All 14 artists she selected accepted the invitation to present their work in her peculiar canal house in the centre of Amsterdam. Most of them visited the location before proposing their contribution or realising it on the spot.

Over a period of four months Roesink sent out invitations to a small selection of people every week. Her guests were allowed to wander through all rooms, in which over 20 works were presented. By also offering them lunch or dinner, visitors were actually forced to take their time. During the meal that followed the tour through the house, conversation naturally resulted in discussions about the artists, the individual works and their presentation, thus offering a completely different environment from the usual.

The works inhabiting the house for this relatively long period in 1994 made *Conceptual Living* (© Stephen Willats, 1991) a very appropriate title. Besides Willats, other artists-guests were: Don Brown, Christiaan Bastiaans, Martin Creed, Douglas Gordon, Alex Hartley, Anne Veronica Janssens, Carlo Mistiaen, Stephen Murphy, Jack Pierson, Steven Pippin, Julie Roberts and Sam Samore.

Gerrie van Noord

Landing: *Carlo Mistiaen*, Na elk gesprek hang ik mijn woorden te drogen, *(After every talk I hang out my words to let them dry), 1994, chair, wire, pegs, paper, dimensions variable*

Toilet: *Martin Creed*, Work no 100, *1994, Winckelman tiles, 10x10x10cm*

Bedroom: *Carlo Mistiaen,*
Elke keer als ik een boek
lees, dwalen mijn gedachten
af, *(Every time I read a book,
my thoughts start wander-
ing), 1994, motor, iron wire,
paper, 30x20cm,*
(background) Alex Hartley,
Untitled, *1994, glass,
plywood, photo,
120x80x60cm*

Kitchen: *Douglas Gordon,*
From someone lost to
someone found, *1994, oil*

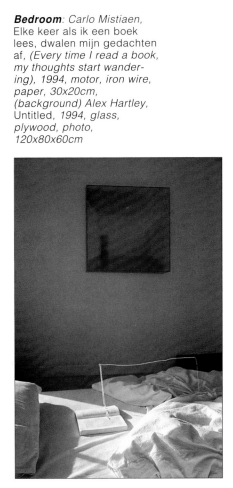

Kitchen: *Julie Roberts,*
Untitled, *1994, wallpaintings
(twice)*

all photos: Bouwer-Jan Swart

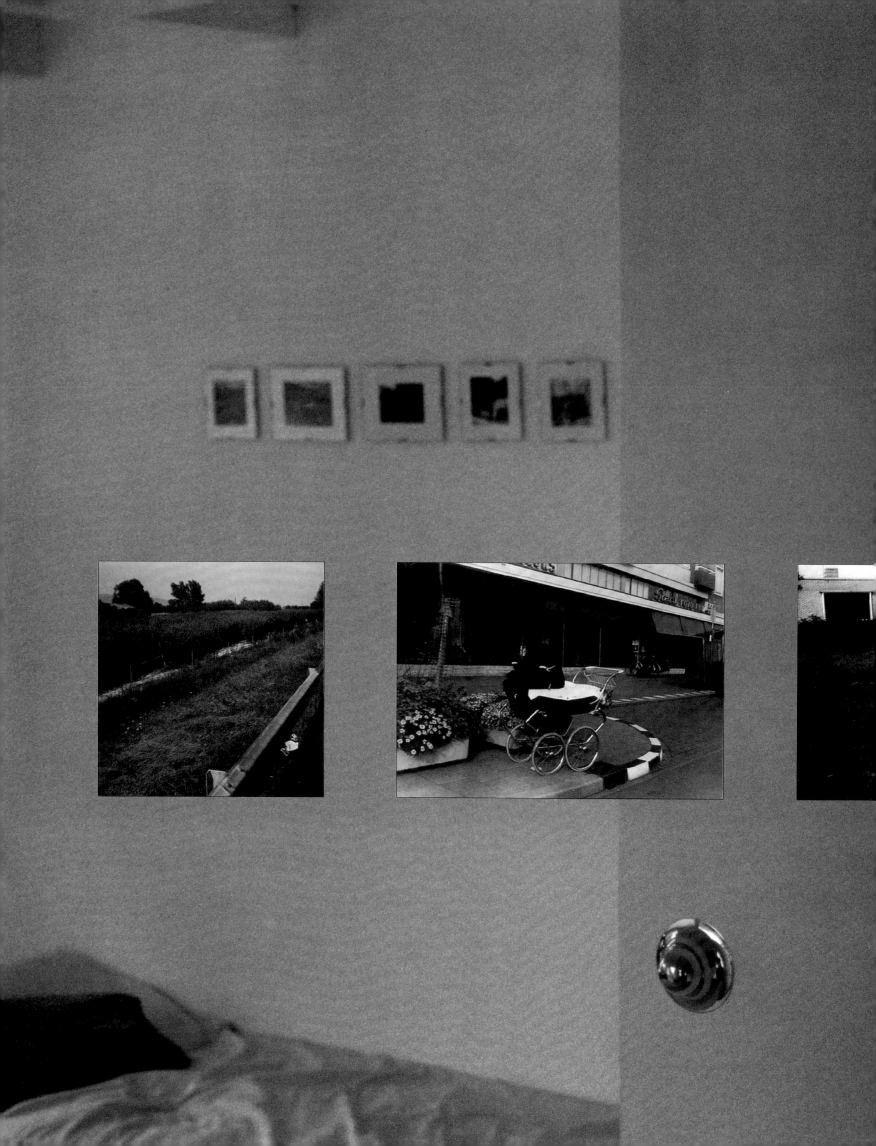

Stephen Murphy, Untitled (E), *1994, dye-sublimation print, 5 parts,*
12.7x12.7cm (3 times) 12.8x18cm (twice); artwork, foreground right:
Martin Creed, Work no 99 (detail), *1994, gold and silver plated,*
circumference 7.5cm (photos:Edwin van Kleef)

NEW TRANSACTIONS
DECLAN McGONAGLE

I

In regular attacks on aspects of contemporary art, some critics/reviewers assert that art can only achieve meaning over time – that time will somehow tell. In my experience, however, it is possible for art to create meaning in the present without resorting to propaganda or reportage. It means thinking of time as a continuous present tense and leaving posterity to construct its own, rather than our, readings.

I regard permanence, therefore, as problematic, and in effect, provisional. In my role as Director of a new Museum of Modern Art I would support the argument that it is no longer possible to promote the idea of a permanent, authoritative, consensual representation of anything. Attempts at new processes or structures in this period should take this into account.

The notion that time is the ultimate test for art hinges on the idea that there is a separate, absolute current of meaning, independent of the present tense or the social environment, with which some artists connect and others miss. However, this ignores the fact that all human activity, including artmaking, swims in a sea of constructed meanings. Critics who attack the frontline of contemporary practice often cite 'masters' being important only inasmuch as they connect with this absolute meaning and therefore operate on a plane that the rest of us may reach sometime in the future but which is, by definition, unavailable to contemporary practitioners.

How artists reflect, contribute to, and participate in a much wider range of social, political and cultural forces is discounted in the proposition that art is governed by its own laws in a zone of its own.

Historically, this proposition is a relatively recent construct and has its origins in the period when the surrounding value systems disconnected art and the artist from society as surely as the 'worker' was disconnected from the value of his or her work in the 19th century when European Nation States crystallised along with industrial capitalism and colonialism.

II

In this text I set out to discuss why this disconnection is the antithesis of my own work as a curator. I also track ways of working to clarify certain principles which have emerged in the development and realisation of specific projects in galleries and the public domain. As theory always follows practice these principles are based on experience rather than theory.

The specific projects I discuss have been chosen from others to cover a triangulation between the Orchard Gallery in Derry, the ICA in London, and the Irish Museum of Modern Art in Dublin – a triangulation which carries its own political significance. They are not explored chronologically but in terms of the issues and questions they raise.

The overall process has been one of growing awareness of the matrix which normally defines and holds positions in cultural space and of ongoing attempts to include a reading of that matrix in an understanding of the work. It is for this reason that some inclusive curatorial strategies for the public domain were developed in parallel to projects in gallery spaces and in deliberate contrast to the much more common placing of discrete works in public space.

However, the public domain has no monopoly over the sort of engagement I am recommending. There are clear examples of the traditional strategy of showing paintings in a clean white gallery space also revealing underlying systems which define cultural value in our society.

The space beyond the gallery cannot be privileged over the gallery as both mechanisms have distinct codes, methodologies and narratives through which meaning and value flow.

III

A clear example of this is the range of responses which Richard Hamilton's painting, *The Citizen*, elicited when it was first shown in Derry in late 1983, to its showings in London at the ICA and the Tate Gallery. *The Citizen* was the first of a trio of major paintings completed by Hamilton in the last decade using news imagery from Northern Ireland. The Christ-like image of a republican prisoner on the dirty protest, which preceded the 1981 hunger strikes, was based on television news footage. The conscious image-making and manipulation of information by both prison authorities and prisoners sparked Hamilton's interest. The painting was shown in the Orchard Gallery alongside a much larger exhibition of paintings and works on paper by Rita Donagh, based on aerial images of the H Blocks in the Maze prison and maps of Northern Ireland. Together these works made an extraordinarily powerful statement in Derry at the time and connected with a process of virtual canonisation of the hunger strikers in sections of the nationalist community. It was clear that members of the public were taking the gallery space as a mechanism for validating experience, including those who disagreed with any sort of validation process for this particular imagery. There was an

underlying consensus about the power of the gallery as a validating mechanism in a local context.

This first showing of the painting was covered by local media but was ignored by the wider art media. While this could be explained by the well-known inability of critics in the dominant media to travel beyond their own parish, it does not account for subsequent critical response when the work was shown in London.

Shortly after the Donagh/Hamilton exhibition in Derry I moved to the ICA in London as Exhibitions Director and one of the first exhibitions I curated there was a showing of *The Citizen* and a selection of the H Block paintings by Rita Donagh. The exhibition had been programmed by the previous Exhibitions Director at the ICA before my appointment. It was a curious and revealing experience having presented the work in Derry to present it in London within such a short period. But there was almost total critical silence in response to the work. No praise, faint or otherwise, no attacks, no engagement with Hamilton's engagement with Northern Ireland, yet the work was as much about Hamilton's own preoccupations about language and the construction of meaning through images as it was about Northern Ireland specifically. I believe it was not reviewed because dealing with the work meant dealing with its origins and at that time, and maybe even to this day, the English establishment seems totally incapable of addressing the fundamental issues, which are actually cultural issues, represented by the situation in Northern Ireland. Ignoring *The Citizen* at that time was part of a larger dismissal of Northern Ireland. I am not suggesting that the work should have attracted automatic praise but the idea of a major figure in British art turning to this subject, this source, was at least worthy of debate about what such a process did or could mean. There was no such debate. Within a year, however, the critical reticence shown in the face of this work disappeared when *The Citizen* was included in the Tate Gallery's exhibition *The Hard Won Image*.

One of the key points about this painting was its installation, for example, low hanging height to match eye level of the image to eye level of the viewer. In the Tate installation the work was hung high alongside a similar scaled painting of a bound, hanging figure by another artist. The juxtaposition of works in this case assisted in diminishing the specific political reading of *The Citizen* and brought forward a more generalised humanist reading.

What was really interesting was that only in this context was Hamilton's painting then discussed at any length in critical reviews because, I believe, the context had made it possible to set aside its political meaning. A painting which had been untouchable by the dominant critical media in two previous contexts was suddenly consumable in another because a new primary meaning had been constructed where a sort of humanism replaced a political narrative.

IV

To have moved from the edge, as it were, in Derry, to the centre, as it were, in London and to realise that the capital had its own parochialism was an interesting experience.

This relationship between the metropolitan centre and the local edge usually disempowers the locality. Mainstream cultural presumptions on which most cultural power (ie, funding) is distributed imply broadly that only the centre can deal with contemporary practice. Of course many people in local situations also believe this and so conspire in their own marginalisation. My own experience in the Orchard Gallery over two separate periods of work contradicted that view and it played no part in the programming strategies.

In 1987 Antony Gormley made a work for the City Walls in Derry as part of the TSWA project. The effect was to demonstrate how an artwork which addresses place can reverse the usual positions of cultural power. Antony Gormley was invited by the Orchard Gallery and TSWA to realise a proposal to site three cast iron, Janus-like life-size figures on key positions on Derry City Walls. Gormley's advance research led him to understand clearly the essential duality which operated in that context – ie, power within the City Walls, perceived and symbolic if not actual, and powerlessness without. There are two names for the city: Derry and Londonderry; two newspapers and two communities now divided by the River Foyle, more or less nationalist on the west bank and more or less loyalist on the east bank. This divide reflects two ownerships of the history, or two readings of the same geographical and ideological territory. The divide that divides Ireland in general and Derry in particular has its origins in the wars over succession to the English throne in the context of 17th-century politics in Europe. In general it reflects a schism between a modernist belief system that events happen as a result of the action of man, and a premodern belief system that events take place as a result of the action of nature. This schism has never been successfully resolved in Ireland. Historically, it has been

dramatised as a divide between Protestant and Catholic but these should be understood and addressed as, firstly, cultural alignments then political projections rather than merely religious antagonisms. While the forms of the drama may be specific, the cultural underpinnings are universal. It can be argued that similar divisions along that same faultline have re-emerged in Europe in recent years.

Antony Gormley addressed those issues directly in making and siting his work, and literally building that duality into the double figures. Gormley tapped the charge that still runs through the City Walls which themselves embody cultural value. The Walls retain their original voltage because the political/cultural territory they inhabit, which was mapped out in the 17th century is still contested ground, literally. Because their past is present it is impossible to relegate such environments to tourism. An artist who tunes into this process anywhere becomes a participant in a total cultural process and not just the producer of cultural products. Gormley's *Angel in Gateshead* must include all the debates which have preceded its construction but also the enthusiasms which are also present.

While the process is very dramatic in a place like Derry which Gormley and his work entered, the underlying principles can be tapped in other situations – like sinking a shaft into a reservoir of meaning. It is because Gormley succeeded in connecting with this reservoir of meaning that his Derry work was locally and internationally legible. Local readings were not consensual and loyalists, including Unionist councillors, who initially rejected the piece believing that it did not confirm a Unionist ownership of history, within a few months were describing the cast iron figures as representations of the iron will of Unionism. But overall, the people for whom this project provided the greatest challenge were commentators who travelled to Derry from elsewhere. They could not get the

full meaning of the work without massive local mediation. For me it was one of the clearest examples of how meaning in art is extrinsic not intrinsic.

The meaning of this work lay in the two elements coming together – the piece plus the City Walls and all the baggage associated with them. The sculptures stayed in situ for several years as new readings came into play although the original timetable was only intended to be a few months. At one point, early on in the process, the artist was asked if he was worried about vandalism and the survival of the works; he answered that the works were physically designed to survive those inevitable attentions but were also conceived to be completed by any addition of extra material. Like a poultice or a lightning conductor the pieces drew out what was already in the air in that community. The process involved no deviation from the artist's ongoing concerns about body/spirit. The pieces took a cruciform shape and referred on one level to the possibility of redemption, something which Gormley has regularly explored in his other work.

V

In the case of another work in the public domain in Derry it was the absence of such engagement which led to what I would describe as a failed project. However, the failure in the case of Barbara Kruger's billboard project was a failure on the part of the mediation structure, not of the artist.

As part of a wider billboard project linked to a Channel 4 series on contemporary art, a billboard work *We Don't Need Another Hero* was installed in a number of cities in Britain and in a series of sites in Derry City centre. It was seen at the time as another opportunity to work outside the gallery but almost as soon as the billboards were in place they became banal. The artist had not been invited to visit and had not made the

Antony Gormley, Project for City Walls, *Derry, 1987 (figure at Cathedral Bastion)*

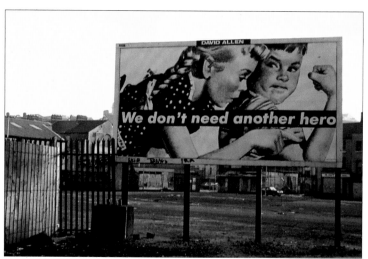

Barbara Kruger, We Don't Need Another Hero, *Derry, 1988, billboard project, various sites*

work specifically for any of the locations, least of all a highly charged environment like Derry. This is not to suggest that a work has to be reduced in some way, or limited to the specifics of any place, but to say that any work intended for the public domain has to take into account other languages, signs and symbols which already inhabit that domain – any domain.

In the particular context of Derry, public space is understood as a contested rather than consensual zone. Such an overcharged reading and understanding of public space meant that a work that was simply dropped in would never really operate, even temporarily. While the implied challenge to institutional space might fulfil other goals in that particular context, the Kruger billboard did not communicate.

This project also coincided with the British Government's first billboard campaign about AIDS. *We Don't Need Another Hero* occupied space beside AIDS posters and when local people were asked in vox-pop interviews what they thought of the Kruger work, a majority of those interviewed said they thought it was an extension of the AIDS campaign, that it was a subtle anti-AIDS poster.

VI

It is not enough therefore for art just to be in the public domain, in a place it should do something to, for, or with the people who experience it. What really made this particular project fail was our misjudgement about the context adding meaning as with Gormley, or in Kruger's case, subtracting meaning. The Kruger billboard was drained of its vitality by the way in which public space was already being articulated. Kruger's work in general creates a third meaning by putting together image and text, each resonating off and problematising the other. In a context where public political imagery is commonplace it was always going to be difficult if not impossible

for a more detached approach to register. In the illustration the slogan writer has added his text to the image of the City Walls in Derry where they overlook the Catholic Bogside area and has historically represented the victory of one community inside, over the other, outside. The slogan writer, by writing his text, conditioned the received reading of the Walls in full view of his own constituency in order to claim part ownership of that history. In another image of a well-known location in Belfast, the painter of the armalite rifle was adding a reading to a wall used for cover by military vehicles during riots. The statement was only complete when the vehicle parked beside the painted wall to create a third reading in the mind of the viewer. The painted rifle problematised the power of the military vehicle. Some would argue that it took some of that power away or at the very least conditioned or renegotiated it. As a strategy this should not be dismissed as only possible in situations as raw or as dramatic as Derry or Belfast. The strategy is possible anywhere – ie, seeing art as a medium of negotiation in an empowering encounter. To enter the public domain anywhere is to enter that process of negotiation and that encounter anyway. With that in mind it is a mistake not to give the artist the best possible opportunity to become part of that process at the earliest possible stage so that all the elements in that process, including the negative, become part of the meaning of the encounter.

VII

In the past I have had to regularly argue against the view that this sort of role for art is only possible or is at least easier to develop in a context like Derry. Seamus Heaney has written on how odd it is to be accused of being lucky to have had a war; and there is danger in settling into a dramatic situation and surfing it. I was reminded of the danger of any such compla-

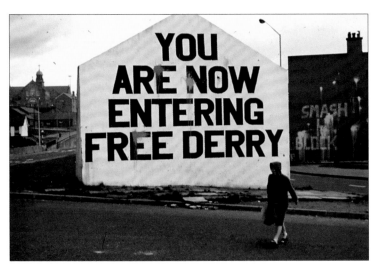

Gable Wall, Bogside, Derry, 1969-present (photo: Camerawork, Derry)

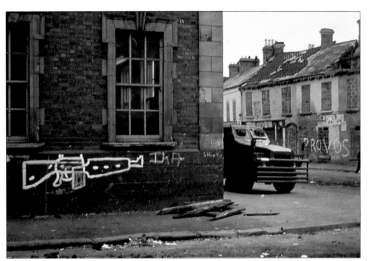

Wall painting, Belfast, 1981-83

Les Levine, Blame God, *billboard project; FROM ABOVE, L to R:* Hate God, *south London, 1985; altered billboard, Dublin, 1994;* Attack God, *billboard, south London, 1995; project seen as a whole, Dublin, 1994*

cency in exchange with the native American artist Jimmie Durham in the late 1980s when he responded to my invitation for him to spend time in Derry with the possibility of making a new work. I suggested that he might be particularly interested in Derry because of the experience of repression and colonialism which native Americans and the Irish had in common. In accepting the invitation Jimmie pointed out that such an equation was too simple and that some of the worst Indian killers in the history of the US had, in fact, been Irish.

We should not forget that the political drama of Northern Ireland is a product of the underlying meaning of place.

Elsewhere the drama may not exist in this way, but similar questions about the nature and meaning of human experience do and should be addressed. Those art projects that work are those which create that conversation whether it is in a traditional or non-traditional exhibition space. As a curator I am interested in the creation of that conversation or negotiation, though in many cases it is actually a renegotiation because of the inheritance of distrust of contemporary visual art which seems to be deeply implanted in the public mind. It was this working attitude which underpinned my response to the invitation to curate the first Tyne International, centred on the Gateshead Garden Festival in 1990 but also using the Laing Art Gallery in Newcastle and public spaces. *A New Necessity* was meant as an attempt to create this inclusive, speculative approach rather than an exclusive celebration of international connoisseurship.

VIII

As Director of exhibitions at the ICA in 1985 I invited Les Levine to make new billboard works for the galleries and public sites in London. He proposed a series of pieces, *Blame God*, which would address London as a locality of cultural, economic, political and media power. Levine wanted to reveal these processes and explore the public language of advertising. The images he used were based on photographs he had taken in Northern Ireland in the early 1970s and were combined with large texts such as KILL GOD, STARVE GOD, BOMB GOD. While the imagery and the import of the work had its origins in Northern Ireland and Northern Irish issues, it also touched upon other issues concerning the production and distribution of information. The British media has consistently presented the conflict in Northern Ireland as religious and the artist wanted to deal with this by speculating if it was possible to make 'religious work' any more, as well as suggesting another way of looking at the information being given. With the assistance of the Artangel Trust it was possible not to rely on sponsorship but to engage sites on a commercial basis as in any other campaign. Key sites were selected for maximum exposure and we operated on the same principle as other buyers of media space. This saved the project. It was revealing to see the billboard company's map of an urban space

based on economic – ie, disposal income – patterns and how availability and the cost of sites reflected that. The images were printed in Tennessee using an old style stencil process based on the scale drawings of the artist. Alongside glossy photo billboards, Levine's images had a handmade feel and problematised the norms within which they existed, albeit temporarily, as advertisements.

IX

Levine argues that advertising works by creating anxieties and then providing the resolution to those anxieties. With his imagery, the texts and the nature of the production, he set out to create this anxiety but gave no easy resolution. The reaction to this project was immediate on the part of the public, on the part of the police who made enquiries though they had no legal basis on which to become involved, and on the part of the billboard company who refused to finish posting the full set of images. As it was crucial that the project was completed – for the images were intended to be seen in particular sequences and required all 50 or so sites to be fully used – the ICA insisted that the company met its contractual obligations. The media response to the controversy was such that had the project been stopped there could have been a media story about censorship but it would have meant that the artist's statement would not have reached its audience. It was therefore important to use the normal contractual mechanisms to complete the project – all of which was part of the work. In terms of response, many people were upset by the initial reading of the work as recommending that we kill God. But it was interesting how people who, while complaining, claimed the greatest Christian credentials were the very people who became more angry rather than less when the central idea of the project was explained.

If you kill, starve, bomb, etc, another human being, then in a society that claims to be Christian you are killing, starving, bombing God. It was also clear that while the billboard company and others were happy to promote carcinogenic drugs, debase women and celebrate violence on their poster sites, Les Levine's message was obviously too much. Because we had used the commercial process fully and had a contract, it was possible to pressurise the billboard company to finish the campaign which they did.

There is an echo here of the reaction to the Hamilton painting in that there was a complete absence of critical art coverage or reviews of this work. It is also interesting that, as with the Gormley work in Derry, such mediation was not actually needed. The Levine work transcended the need for art mediation. It functioned across the boundaries of the art constituency, literally and conceptually.

The project was originally a collaboration with the Douglas Hyde Gallery in Dublin and the Orchard Gallery in Derry but following the publicity about the London showing, the bill-

board companies in Derry and Dublin were very negative about booking sites and posting the images. It also became clear that what looked like a plethora of billboard companies on one level were actually traceable to two or three holding companies. No outside sites were contracted or eventually used in Derry, and the imagery was only shown in the gallery space.

In Dublin only one site could be used on which individual images were rotated. The project, including its reverberations, revealed, if only momentarily, the extent to which information in society is controlled by a range of public and private agencies which already command the public domain.

In 1994 *Blame God* was borrowed for a season of exhibitions in Dublin at the Irish Museum of Modern Art in which issues of identity and consensus were explored. Les Levine's original drawings were shown in the gallery space and a temporary billboard was erected at the Museum with images posted on fifty other sites around Dublin. What had been impossible in the mid-1980s in Dublin had become possible by the mid-90s, which is one expression of the degree of change that has taken place in Irish society over the decade from 1985. The context in Dublin was much better prepared in advance and all potential sources of 'outrage' likely to be contacted by journalists, the churches, politicians and religious groups were contacted by IMMA in advance of the project and the whole idea discussed and clarified. When the images were in place, the media tried but failed to whip up a storm. While we received an equivalent number of individual complaints as in the London project, there was easily as many calls of support. The questions raised were debated in the media and towards the end of the project a fundamentalist Catholic organisation took the Museum to the High Court for blasphemy under Section 42 of the Irish Constitution. The Government of Ireland, the Attorney General, the billboard companies and site owners were also named in the action. A genuine constitutional issue had been raised and we were aware that in creating this project there was a possibility of ending up in court but this was part of the meaning of the work and as a national institution concerned with contemporary practice it was important for the Museum to see it through. The case was dismissed, however, as by the time we got to court the booking period had ended and nearly all the images had come down.

There are important differences between the two projects in London and Dublin, as well as the two moments in time. The second time around I had a much clearer sense of the degree to which social processes which surround a work in the public domain are actually part of its meaning and how they have to be understood and engaged as fully as the internal properties of the artwork or the practice of the artist. When this is done successfully the emancipating power of (visual) culture can be revealed as enormous. Far from limiting the nature and value of visual art this social connection actually enhances and enriches it.

X

In Dublin *Blame God* formed part of a season of exhibitions and projects called *From Beyond the Pale* which explored issues of identity and diversity but also marked the first three years of the life of a New Museum of Modern Art in Ireland. Latterly, the principles I have been illustrating here have informed the setting up and development of the Irish Museum of Modern Art in Dublin. The Museum is housed in the finest 17th-century building in Ireland, set in a rich historical site on the west side of the city. The Royal Hospital Kilmainham was the first Classical building in Ireland and was partly modelled on Les Invalides in Paris, both in form and in function, providing hospitality for pensioner soldiers of the British army until

Royal Hospital Kilmainham, Dublin (built 1681-84, now IMMA),
L to R: East Wing; aerial view

1928. The original architect was instructed to create a European building – a product of the Enlightenment and of rationality and imperial order over native disorder at a time when Dublin was a late medieval city. In one sense, therefore, the building itself is a very powerful cultural artefact complete with enormous ideological baggage. There was much discussion when it was designated the New Museum in 1989 about its inappropriateness, as if it did not conform to a template for a modernist museum of modern art which many people saw at that time as the viable model. In my own view that modernist model was already redundant. It was the problematic identity of the Royal Hospital in the way it did not fit the previous template historically, architecturally and politically, which made it the ideal context in which to establish a cultural institution which would try to unfix and renegotiate rather than fix value, that would try to speculate about the nature and role of art in society and set out to redefine the relationships between the artist and non-artist and the institution and the community.

Far from being inappropriate, therefore, the building and the elements which were cited as disadvantages according to previous models for museums, actually provided IMMA with all its advantages.

XI

I have always seen art as a means of dealing with reality, rather than as an antidote to it. Unlike many modernist galleries or museum spaces where all social referencing is removed in the pretence that one can create a neutral zone for art and its experience, neutrality and innocence are simply not applicable to the Royal Hospital. It is therefore impossible to avoid responsibilities as a public institution that I believe we should welcome. Neutrality and innocence are not an option. The context is legible both locally, because of the specific history of place, and globally, because its characteristics as a building and a museum are legible in radiating sets of constituencies. The context makes ideas and issues which interesting artists are already addressing as unavoidable in the curatorial work at IMMA. It is a question of figure and ground. As surely as Giotto's figures and Renaissance painting developed volume and became separated from a Byzantine ground, the modernist project has involved the separation of the figure of the artist from the ground of community. The issue for me at this stage is to what degree the figure of the artist or even the institution can interact with the ground of community without dissolving and disappearing within it. That tension is creative and dynamic. It is a state of becoming rather than of being.

The 19th-century museum model was the place apart, a temple which fixed value just as a bank fixed and maintained fiscal values. It is no coincidence that for a long period both banks and museums mimicked Classical temples. Both were calling up that earlier Modernist project in antiquity to validate its new manifestation. The previous model of the museum was of a Temple which had to provide an authoritative fix on culture. The new momentum is about speculating and unfixing such definitions and hierarchies of value. It is a question of adding the Forum – where in ancient Rome social interaction took place – to the Temple to create a third process which is inclusive of both. It is not a question of closing down museums as we know them but of adding value. In its programme, IMMA can be the Temple or the Forum or both. So when I refer to Modernism or to pre-Modernism, I am not referring to points in the chronology of cultural history but as states of mind which can coexist. The third process which emerges from the combination of apparent opposites is actually the conversation in which artists and non artists can participate without devaluing or disempowering each other.

XII

A received idea about the marginalia on medieval religious texts was that those strange, vulgar images were deviant products of the boredom of the scribe as he copied out endless pieties. Recent research suggests that they were, in fact, conscious placings of specific imagery whose function was to problematise the main text, to create a third reading for the reader of the book who understood precisely the references and juxtapositions.

Looking back, not just over the last decade, but over a longer period, I realise that what I have been doing is an increasingly conscious attempt to construct what I would now call an inclusive third process and to negotiate a new public transaction rather than private transaction for art in whatever context or circumstances I find myself working.

RETROSPECTIVE PROSPECTIVE
SIRAJ IZHAR

The telltale feature of my role in Memorandum *is that nobody sees me though I write many messages. Regarding the messages I must wonder whether they get through at all. This is a source of anxiety I discuss elsewhere. But there is surely an anxiety for the spectator as well: does Josh Oppenheimer exist at all?*

But I will say that my absence is appropriate to the multiple ways in which the lavatory in which you are reading this now haunts me. As a cottage I (who?) am reminded of anonymity and silence. Such anonymity and silence bears the double and paradoxical significance of a space for fantasy and a legacy of shame whereby queers did not wish to be identified.

The extract is the first part of an e-mail, from Josh Oppenheimer, gay activist, church infiltrator and son of an Auschwitz survivor to Siraj Izhar, curator at the lavatory at Spitalfields. The memorandum project was based on the chain of e-mail from the activist to the curator, in a work attempting to keep apace with the ongoing activist infiltrations and secret recordings. Directives by electronic transmission, however, brought out the anomalies in the attempt to construct such a work. Digital transmission in its increasing ability to connect realities shows up the harshness with which the realities involved cannot see nor comprehend one another. This is markedly so as the technology itself is seemingly neutral and invisible, yet it magnifies distance and power relations. In the new digital realm, old fears awaken; when talking across virtualised distances, experiences need to inflate, hyperventilate, in order to survive.

These are apprehensions that Oppenheimer's profusive chain of e-mail repeatedly testify to, that the copperwire networks will fail to bear out his situation. The same e-mail above continues and becomes didactic:

Ellipses are a figure of amnesia, a sign of forgetting. Signs are mnemonic triggers to encourage remembering (bind these words as a sign upon your hands, upon your gates, lest you should forget) . . . in this context ellipses are haunted by the total annihilation figured in Auschwitz. How does a community – gay or Jewish – recuperate an identity after the amnesia of genocide?

And regarding Auschwitz itself, how do the victims recall everything so vividly? Precisely, as the etymology of 'vividly' implies, because they are not victims but survivors: sur-vivor, to live on.

Everything lives on, and has not yet matured. The fragments we offer will be signified only through the multiple imaginings of those who behold them, who live in the full richness of the day.
Auschwitz 1: There will be cement walls with a few ventilation flaps.
Auschwitz 2: A glass ceiling, the light streams forth in an anarchy of smoke. Traces of footsteps, cars. However: oxygen only available from several tanks.

With *Memorandum*, what was attempted was not reinterpretation, but re-enactment, to animate anxieties through action. What materialised – and this is to reflect on digital globalisation – were collaged realities which stood outside any understandable narratives, cutouts which then could only heighten and profile anxiety. In the absence of genuine contact between subjects, the only possibility is to act – actions create works – figural images and objects which can animate, iconic moments which the memory can retain, which survive.

Memorandum arose out of the fundamental shifts in the ways images and objects are produced with digital technology, and the means we use to communicate with each other; what is at stake in consequence is the way society itself is restructured. This is prospective work: prospective curation which does not prescribe use or frame – a work is let loose, to see how it survives, how it circulates, invents its own spaces, develops its own relationships in a visual eco-system.

The necessity to work in this way, compressing activism

and art into the one process is reinforced by one of the more abiding images from the past year during the M11 motorway building protests in Leytonstone, east London. Here, the last remaining tree standing in the way of the proposed motorway became a symbol of the stance against the developers. By living in the tree, the protesters managed to obtain a (temporary) legal injunction to prevent its demolition on the basis that it was no longer a tree but a house. The construction of such an epic scenario distils fundamental conflicts through the one object but the image remained unaestheticised. This illustrates how distanced the modes of production that art constitutes are from the protagonist aspect of contemporary culture, which actively generates its own visual symbols and metaphors.

How does the image live or die? Art is a representational machine which enables objects and images to live, but can only appropriate and extract. Inherited models of curating – retrospective curation, rooted in extraction and appropriation does not generate *in situ* meanings without itself becoming the subject of all meanings. In this measure, art's experience of the *in situ* is purely vicarious. The paradox is this: art assures life, survival for what it self-references as art whilst in the process of consigning what it claims to narrow repetitive frames of consumption. Invariably this is what cannot survive, what fails to engender *in situ* meanings and associations. This engineered paradox which has long offered possibilities of the democratisation of high art, equally makes possible the fantasy of cyberspace. Both have the same root in the endless deferral of the repressed. The truism is that the repressed must return and take its rightful place; otherwise it will seek to destroy. By dematerialising, the internet then accrues all available repressions to service the cultural need for empty spaces; the empty space, *res nullius*. Thus, the myth of cyberspace with its seamless communication . . . which transcends real time encounters and unequal power relations, transcends gender difference, racial difference . . .

These are projections, neither real nor false. They are plants, simulations. Narratives transposed, for to work in cyberspace is effectively to sever the two ends of a dialogue; for example, to sever the two ends of the *Memorandum* project, and pinion the subject in the virtual.

However, whilst any attempt to stake a presence on the internet results in the reduction to the minuscule, such presence strikes at the root of a different notion of existence: that a clone is not a multiple . . . that biological time – preprogrammed to decay – which conditions every aspect of our thinking does not correlate in binary terms . . . that the economies by which information technology sustains its own life may re-format memory, experience: as information, symbols, signs, myths recover an autonomy for themselves. Autonomy as a categorical imperative transfers from us as subjects to computational processes, other authors. That is cyberspace's inherent disruptive potential: to transgress totally the mechanised means through which the cultural meanings today are produced.

However, these are new forms of re-articulation. How we re-animate them in real space is another matter. The internet is a network of software and it has its generative potential – what it reasserts for the possibilities of new curating most acutely is that art is essentially a by-product, that it needs to be a by-product before it can be a product. Retrospective curation, by forcing the product, for its own consumption, into predetermined discourse restricts the field of interactions too drastically to allow the networks any more than a creatively marginal or compliant role.

The strike project was set up in Spring 1992 at the Public Lavatory, Spitalfields, London E1, and is named after the film by Sergei Eisenstein.
strike@gn.apc.org
http://www.artec.org.uk/buffer
buffer@artec.org.uk

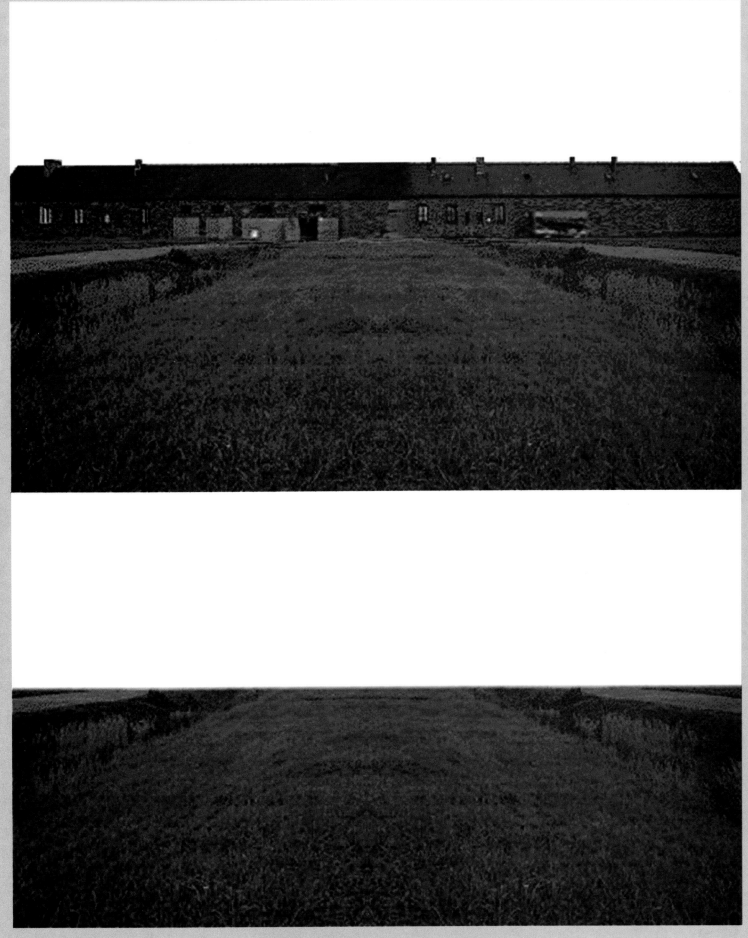

OPPOSITE and ABOVE: Memorandum Project, *Josh Oppenheimer & Siraj Izhar with Paul Burwell, Ranjana Choudhuri, Steve Farrer, Daniel Rehahn, Spitalfields, 1995*

Jenny Holzer, Truisms, *1992, outside the Palace of Culture and Science, Warsaw, organised by CCA Warsaw (photo: M Grygiel)*

NOT QUITE AT HOME[1]

Milada Ślizińska, Curator for Contemporary Art, Warsaw

MARYSIA LEWANDOWSKA

One summer afternoon in the heat of the tourist season I met Milada Ślizińska in the Old Market Square of Krakow. Later that same afternoon, she was discussing a future show with three Polish artists (Jerzy Nowosielski, Mikolaj Smoczynski and Leon Tarasewicz) whose Russian Orthodox faith marks their foreignness within a largely Catholic society.

We began by discussing her role as the Curator responsible for the international programme at the Centre of Contemporary Art in Warsaw. Her brief, largely an anachronistic product of the bureaucratic legacy of an earlier era, enabled her to continue her commitment to show foreign artists in the context of the newly emerging Polish realities.

With the awareness of new beginnings (yet professionally continuing her work begun at Foksal Gallery, 1973-87) in 1990 at the invitation of Wojciech Krukowski, Director of the CCA, Ślizińska joined the team shaping the programme. The CCA is located in a spacious 1970s reconstruction of the 17th-century Ujazdowski Castle. While architecturally impressive, for the last six years it has suffered from a chronic lack of funds, which continually stalls the completion of its refurbishment. Various parts still resemble a building site while others are gleaming with elegant marble detail.

While the 1980s in Western Europe and the USA saw excesses in art production, coupled with the consolidation of strong critical practices, Poland was undergoing a series of major political struggles which eventually resulted in the democratic elections of 1989. To quote Ślizińska 'The reality of the everyday in those years has overpowered any immediate artistic concerns'. Our conversation centred on the question of 'foreignness' as a curatorial and cultural problem in that particular part of the world. Where does one look for possibilities of artistic input in a situation marked by years of fragmentary information, sporadic international shows and lack of serious and consistent critical debate. Which gaps need to be filled first, what discussions initiated, and when?

Ślizińska's coherent and relevant foreign programme can be traced in a number of ambitious projects with artists such as Jenny Holzer, Andres Serrano, Kosuth/Kabakov and most recently Krzysztof Wodiczko.

Jenny Holzer's *Truisms*, translated into Polish, spoke with authority of a truth which otherwise appeared too banal, and too painful, for the official press or media. However they resonated in the streets of Warsaw.

The following year, 1993, the most unpredictable response was generated around the show of Andres Serrano. During the exhibition, formal and informal discussions, both in the media and in classrooms, touched upon sensitive subjects prompted by the exhibition, religious tolerance, censorship and death. In a climate marked by struggles for moral influence between the Catholic Church and secular institutions, both the Morgue series and earlier pieces such as *Piss Christ* (banned from the exhibition but included in the catalogue) were capable of introducing an alternative voice. The urgent social and ethical debate ultimately transformed into questions about the nature of representation.

Similarly, a recent Krzysztof Wodiczko retrospective has been received with timely recognition. His work with the homeless, issues of xenophobia, and the nature of social responsibility in this current climate uncomfortably mixes art with a more overt political agenda. Wodiczko offers a possibility of a more open approach to the often unmentionable and embarrassing subjects emerging in Polish political life.

A different aspect of 'foreignness' has been explored in the installation by Joseph Kosuth and Illya Kabakov entitled *The Corridor of Two Banalities* shown at the CCA in 1994. By inviting two artists whose separate biographies have been entangled in both East and West, by bringing their practices together and proposing a collaborative project, Ślizińska was able to emphasise some of the dilemmas of staging exhibitions in Warsaw. In one of the accompanying interviews she has succinctly observed that what presented a particular challenge for her as a curator was precisely the ambiguity of the crossroads. She once said, 'For London, Paris, New York we are the East; for Moscow, Vilnius, Kiev, we represent the West.' The model of the crossroads, and its tensions, resulted in a show which laid bare the assumptions of clear divisions and singular influences. Through months of patient negotiations with the artists, a complex narrative unfolded.

While planning her foreign exhibitions programme, Ślizińska discusses being faced with a number of pressing problems. These are to do with her own didactic ambition of showing artists who might only be known in reproductions. She aims to provoke discussions amongst art professionals without alienating a wider audience, especially the younger generation.

In her curatorial decisions she has often followed some earlier contacts, especially those from the English-speaking world. She relishes the possibility of inviting artists who respond to the context marked by political uncertainty and change.

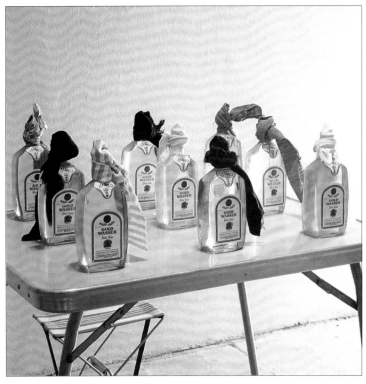

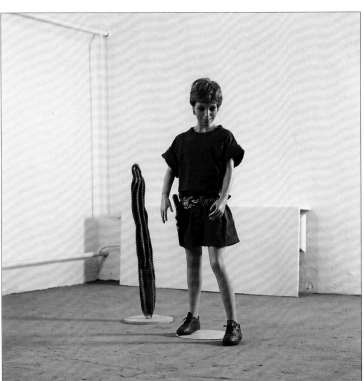

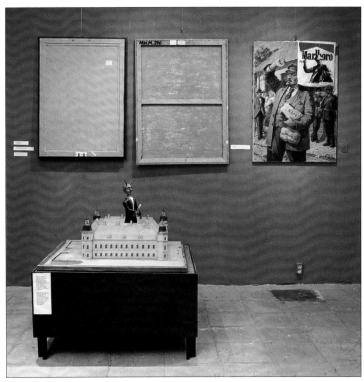

OPPOSITE: Jessica Diamond, Dollar Signs 1,3,4,5,6, *from the exhibition* Translation, *1992 (photo M Michalski and B Wójcik); ABOVE: Nayland Blake,* Handicrafts *from* Translation, *CCA, Warsaw, 1992; BELOW, L to R: John Miller, installation view from solo exhibition, CCA, Warsaw, 1992; Fred Wilson, installation from* Translation, *CCA, Warsaw, 1992 (all photos: M Michalski and B Wójcik)*

Amongst the most successful of her shows were those involving artists and guest curators who made no particular assumptions about creating an exhibition in a post-communist country; those who were willing to rethink certain stereotypes connected with exhibiting in Eastern Europe and who were able to overcome the habit of having yet another exhibition, and doing what they always do. In recent years Ślizińska has embarked on a number of collaborations with artists who have made new work contextually informed by a visit to Warsaw (Maria Eichorn, Fortuyn O'Brien). Often excited by a kind of exoticism which post-communism coupled with consumerism conjures up, a number of established artists were keen to take risks in an unfamiliar environment. They responded to a truly unpredictable reality of mixed signs in a culture without home-grown dealers, and the attendant oxygen of commercial galleries, collectors and publicity.

In those forbidding circumstances Ślizińska managed to produce some of the most interesting interventions in more than just the local sense. An exhibition developed in collaboration with another curator, Kim Levin from New York, entitled *Translation*, was originally planned for Moscow.[2] It consisted of the younger generation American artists whose practice evolved around the post-Duchampian tradition, with specific emphasis on questions of representation and social critique.

> *Translation* is about an encounter between two cultures. And since Poland is in the midst of an internal collision of cultures right now, its own translation from one economic and political language to another, it is about that too. In Warsaw in 1991, there was talk about demolishing Stalin's Palace of Culture and Science; in 1992, the Palace houses a casino and a department store. The monumental workers in their niches look out upon window display mannequins. The red emblems of Marlboro and Coca-Cola replace the icons of Lenin.[3]

The show was received with caution. Polish artists and intellectuals were unimpressed, and slightly angered by the interventions into what they were trying to protect as their own domain. The press responded with hostility, which derived mainly from the fact that the Americans were attempting to engage critically with the current Polish predicament. Nayland Blake made a particularly poignant work. He made use of a fictional folk tradition, by exhibiting handcrafted figures of Hasidic Jews, mass produced and destined for the souvenir shops.

Fred Wilson literally addressed the myths implied in the Stalinist iconography collected from various local museums. Karen Kilimnik staged a *tableau-vivant*, transforming the entrance hall into a fantasy stable, embarking on a fictional history of the aristocracy, once the original owners of the Castle.

The show has established an important precedent for thinking about curatorial practices in Central Europe. By forcing artists to explore a specific cultural moment, Ślizińska has enabled artists and audiences to extend their own vocabularies.

Notes

1 Title of Mariusz Kruk's exhibition, the first curated by Milada Ślizińska for Centre for Contemporary Art in 1990.

2 Artists in *Translation*: Erickson/Ziegler, Karen Kilimnik, Mark Dion, Michael Timpson, Pruitt and Early, Matthew McCaslin, Haim Steinbach, Fred Wilson, Nayland Blake, Ashley Bickerton.

3 Kim Levin, Introduction, *Translation*, catalogue, Centre for Contemporary Art, Ujazdowski Castle, Warsaw, 1992.

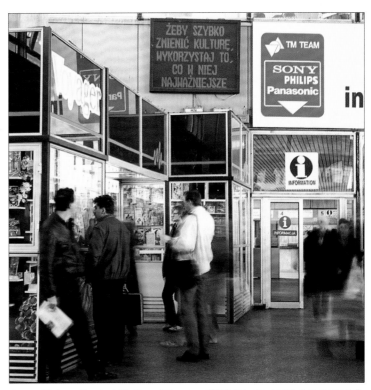

Jenny Holzer, Central Station, *Warsaw, 1993 (photo: M Michalski and B Wójcik)*

OPPOSITE: Matt Mullican, banners from solo exhibition, CCA, Warsaw, 1996 (photo: M Michalski and B Wójcik)

DER UMBAU RAUM

Nicolaus Schafhausen's Viable Place

LIAM GILLICK

Der Umbau Raum, *1996, Kunstlerhaus, Stuttgart (photo: Sandra Schuck)*

A Viable Place: *Der Umbau Raum*

Der Umbau Raum was not created on the edge of any particular activity, it operates in the centre, providing a middle ground space to occupy and exploit. It is a project that functions as a necessary borrowing from other areas of art activity. On one basic level it provides a place for the research of urban development, offering a library of important literature as well as providing access to artists' video work; beyond these aspects it focuses upon a structural area of art contextualisation that increasingly requires further investigation.

tion of art activity in the last 50 years. This tendency towards the inclusion of the information centre in exhibitions evolved at a time when people felt that art could have a clear usefulness, while at the same time recognising its growing opacity. There developed a need to help people join in the understanding of things like plain white paintings along with an obligation to help them de-code the potential utility of art in relation to a way of looking at the world beyond representation and personal spirituality. While that is still a laudable desire, theories of social structure have helped us question whose information

Der Umbau Raum, *1996 (photo: Oliver Klasen)*

Within art centres, exhibitions and one-off projects it has become normal to provide a place for reflection, work and action. Visitors to shows have got so used to these parallel structures that a whole set of codes have evolved alongside the exhibition of artwork alone. People can even read ironic references to the information room as it emerges through the mire of the most scatological 'alternative' project. So it is clear that many group exhibitions propose parallel back-up systems to aid the 'public' in its understanding, a phenomenon that has grown in direct relation to the increasing diversifica-

and whose story we are hearing in parallel to art works. Hence it is becoming increasingly clear that a perceived need to provide a place for parallel development within an art centre or gallery must be seen as part of a whole web of information fetishes well beyond the necessity to offer a series of guide-texts and maps – a place that offers a number of potential stories and the opportunity to create new readings of art and how it is shown.

So we have become used to the information room and the visitor centre. And there is a sense in which although the

primacy of the curator-authored guide has been challenged, the replacement of that text with certain 'tools' can still lead us to reach a limited number of conclusions. The opening up of cognitive development or further understanding that is implied by the standard arrangement of an increasingly familiar group of objects alongside a gallery space has become normalised and goes along with a whole new set of barely repressed instructions. An aesthetic has developed in parallel to exhibitions that can be read and replicated, whatever the work on show happens to be. Examples from alongside the art

rather than its specifics. Yet a brief description of its context and construction might be useful. Located in the Kunstlerhaus, Stuttgart, the room is only a small part of Director Nicolaus Schafhausen's extraordinary flexibility of vision in relation to the brittle structure of the typical arts centre. A German Kunstlerhaus embodies a club mentality. Originally founded to provide studios, resources and exhibiting possibilities to a local population, over the years some Kunstlerhaus – like the one in Stuttgart – have developed into the consensual model of a neatly designated quasi-public art space programming a

Der Umbau Raum, *1996 (photo: Oliver Klasen)*

include beanbags or casual seating; straightforward table design; some thought about lighting and decoration; an interneted computer or two; a selection of good reading and good-for-you reading.

Der Umbau Raum has all of these elements yet is different in that it stands alone, clearly unaligned to any specific show, a recognition of the self-standing aesthetic of the information room. It is something in itself and as such focuses attention on parallel structures in general. It is important to recognise these generalised qualities when thinking about *Der Umbau Raum*,

series of recognisably contemporary art exhibitions, usually imported from beyond the city boundaries. This is a reasonable development, seeing as it is in the interest of the local art population to increase its contact with outsiders and in turn be seen by those visiting to show. On the surface, Schafhausen inherited a Kunstlerhaus of this expanded sort. His response to this has been to complicate things. His strategy is multiple, apparently contradictory and essentially geared towards the potential of development rather than the terrified orthodoxy of consolidation seen in art schools and centres all over Europe.

Instead of acting as if under siege, Schafhausen has tried successfully to put in place small shifts of emphasis that might have extraordinary consequences. In acknowledgement of the butterfly effect, where a tiny action can influence everything, he has seen value in side-steps. For example, offering responsibility to youth; combining artists from across perceived intellectual borders; corrupting the relative status of artworks on show; providing rhetorical platforms for others in the face of his own deliberately repressed and mobile ideology. And in his most complex imploded desire to position the Kunstlerhaus

could lead to new readings; allowing artists access to pre- and post-production strategies rather than merely focusing on the primacy of the supposedly completed work; recharging the educational obligation of a place while at the same time calling into question the direction of parallel structures. A real *Raumsituation*.

Der Umbau Raum, *1996 (photo: Oliver Klasen)*

alongside social effects rather than in front of them, he invited a number of artists to furnish a working place – a semi-designated site for research, reflection and development; a de-specified environment that offers artists the possibility of being used; of providing a service, and recognising the potential of their under used resources, both intellectually and physically. *Der Umbau Raum* is a place that provides what is missing from so many art centres, namely somewhere to work beyond the art that does not take second place in an art hierarchy; a zone that is out of sync with the programme, yet

Der Umbau Raum: *a room situation with furnishings and objects by Uli Aigner, Angela Bulloch, Liam Gillick, Eva Grubinger, Stefan Kern, Jasper Morrison, Jorge Pardo, Tobias Rehberger, Pietro Sanguinetti and Joseph Zehrer. The room is a centre for a library of architecture and urban planning, a videotheque and an internet site. There is no clear timetable for the completion of the project or its conclusion.*

ON LOCUS+
JON BEWLEY & SIMON HERBERT

Locus+ is the latest incarnation of three artist-run initiatives which have operated in the northeast of England for the last 17 years. Between December 1979 and November 1983, The Basement programmed over 236 events in a physical space designed for flexible response to current developments in time-based projects. Between March 1983 and May 1992, Projects UK programmed over 248 events in a variety of mainly urban locations that addressed issues of physical, historical and cultural context. Since April 1993 Locus+ has broadened the initiatives of its predecessors within a national and international policy of collaboration with visual artists, collectives, institutions and writers.

Today there are many more organisations than 17 years ago which address the needs and promote the practice of artists wishing to work outside the gallery. However, not all share the same motivations or purposes. The majority are informed by the political and critical orthodoxies of the dominant exhibition structure; a structure which excludes artists from equal and integral participation. Here the original ideological and intellectual impetus for artists to develop different strategies is secondary to the curator's needs for peer group and establishment acknowledgement. This conflict and process of absorption, of appropriation of practice, creates the impression that social or political intervention achieves critical validity only when sanctioned by the museological mainstream. It removes opportunity through predetermined expectation and demands that conflicting needs are reluctantly renegotiated. Control and ideological context are bartered away. Furthermore, legitimacy, within a broader cultural overview, is only granted with historical and emotional distance. This negates the most potent element in the armoury of contemporary artists: the immediacy of relevant engagement (and the attendant risks). For most artists, particularly those addressing constantly shifting social and political issues, or working as catalysts and activists, being able to predict or desire a position in a future perspective is irrelevant, if not impossible.

Locus+ is a visual arts facility that recognises the partial incompatibility and imbalance in the relationship between contemporary artists and the exhibition mainstream. Locus+ places the collaborative artist at the centre of production and provides logistic and financial support to those who wish to work in different contexts and/or across formats. This indicates the opening of a cultural space for the creation of new works that challenge issues both formally and conceptually. Locus+ is not an organisation that promotes the interests of one area of practice or the issues of a particular exhibition or production methodology. Rather, through collaborative relationships with artists and organisations, it seeks to create opportunities and frameworks in response to artists' initiatives.

url: http://www.locusplus.org.uk

Stefan Gec, Buoy, *River Tyne, 1996 (photo: Steve White)*

In 1996, Stefan Gec melted down metal from eight decommissioned Soviet Whisky Class submarines (residing at the time in the naval scrapyard at Blyth) into eight bells that were temporarily fixed to a wooden structure on the River Tyne. At low tide the bells were exposed and at high tide submerged. *Trace Elements* (organised by Locus+ predecessor Projects UK, as part of the TSWA Four Cities project) was the first stage of an ongoing artwork by Gec. The latest incarnation is *Buoy*, in which the metal has been recast again into a fully working navigational buoy. *Buoy* was premiered on land in Hartlepool in June 1996. With the assistance of the International Association of Lighthouse Authorities it will be transported first by land and then by sea to ports in the UK, before travelling further afield to ports in Eastern Europe. This migration mimics in reverse the route originally undertaken by the Soviet submarines. *Buoy* has been electronically modified to become 'intelligent', transmitting details of its immediate oceanic environment via a global positioning system to the Internet. Access to this information will be through a dedicated web site (http://www.ruskin-sch.ox.ac.uk/lab/buoy). In collaboration with the Laboratory at the Ruskin School of Drawing and Fine Art and the Ormeau Baths Gallery.

Lloyd Gibson, Crash Subjectivity, *bell tower of All Saints Church, Newcastle upon Tyne, 1993 (photo: Steve Collins)*

A fibreglass figure containing a hybrid mix of male and female, adult and infant, elements. *Crash Subjectivity,* a work which combined polarities and paradox, was shown in three separate and distinct sites: in the bell tower of All Saints Church, Newcastle upon Tyne (1993), a deconsecrated church: in the bell tower of Carlisle Memorial Church on the Crumlin Road in Belfast (1994), overlooking Carlisle Circus, a border between Belfast's divided communities: and in the foyer of the Dublin Institute of Technology (1995), originally the Jacobs Biscuit Factory and one of the sites occupied by Irish Volunteers in the Easter Rising of 1916.

John Newling, Skeleton, *All Saints Church, Newcastle upon Tyne, 1994 (photo: Steve Collins)*

A temporary site-specific installation in which the
residue of approximately 80,000 template sheets of
holy bread (each 2' x 1' sheet marked by the holes
left when the Eucharist wafer had been punched out)
were stacked sporadically in the pews of All Saints
Church, Newcastle upon Tyne in Easter 1994. Of
particular concern to Newling, in his 'interrogation of
the space', was to emphasise a sense of absence,
both within the overall auditorium and within the
empty columns of the stacked sheets. For Newling,
each absence formed part of an archive. In addition,
a hymn book was placed at intervals on the pews,
modified so that only those sentences ending in a
question mark were retained.

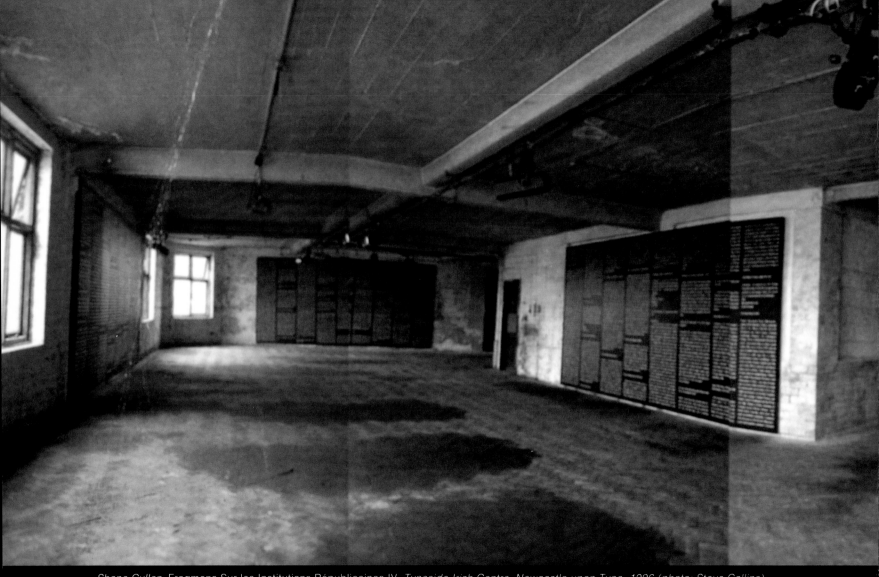

Shane Cullen, Fragmens Sur les Institutions Républicaines IV, *Tyneside Irish Centre, Newcastle upon Tyne, 1996 (photo: Steve Collins)*

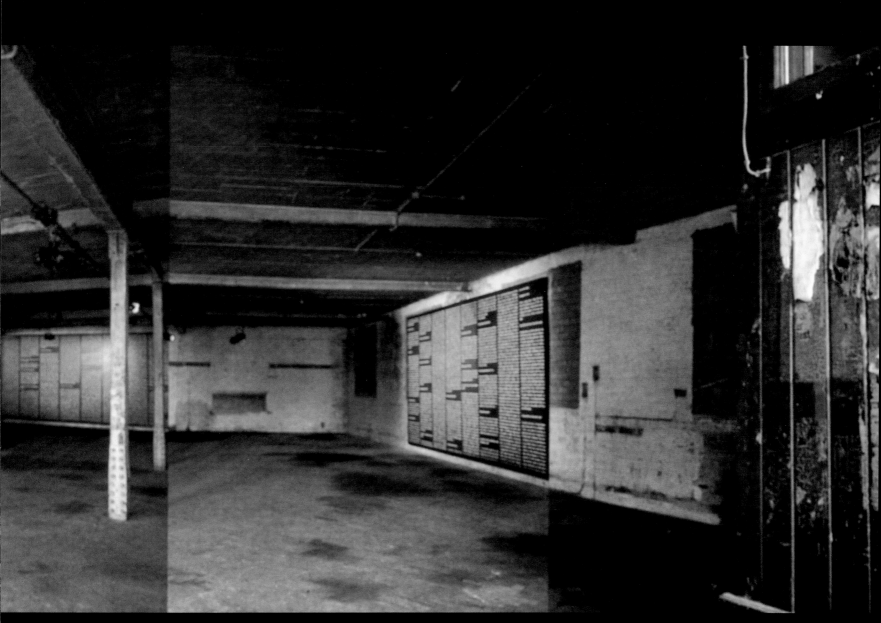

Gregory Green, Gregnik (Proto 1), 1:3 scale maquette, 1996 (photo: Steve Collins)

In November 1996 Gregory Green ran a live workshop
on the Meadow Well Estate (an estate which still
bears the marks of economic neglect which contrib-
uted to the Meadow Well riots of 1992), involving the
research, development and construction of a
functional prototype communications satellite. Public
access to the artist's workshop was allowed, and
residents of the Meadow Well were encouraged to
submit audio anecdotes about their immediate
community. These tapes were broadcast from
Gregnik (Proto 1) on a local radio frequency.

Richard Wilson, The Joint's Jumping, *3D computer images, © Interactive Architecture Ltd*

As part of the transformation of the Baltic Flour Mills, on the River Tyne, into a museum of contemporary art, Wilson will create an artwork which will be Europe's largest single freestanding neon structure. Chosen verticals and horizontals on the riverface of the building will be geometrically outlined in red neon. This will be repeated over the facade; however, it will be fitted five degrees off vertical and five metres higher. The two architectural neon outlines will randomly flick on/off, oscillating and thereby giving the impression of the building being in motion or jumping. At this stage, Wilson is working directly with the building's architect Dominic Williams (of Ellis Williams). These images have been produced using 3-D Studio software by Interactive Architecture Ltd.

Clare Palmier, installation in her home as part of Cottage Industry, *1995*

LEFT: Siobhan Davies, Dust to Dust, *installation in her home as part of* Cottage Industry, *1995; BELOW: Clare Palmier, installation in her home as part of* Cottage Industry, *1995*

Siobhan Davies, Dust to Dust, *installation in her home as part of* Cottage Industry, *1995*

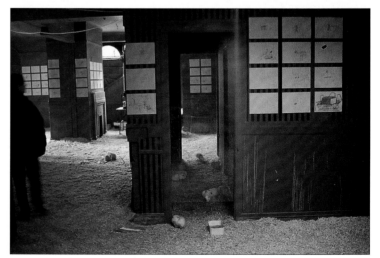

David Crawforth, David Mollins and Matthew Arnatt, The Lisson Gallery, *1994, a Beaconsfield/Nosepaint Collaboration (photo: Angus Neill)*

ARTIST-CURATORS AND THE NEW BRITISH ART
JULIAN STALLABRASS

If isolated amongst pure specialists, artist-curators would be curiously hybrid figures, but in fact they are surrounded by artist-theorists, -critics and -teachers, not to mention artists who wait at tables, work in warehouses, or sign on. In a time of economic insecurity and in a world of temporary and part-time work where people turn their hands to many things, artists quite naturally adopt a curatorial role. Even so, the incidental appearance of this particular hybrid has had consequences for art and curatorship which go beyond the merely economic.

That diverse, even incoherent, phenomenon which has come to be labelled 'New British Art'[1] was also an outgrowth of economic insecurity, and within it artist-curatorship has been prominent. It was there at the tendency's retrospectively established inception, *Freeze*, curated by Goldsmiths' students in an empty industrial space in 1988. This, and subsequent shows, such as *Modern Medicine* and *Gambler*, perhaps more celebrated now than they were then, demonstrated that artist-curated shows in makeshift, temporary galleries could be successful. They garnered publicity and, at first, commercial success for their participants – many of the Freeze artists were picked up by private galleries. In no sense was this the establishment of a new avant-garde, for there was no programme, only a certain arch positioning. Nor was it anything particularly new or radical: 'Everybody had quite grand ideas at the time [1988] which were best handled by doing big fuck-off shows that didn't need to be compromised by working within a gallery system. But it wasn't saying "fuck off" to the galleries. It was just an alternative . . . '[2]

In these exhibitions, the exclusion of professional curators was an important mark of the alternative scene's authenticity; together, artists and shows marketed themselves with rawness and straightforwardness. If artist-curatorship and the new British art have become closely associated, it should be asked whether the link is more than contingent. The coherence of the category, 'new British art', has been questioned but even if the unity wished on the trend is in part retrospective and has been exaggerated (especially by bodies which have an interest in doing so, like the British Council), looking at artist-curatorship may be a way of approaching the issue of its distinct nature.

The embrace of mass culture by much new British art seems at first to be a simple fulfilment of the postmodern proclamation that there is no longer a meaningful distinction between high and low. This work looks friendlier than the conceptual complexities that preceded it, and appears to speak directly to people's everyday concerns. When artists such as Sarah Lucas use spreads from tabloid newspapers, they no longer need to belabour the theoretical grounds for co-opting this material; they just go ahead and do it.[3] This attitude towards mass culture has been highly successful in encouraging new and wider audiences for contemporary art, and in gaining it a good deal of media attention.

Because for such artists the transparency of material drawn from mass culture is important, specialist knowledge is rejected, not only of cultural theory, but also of art history and curatorship. Knowing about, say, cyperpunk, or football, or *The Partridge Family* – and as a fan, not an analyst – may be more important for the understanding of this art than knowledge of Velázquez or Picasso, or even Art & Language. The use of mass culture is more than a mere enthusiasm for the popular; it is an anti-élitist strategy which runs alongside showing art outside conventional gallery spaces, and the refusal to create valuable, durable art-objects. The effect is a decided shift of power away from artworld professionals to the artists themselves and to the mass media. Even art criticism, though important, is no longer much about critique but mostly about column inches – often purchased in exchange for the placement of adverts or even works of art. As a consequence, criticism is in decline, giving comforting puffs to the favoured and entirely ignoring the rest.

Yet the inclusion of a wider audience at the level of art and theory in the new British art have produced a reaction of exclusion at another level. New British art is only apparently flippant and friendly. It exploits the transparency of mass culture to give it access to markets beyond the high-cultural élite but, guarded by a small group of well-informed, theoretically adept insiders (often postgraduates from art and theory courses) reserves for itself a stern exclusivity. For those in the know, the works are loaded with in-jokes. These artists' philistine gestures are safe only because everyone knows that they are a matter of choice, and that if they wanted once more to make work based on Derrida, Foucault, Lacan, Kristeva – the usual suspects, in short – they still could.[4] So the work has a double face: outwards to wider audiences and media notoriety, inwards to the 'clubby' art world,[5] where the old institutions, private galleries and public bodies, are definitely not excluded.

Curating has always been an odd mix of the professional and the aesthetic; if it is dominated by artists in contemporary shows, that makes a certain sense for it is only to play up the

aesthetic side to the exclusion of specialist knowledge. Damien Hirst has said that for him there is no difference between making work and curating.[6] Artists' curatorial qualifications are of a primary order, and artists' selections and arrangements have a weight just because of who they are. Like the art, the names of the shows compete with each other to be as flip and cool as they can, though maybe this reached a terminus with Bank's exhibition title *Fuck Off*. Such curatorship bears the mark of authenticity at the expense of critical distance.

Given this, the distinction we should look at is not so much that between pure curators and artist-curators, but between those curators who are part of the scene – whether or not they are artists – and those who remain outside. Carl Freedman, for instance, who curated *Minky Manky* at the South London Gallery in summer 1995, is not an artist but his exhibitions certainly fit the pattern of artist-curatorship.

The scene is exclusive aesthetically as well as socially but the grounds of the former exclusion are hard to define. In one sense, as Matt Collishaw pointed out, because of the post-minimalist nature of this art, these alternative shows were not hard to put together: 'it was not that difficult to curate an exhibition out of works like that because they've all got the same flavour and they work quite well together in a group situation'.[7] Taking the shows together, selection occurs less at the level of curatorial decision than at that of the scene itself.

The difficulty with definition is a fundamental matter. When Martin Creed's band takes apart the rhetoric of pop, starting a song, and then continually restarting it, or begins counting, 'one, two, three, four', but then carries right on up to one hundred, it is easy to appreciate the humour and to know that some responses – like dancing – are inappropriate, because we have a good feeling for the rules which are being violated. With high art it is rather more difficult since this kind of critical dismantling has been continuing for decades, and it is hard to know with what level of reference we are dealing: is a work referring to something else or to itself, to rhetoric or reference, or to some still further recursion? A shop which Tracey Emin and Sarah Lucas ran in 1993 to sell art junk, most notoriously ashtrays with photographs of Damien Hirst stuck to the bottom (stub out your fag on the face of that celebrated lover of cigarettes) was in one sense a powerful curatorial statement about commerce, but it was also a real shop which made and sold stuff, and, as Emin says, they lived off it for six months.[8]

Faced with such difficulties, the frequent recourse of critics and historians has been to rely on the statements of the artists. This has always been a dubious strategy because it assumes not only that these informants are open and honest but also that they know exactly what they are doing, and are able to express it. Now artists are often (rightly) refusing to let critics off the hook in this fashion; Hirst says 'I sometimes feel I have nothing to say, I often want to communicate this',[9] and in general is anxious to place all responsibility for the reading of

his work with the viewer, while Lucas responds to critical questioning with: 'I'm saying nothing. Just look at the picture and think what you like.'[10]

This undecidability is not a product of the postmodern condition, or the liminal, or deconstruction in any essential sense, but of a product of a specific situation in which art simultaneously addresses diverse audiences, facing outward to the general audience and inward to the in-crowd. Since the connections between the two are rather tenuous (the mass media are intent on seeing some connection with Brit-pop, for instance), the task of the critic and the curator becomes very difficult. A manifestly subjective and detached attitude is one of the few ways out. This manner of working is a choice and a strategy. It breaks the dead hold of professional standards, of high theory, of the inverse but vulgar Marxism of political correctness over high art, but does so at the expense of a new powerlessness. While there may be a certain radical charge in the act of negation against the high-culture industry, there is no sense in which anything is recommended except the loosest and hippest of liberalisms, defended but also defanged by irony. The inner art circle are far too cool to be offended by anything – ask yourself, especially if you are on the scene yourself, what it would take to offend these people (Jake and Dinos Chapman do not come close – not, of course, that they are trying).

The result is lots of shows which all claim to be unique but which all say much the same thing: that they are 'alternative'. The most important claim that these exhibitions make is negative: it is to proclaim what they are not. That they are not earnest, forehead-creasing displays of postmodern rectitude, nor faux-naive nature- and spirit-vendors in the British tradition, like Gormley, Kapoor or Goldsworthy, so beloved of the mainstream institutions. As a consequence, the links between works in artist-curated group shows may have little to do with their content; for those in the know, they are much more to do with certain social sets, or who went to college where, or was taught by, and/or is going out with, whom. Of course, it is foolish to think that such factors do not intrude into professionally curated shows, but they are generally not so primary, and also a little better concealed.

Such shows certainly have many precedents, not in the public but in the private sector, in the numerous group exhibitions which brought artists together by commercial accident and celebrated their diversity. As a pure strategy, the fact that for a time such shows were run by artists rather than galleries may turn out to have little long-term consequence, and indeed we have seen that private galleries have found it very easy to bring this work, and the practices which govern its curating (which were always their own), back within their confines.

Yet not all artist-curated shows have been exactly the same. Bank and Plummet, for instance, have made distinct curatorial interventions. I was involved as a writer with *Candyman II*, in

which the curators, Matthew Arnatt and Peter Lewis, were interested in making an exhibition which questioned the resolutely affirmative role of curating. To make a show, in other words, which did not support the work, which was, at best, neutral towards it. In many ways, this looked like a typical alternative show, with a group of diverse artists shown in the vast spaces of an old biscuit factory. No attempt had been made to renovate the space, however, which was so massive that even large works looked lost within it, and viewers were at one point herded into a space surrounded by an electric fence. *Candyman II* raised questions about the attitude of viewers and curators to art as a pursuit worthy of time, space and attention. When the show was reviewed, however, it was treated like any other alternative event. It was an instructive experience since it showed the liberal tolerance of the system for an activity which tried to go against it, and the difficulty of doing anything which could stand visibly outside its ambit.[11]

Others have tried to break with the atmosphere of pure authenticity surrounding the alternative scene. Two very different exhibitions curated by Beaconsfield, a curatorial organisation in which two of the three members, David Crawforth and Naomi Siderfin, are artists (the third is Angus Neill) illustrate this. In a show called *The Lisson Gallery*, and publicised using Lisson-style adverts, an old pub was converted into a gallery showing drawings by David Mollins and text works by Matthew Arnatt – the latter was also responsible for the idea. David Crawforth had covered the pub floor with straw and had installed a herd of 24 guinea pigs – these are herd animals, you realise, when seen en masse. This was obviously to disrupt the viewing of art with defamiliarised domestic elements, but the guinea pigs also stood in for artists, and referred to competition and selection – based of course on experimentation – in the bright laboratories of the gallery system.

Very different was the Beaconsfield show *Cottage Industry*, in which various artists reflected, either in the gallery or from their homes, on their different roles as artists, workers and mothers.[12] Again, the lottery of the market was questioned, as was the fate of the vast majority of artists who do not 'make it',

or who, at any rate, do not make quite enough. This exhibition brought art up against the contingencies of the everyday, showing how it connects to the ordinary world of work and life. It acknowledged that fine art is very often a cottage industry, and allowed a more democratic identification with it from those who also have to juggle work, family and the pursuits which happen to be their passion.

The loose group show, by contrast, the one which says only that the selected group of artists are on the scene, is a consequence of deep but masked scepticism about the effects and the ethics of art. Yet, despite themselves, these shows did have lasting consequences because attitude and venue reinforced each other. As Robert Garnett has put it, 'It was one thing to be claiming to be launching an assault upon the "scopic regimes of modernity" from within the confines of the pristine spaces of transnational Postmodernism, another to make the same claims [from] a disused storefront in the East End.'[13] There is an implicit project of openness and democratisation within aspects of new British art, but if it is to be fulfilled such work needs to take its wider audience seriously, and to explore the conditions which make the work's existence and distribution possible.

Despite its positive aspects – which as we have seen are partly negative, though it has to be said that not being Antony Gormley is a very good thing to be – new British art is very much a product of its time; it is generally apolitical, cynically careerist, and out for a good time. New British art is, then, the cultural equivalent of New Labour – and this is not an entirely arbitrary comparison, for both are products of the apparently global closing-off of radical alternatives (so that radicalism becomes a matter of pure image) and of the bankruptcy of the accepted order. When new British art elides high and mass culture, it is like New Labour when it assures us that there is no distinction between efficiency and fairness. Like New Labour, new British art is an establishment in waiting. How much can we expect from it? Well, as Margaret Thatcher once put it, describing her concessions on sanctions against South Africa while holding her fingers the tiniest distance apart, 'this much'.

Notes

1 Simon Ford, 'Myth Making', *Art Monthly*, no 194, March 1996, pp3-9.

2 Angus Fairhurst in *Brilliant*, Walker Art Center, Minneapolis 1995, p34.

3 See John Roberts, 'Mad for It! Bank and the New British Art', *Everything*, no 18, 1996, p16.

4 On the definition and radical nature (or otherwise) of philistinism, which has important implications for recent developments in the British art scene, see Dave Beech and John Roberts, 'Spectres of the Aesthetic', *New Left Review*, no 218, July-August 1996; and Malcolm Bull, 'The Ecstasy of Philistinism', *New Left Review*, no 219, Sept-Oct 1996.

5 *op cit*, Roberts, 'Mad for It!', p19.

6 Interview with Marco Spinelli posted on the World Wide Web at illumin.co.uk.britishart/artists/dh.

7 Matt Collishaw, 'The Freeze Exhibition', posted on the Web at illumin.co.uk/britshart/artists/mc.

8 op cit, *Brilliant*, p31.

9 Institute of Contemporary Arts, *Damien Hirst*, London 1993, np.

10 Sarah Lucas interviewed by Marco Spinelli, *Brilliant*, p64.

11 I was asked to write a similarly unsupportive catalogue essay. Although the catalogue never appeared, an edited version of the essay appeared in *Art Monthly*, no 182, Dec 1994-Jan 1995, pp1-3.

12 *Cottage Industry* was held at Beaconsfield, Vauxhall, in November 1995. It was curated by Naomi Siderfin, and included the work of Sonia Boyce, Siobhan Davies, Mikey Cuddihy, Elsie Mitchell, Clare Palmier and Naomi Siderfin.

13 Robert Garnett, 'Beyond the Hype', *Art Monthly*, no 195, April 1996, pp43-44.

? section

Curator
Ute Meta Bauer

in collaboration with:
Fareed Armaly

Video programmes in cooperation with:
Mara Dakar Blase
Danmarks Radio, Søborg
Det Dansk Filmmuseum, Copenhagen
Goethe-Institut Copenhagen
Günter Minas
Hessicher Rundfunk, Frankfurt a. M.
Nordisk Film, Valby
Caroline Tisdall
West Deutscher Rundfunk, Cologne

Audiotapes:
DJ MO
DJ NURSE
DJ SHIER
DJ T-INA

Zines:
Linda Bilda
Aylın Çatal / Brigitte Braun
Yvonne P Doderer
erreakzioa-reacción
Judith Hopf
-Innen
Barbara Jung
Regina Möller
Network Orange
Michelle Nicol
Konstanze Schäfer
Übung am Phantom
Ina Wudtke

? Office
Stuttgart / Copenhagen
Fareed Armaly
Ute Meta Bauer

Detlev Brinkschulte	Research / 'Sign System'
Saskia Drechsel	Internship
Cecilie Høgsbro Østergaard	Internship
Eva Kolb	Internship
Regina Möller	Collages / 'Sign System'
Andreas Staiger	Assistance

Exhibition sections
in collaboration with:

René Block	Reinstallation of Beuys's *Honigpumpe am Arbeitsplatz*
François Court-Payen	'PH / Lunde'
Yvonne P Doderer	Children's House Section, Louisiana/Christiania
Thomas Eifler	Realization of 'Sign System'
Hans Lauritsen	Review of Danish Modern
Peter Schata	Materials from d6, FIU, *Honigpumpe am Arbeitsplatz*
SMAC Film, Regina Möller	TV / Video Trailers on **?** Character
Vroonen & Snauwaert	Technical design / realisation for **?** Character's costume
Arnold Walz	'Louisiana Children's House Building Box Set'
Wohlert Architekter	Architects of Lousiana Museum

Louisiana

The Louisiana Museum of Modern Art, Denmark, opened in 1958 as a private initiative to introduce Danish modern art and design to a Danish public. Its special character is shaped by the enthusiastic activities of its founder, Knud W Jensen. In 1959, after visiting documenta 2, he decided to shift direction towards an international policy. Louisiana's private museum status gave it the freedom to build a collection reflecting Jensen's personal taste and preferences, which has in turn brought about a large scale public response. Today, it ranks as Denmark's fifth largest tourist attraction. It is this success which requires the museum to address the taste of a vast public.

NowHere

The exhibition *NowHere* was Lousiana's attempt at introducing the contemporary within the space of the Modern. For the first time since 1958, the museum was emptied and the whole collection placed in storage. The Museum had invited outside curators – Bruce Ferguson (New York), Iwona Blazwick (London), Laura Cottingham (New York), myself (Stuttgart) – together with two Louisiana curators, Lars Grambye and Anneli Fuchs. We decided that our projects would operate as five independent satellites, contemporary orbits in the space of the Modern, emphasising that there is no unifying outlook, no one 'new'.

Curators

Laura Cottingham – 'Incandescent'
Bruce Ferguson – 'Walking and Thinking and Walking'
Anneli Fuchs & Lars Grambye – 'Get Lost'
Iwona Blazwick – 'Work in Progress'
Ute Meta Bauer – '?'

Entrances

Several entrances are offered for this part of the South Wing. Each forms a unique transition between inside and outside, lower and upper level, and now between different sections. *NowHere* is to be the Lousiana's transition from the Modern to the Contemporary. **?** introduces this as a change from autonomous art to cultural productions.

? produced a figure modelled after those walking and greeting at theme parks. Their job is to personify the character of the site. The **?** figure exists in a space between Beckett and Disneyland, circulates in the park among the sculptures and public, and seen distributed by media.

INFORMATION, EDUCATION, ENTERTAINMENT

? *section,* NowHere *exhibition, Louisiana Museum of Modern Art, Denmark*

UTE META BAUER IN DIALOGUE WITH FAREED ARMALY

? section

Louisiana itself was one possible outline for this section, but the museum site was no longer the frame; instead along with Pop culture, media, art, architecture, fashion, etc, it is part of the same topography: culture.

10,000 square meters of rooms were emptied to provide a major staging area for the expected 'contemporary', but this merely served to accentuate the Modern Museum with its Danish foundation. The exhibition's unique character came by a less tangible process which hinted at types of dialogues and exchanges. By undertaking such a project, the museum produced another space, but one which was only perceivable by the traces of irritation in its existing structure, the incongruity with the institutional facility's existing parameters – whose range included everyday issues of copyright, the standard loan form and wall labels, to the museum's public media. These parameters were shaped for the administration associated with a certain type of Modern museum, rather than the contemporary productions which had been requested. In a sense, this was the expected 'site' – the indefinite state of being between, a momentary manifestation of difference in the institution that could be taken as the offer of possible 'side entrances'. This moment allowed **?** to bring in its outside point of view onto what was shaped by my own background and previous institutional experiences, and link this to questions of curatorial methodology. The section addressed the flux of the situation through bridges, links and connections – between public, audiences and media – or between the historical notion of the Modern and the contemporary as orientation. A variety of platforms were thematically linked by addressing these aspects, situated within the established areas of 'Entrances', 'Storage', 'Museum', 'Pavilion' and related events.

The section development was shaped by three sets of relations:

– *Circulation/montage*, as emblems for the section are underlying principles which brought together the various topics and materials. The museum's closed circuit of artworks and art history, with its logic of continuity, is substituted by the section's notion of cultural productions in circulation, and another logic implied by montage.

– *Information, Education, Entertainment* is a programme that reflects my ongoing interests regarding the question of how to balance these three terms so that they address relevant cultural issues to different publics. For *NowHere*, **?** referred to the same public mandate that institutions such as the (State) Public Television comply with. With its 600,000 visitors a year (180,000 visitors to *NowHere*), the museum is addressing a similar diverse audience profile. The mandate is seen throughout the section, and is most evident in how the assembled media is balanced under its parameters. This ranges from historical Danish TV compilation to DJ audiotapes, from a rare video programme referring to Beuys's notion of 'Soziale Plastik' and the Free International University to 13 Zines by women editors to a theme park character. I realised that supported by the reputation of a well-known museum, the exhibition was more likely to facilitate the difficult assemblage of certain media works, as well interviews and research – all of which were designed to continue after the exhibition by other distribution systems. The thematic can be seen in my earlier working practice as artistic director of an artist's space, and now, working within the academic system.

– *Structure, Participants, Office, NowHere* created a situation where the given structures did not necessarily fit the scenario, hence each of the outside curators had to develop his or her own structures. For **?** there was, from the beginning, a dialogue format established by inviting the artist, Fareed Armaly, to work in counterbalance to the curator. A shared emphasis on the possibilities of cultural production with a critical discourse linked to popular culture and media was the benefit of this collaboration. As section **?** worked with an emphasis on culture, a variety of backgrounds – architecture, music, design, education – are evident within the selection of the participants. Their common denominator was that they operated with combined disciplines, rather than one clearly defined role. Most either came from Stuttgart or Copenhagen or I knew them from previous associations. The section gave commissions with a clear outline, but every participant was free to decide how he or she would form their contributions. The usual relationship between artist/artwork and curator/selector was replaced by a method emphasising divisions of labour in order to develop and execute an overall concept. This was expected to raise discussion throughout the exhibition time, and did so. It pointed towards the difficulties of the art context, even attempting methods of production taken from other cultural fields. Because inevitably although an actual industry, the art context still operates within grey zones and a semi-professional status that no other cultural field allows. The paradox lies within the fact that this grey zone allows the ongoing

attempt at defining all the terms involved in art production, from reality of insurance values, to copyrights, to definitions of 'artist', 'curator' and 'institution'. It is especially with such large exhibitions with different curatorial endeavours that the budget defines what can be imagined.

The **?** office refers to the fact that an actual dialogue is occuring between two geographically divided sites – the exhibition site in Denmark and the office attached to the curator's base in Stuttgart. It was set up to include an outline that balanced theoretical studies with the complexity of undertaking such large-scale exhibitions. The office and the people involved were a fixed part of the section. As the project combined aspects of education to praxis, this was intended to communicate it in the terms of an actual experience for those involved. From office to final installation, the process is more similar to those associated with architecture or film production than that which is traditionally connected with curating exhibitions. Furthermore, the curatorial role must respond to changes in contemporary artistic practices; in the existing system, however, any methods associated with contemporary cultural projects require conversion in two directions – to the invited producers and to the host institution.

Sign System took the Lousiana *NowHere* identity logo packaging and following the section's organising principles, restated it as the identity of the **?** section. A combination of guiding thread and structuring principle, it clarified four areas, and connected the different platforms with assembled materials from the participants and office.

Articulation

Just as with the Modern, the contemporary art discourse has already created its own circle of types, ie, 'revealing the storage', 'guiding systems', 'design psychology', 'cross-over', etc. The commissions linked with the curatorial outline appear as a combination of elements from these types. This was intended to move away from the formal dead-end of isolating a strategy to a type, instead acknowledging a stable set of types which exist – often already established in Modern art. Both curatorial and artistic practices depend on how these are articulated.

The power of the museum is traditionally judged by its collection, and how this weighs in the exchange with that of other institutions. Section **?** worked with the collection in terms of exchange, involving art discourse and the social narrative: Lousiana owns a large body of work from the Danish still-life artist Lundstrøm. As a participation, the museum's house-architect, François Court-Payen, constructed an installation where a Lundstrøm painting was reconnected to its early history. The painting had been crucial as a test subject for light design experiments by the Danish Modern icon Poul Henningsen, of PH lamps. Explained through PH's 'Rasterklips', the reconstructed apparatus illuminates the painting in the 'Storage' level.

Lousiana owns a major work by Joseph Beuys, *Honigpumpe am Arbeitsplatz*. This provided the rare opportunity to stage questions which Beuys's work causes in relation to museums or exhibitions. As a curator with a background (a German woman from the post-68 generation) I wanted to relate my viewpoint and questions on art and society to a work embodying this dialogue. The *Honigpumpe* has a complex socio-political history and is a difficult task to install as art. Curator René Block was invited for the reinstallation, and publisher Peter Schata to supply documentation material of the '100 Days of Working Collective' at d6 in 1977.

The commissioned media projects stemmed from the initial curatorial interest to work with different women, particularly by way of media circulation, and to introduce these to the large volume of visitors expected. Their character is found in the reworking and remixing. This included '13 Zines', prepared for photocopy production to circulate in as many a number as desired. The shared theme was reworking how the image of women is constructed in different everyday media. The 'Zines' were displayed for reading in the museum's reading room, and available in the museum store. Four DJ audiotapes, produced by women related to the art field and active as DJs could be heard while lying on the outdoor 'Loudspeaker'. A contemporary shared condition is apparent in that most of these women, as myself, have no one fixed role, be it in this exhibition or within life.

For *NowHere*, I shifted from being a programme director of an artist's space with its familiar audience to considering the vast public a museum of this scale attracts. I have experienced working within cultural spaces where the audience shared culture, language, issues, although with radical differences in opinions. This has influenced my working methods so far. In exchange with Louisiana's invitation I introduced questions evident to the generation I belong to. One should not forget the term 'curator' is rather new. There exists a variety of definitions, and this contains the possibilities to use this position as a variable in an entrenched art system, where changes within are already being refused. There is a necessity to define another space, a space which involves working with the discourses refered by the mandate Information, Education, Entertainment. This is a difficult demand in that the effects of deepening conservativism which caused, for example, a backlash in feminism as well as individual rights, is increasing. The reasons why one wants to consider another space is due to the forces which exist to stop any such changes. Although we think it self-evident, one has to consider that culture mirrors its surrounding socio-political status. The issue is not the stated crisis in the art system, it is how we work with the reality of that culture which has a significant influence on our perception of society, which is often underestimated.

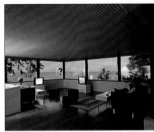
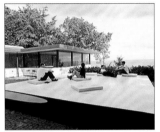

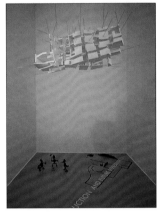
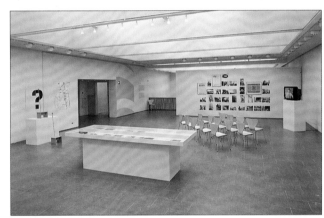
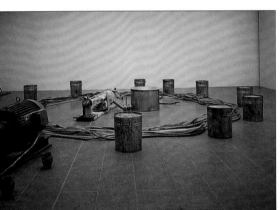
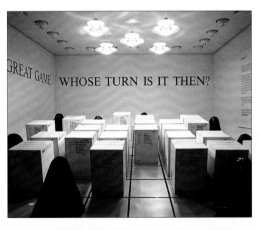
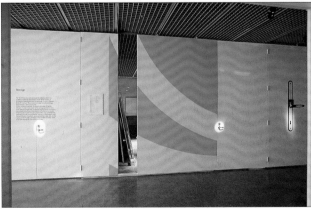

Pavilion

This pavilion is conceived as a break for visitors after their passage through windowless galleries, recreating the comforts of a familiar leisure time. Human scale is evident in this living room with its picture window, the reading room and the courtyard with its view towards the neighbours on the other side of the fence. **?** adds the media to these three spaces. Each addresses its specific public in terms of lifestyle, and points to community formation as an expression of cultural identity.

Museum

This exhibition hall remains as it was – a classical museum space. The curator chose to reinstall one work from the Louisiana collection: Joseph Beuys's *Honigpumpe am Arbeitsplatz*. As the metaphorical heart for d6 in 1977, it stood for '100 Days of Working Collective' together with the activities of the Free International University. The work belongs to Beuys's attempts to enlarge the *Kunstbegriff* of modernity with what he termed *Soziale Plastik*. The **?** section functions within the same cultural parameters suggested by Beuys – *Education, Information, Entertainment*. It reconnects the 'Honey Pump' to the FIU, now by media documentation. Historical material is introduced within questions of contemporary discourse that are oriented towards possibilities in the future.

Storage

For *NowHere* Louisiana removed and stored its collection from the museum buildings. What remains is its history, inseparable from the personal story of the founder, reflecting a heritage and change in policy over time. In this underground level **?** presents a review of the Danish Modern. It adds more room for storage and illuminates from different angles the museum's original Danish inclination. This floor is divided into parts, each offering one contemporary passage through the story of the museum and Danish Modern. The parts are separated by a gap, into which is introduced a heritage of the modern narrative: more than one ending for more than one public.

FROM ABOVE, L to R: **Pavilion***: Sign System – this passage connects* Museum *with* Pavilion *and* Storage; **?** *commissioned for distribution, 13 zines, 4 DJ audiotapes, condoms, MOD game,* **?** *trailer, events;* Family Room Transformation *– an Ikea-furnished TV room with daily TV and a historical Danish TV compilation on the critical use of Family TV genres; the courtyard where the sculpture,* White Square *by Karavan, inspired the form for* Loudspeaker *for the DJ tapes; the reading room, now for zines which reflect in both technique and in the editorial, how women are shaped by/in everyday media;* **Museum***: two works using architectural models to reflect the recent addition of children's houses at Lousiana and Free State Christiania;* Museum*'s largest area presents a Goethe Institute video compilation on Beuys's* Soziale Plastik, *rare videos by/on Beuys's use of the TV medium and the transformation to popular icon, documentation on the event aspect of '100 Days of Working Collective'; reinstalled* Honigpumpe am Arbeitsplatz; **Storage** *– MOD game (installation), lit by PH5 lamps, part of the* Review of Danish Modern; Sign System *with locked storage doors, and window onto the* **?** *added storage*

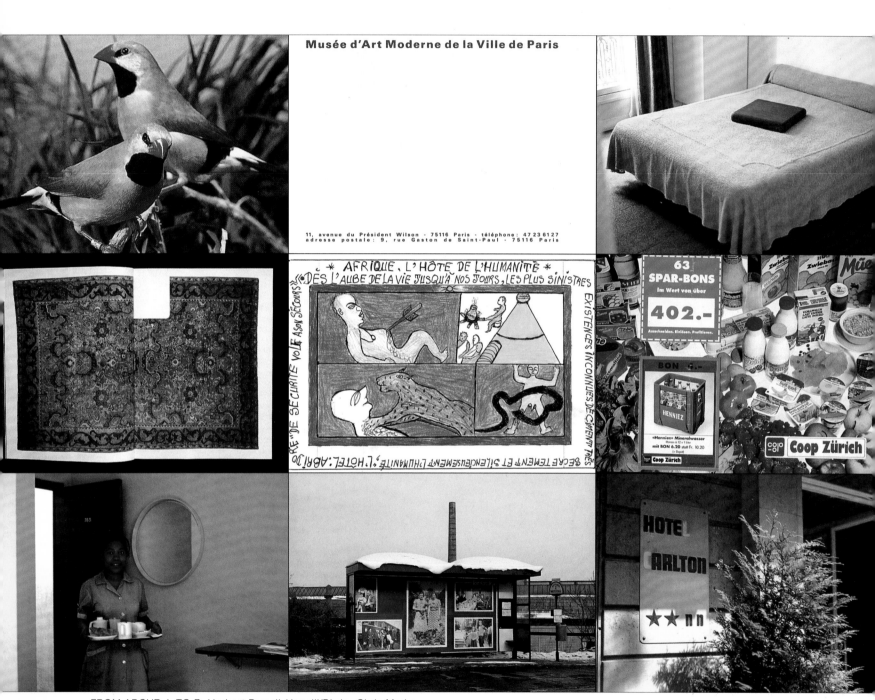

FROM ABOVE, L TO R: Herbert Brandl, Uccelli/Birds; Chris Marker, Uccelli/Birds, 1996; Reiner Ruthenbeck, Hotel Carlton Palace, Paris; Andreas Slominski, exhibition on board Austrian Airlines, 1994; Frédéric Bruly-Bouabré, Hotel Carlton Palace, Paris, Room 763; Peter Fischli & David Weiss, artist's book for the Kitchen Show, Oktagon Publishers, 1994; Rirkrit Tiravanija, Hotel Carlton Palace, Paris (photo: Pierre Leguillon); Hans-Peter Feldmann, billboards, Vienna, 1994; Entrance, Hotel Carlton Palace, Paris

IN THE MIDST OF THINGS, AT THE CENTRE OF NOTHING

HANS ULRICH OBRIST

'Both/and' instead of 'either/or' instead of 'neither/nor'
Hans Ulrich Obrist

Museums are often the right venue for exhibitions. Exhibitions which take place in other contexts generate tension with what is happening in museums and vice versa. The result is a mutually inspiring dynamic. A minuscule exhibition can be just as important as a major project. Established and accepted division into major and minor venues has to be undermined. The periphery suddenly turns out to be the centre. The museum has the problem of being defined as an art space; what the public expects as well as what is expected of the public has usually been determined long before the exhibition opens. Museums become more active when we constantly question the assumption that art is only to be found in sites specifically reserved for its presentation. Monopolies are not only inefficient in the business world . . .

Various steadily expanding fields of activity have emerged from the dialectics of intramural and extramural exhibitions. In the 1960s and 70s the ceaseless search for other exhibition forms and sites was essentially an anti-museum activity, the goal being to abandon the museum. Now the dogmatic 'either/or' approach can be laid to rest because in-between spaces are opening up: IN-BETWEEN displaying and concealing, near and far, concentration and distraction, fragment and connection, original and copy, affirmation and negation, horizontal expansion and vertical depth. From maximum exposure to exhibitions on the verge of invisibility: back and forth.

The moment any anti-structure or anti-museum is recognised as such, it will sooner or later be institutionalised. Structures tend to congeal; they must constantly be liquefied until

SMALL EXCURSUS: FELIX FENEON, HARRY GRAF KESSLER, ALEXANDER DORNER, HERWARTH WALDEN

THE CURATOR IS A CATALYST, OR AS FELIX FENEON USED TO SAY, 'A PEDESTRIAN BRIDGE'. I ALSO LIKE THE EVEN MORE MODEST DEFINITION BY SUZANNE PAGE (DIRECTOR OF THE MUSEUM OF MODERN ART OF THE CITY OF PARIS) WHO TALKS ABOUT THE *COMMIS DE L'ARTISTE* IN TERMS OF THE ROLE AND THE RESPONSIBILITY OF THE CURATOR AS A CATALYST. I SEE PERFECT EXAMPLES OF THIS IN FELIX FENEON, HARRY GRAF KESSLER, HERWARTH WALDEN AND ALEXANDER DORNER. BESIDES THE ALREADY MENTIONED DEFINITION OF THE CATALYST, FENEON CREATED BRIDGES BETWEEN ART AND THE WHOLE RANGE OF PUBLICS AS WELL AS BETWEEN ART AND OTHER FIELDS. BALLARD COINED THE TERM, 'JUNCTION MARKER' WHICH SUITS FENEON RATHER WELL.

everything is wide open again. Flexible strategies displace pat recipes. As Gilles Deleuze puts it: 'In the midst of things but at the centre of nothing'.

Based on the variety of events called exhibitions and the variety of sites where they take place, I have distinguished the following modes of transmitting art:

1 New structures, that is, structures created for a specific project like the (travelling) Nano Museum or the Robert Walser Museum which I founded in 1993.

1a The Museum as a Walk. Taking a walk is the museum. As illustrated by Robert Walser and Marcel Broodthaers. The former's oeuvre conveys an atmosphere of unimportance and insignificance, but the attention devoted to insignificant things involves the observation of banal and yet profound details linked with quotes from 'great' literature. Walser keeps fracturing the linearity of the narrative. The lack of a narrative plot is perceived by readers as a shortage of action; shortage in Walser's case is participation and opens up several avenues of interpretation. Paradoxically, great urgency is a companion to the various forms of detour and rupture, establishing links between fragments that intrinsically have nothing to do with each other. Without an enduring perspective, only fragments remain. Walser's gaze is related to that of the walker who experiences the present as a simultaneous layering of time. In *Zeit ohne Chronos* Massimo Cacciari describes this nowness as a complex of sections, of irreducible singularities.

The military connotations of avant-garde vocabulary have been obsolete for a very long time. For want of a better model,

this simplification of things often prevails. As a result, the history of art is defined as a linear progress.

An exhibition always takes place here and now, ie where past, present and future meet. Hakim Bey speaks of 'immediatism' and declares that games are the most sudden and most immediate of all experiences.

Taking a walk is also an extremely immediate form of experience. Serge Daney describes the act of perception while taking a walk: 'Because I am not particularly fond of bravura pieces, I always need a transition from one thing to the next. And I am glad that I can find it through my body and experience of walking . . . Marching from one plan to the next: Fellini's greatness lies in never showing us a plan without showing us what precedes and follows it. He conceives his films with the logic of a walker . . . The walker always accepts the idea that the show has already begun. This feeling of bare existence is so strong when you walk that it protects you. It is often a very light feeling which writers such as Rimbauld or Walser have described more fluently.'

The visual memory of the walker/viewer determines the sequence of the pictures. Since the 1960s Marcel Broodthaers has defined the exhibition as a cinematic sequence of pictures and objects, thereby subverting the fixity of the single object through constant recontextualisation.

In connection with his Musée d'Art Moderne Département des Aigles, Broodthaers speaks of (a) an artistic travesty of political events and (b) a political travesty of artistic events. It was his opinion that the non-official, fictional museum has the advantage of embodying both (a) and (b).

HENRY GRAF KESSLER'S MAIN CONCERN WAS TO CONNECT PEOPLE. AS WITH FENEON, MANY OF HIS PROJECTS WERE TRANSDISCIPLINARY. KESSLER ATTEMPTED TO DISCUSS ART IN A BROADER SOCIAL AND POLITICAL CONTEXT, DRAWING UPON HIS WIDE RANGE OF ACTIVITIES WHICH INCLUDED ORGANISING EXHIBITIONS, WRITING AND BEING ACTIVELY POLITICAL AT FORUMS – ALTOGETHER AIMING AT A *KOMPLEX DER VERMITTLUNGSBEMUEHUMGEN.*

ALEXANDER DORNER DYNAMISED AN INSTITUTION FROM WITHIN. HE BROUGHT TOGETHER THE MOST IMPORTANT PIONEERS OF RUSSIAN CONSTRUCTIVISM AND CREATED THE FLUID MUSEUM WHICH WAS TRANSFORMABLE AND FLEXIBLE ACCORDING TO THE NECESSITIES OF THE ARTISTS. HE WAS BEFORE HIS TIME IN HIS DISCUSSIONS OF FILM IN MUSEUMS. THROUGH HIM THE FORCE OF SPONTANEOUS CHANGES AND SHIFTS, WHICH USED TO BE THE NIGHTMARE OF THE STATIC MUSEUM, BECAME A SOURCE OF HOPE. DORNER AGAIN STRESSED THE TRANSDISCIPLINARIANESS OF THE *VERMITTLUNG.*

shot has been fired, new works kept being added and artists sometimes replaced their original contributions. This exhibition in a small space was the attempt to make a tiny major exhibition, as well as exercising all the functions of an exhibition maker. Curating the hotel-room exhibition involved not only the functions listed by Harald Szeemann of 'administrator, emphatic lover, preface writer, librarian, manager and accountant, animator, conservator, financier and diplomat' but also those of guard, guide, press attaché and transporter. As in the kitchen exhibition, the first two weeks were private and clandestine; the only visitors were friends and acquaintances. In the third week the site became public and by the end of the exhibition, I had up to 250 visitors a day.

The hotel-room exhibition included a CUPBOARD EXHIBITION designed as an interactive armoire show in celebration of the 80th birthday of the Armory Show. Visitors were invited to view and test the clothing made by the artists.

3 The infiltration of existing structures and institutions not designed to present contemporary art so that the exhibition creates a heterogeneous situation, allowing a mix of practices and forms of display.

In this case, the exhibition is usually a supplement, an extra that disrupts and critically questions an existing structure but does not render it invisible. Rather than abrogating the existing display, the exhibition expands it. A symbiotic relationship results between the reality of the permanent collection on display and the reality of the temporary exhibition.

3a (cf: Cloaca Maxima). An exhibition of contemporary art which I organised at the City Sanitation Museum of Zurich or the Gerhard Richter show I put together for the Nietzsche Haus in SILS-MARIA, as well as an exhibition of Christian Boltanski in the Old Library of the Abbey of St Jallen.

4 Exhibitions in contexts designed for them. *Cue*: the mutation of existing structures.

4a Exhibitions are interesting if they are 'between' – marking a 'between space'. It is similar to something out of Godard's

2 Exhibitions in a real life context maintained for the duration of the exhibition; in the hotel and kitchen exhibitions (in 1991 I invited eight artists to exhibit in my kitchen in St Gallen, Switzerland), the separation of art and life was temporarily voided.

2a For one month in the summer of 1993, I converted my room at the Carlton Palace Hotel, Paris, into an exhibition space. The exhibition followed an evolutionary principle. In contrast to conventional exhibitions that remain static once the starting

short film about the city of Lausanne on Lake Geneva in Switzerland: Godard was commissioned to create a filmic portrait of the city so that it appeared as an oscillation between the blue of the sky and the blue of the lake.

If we examine the recent and present history of large-scale exhibitions, a significant pattern emerges of two different types of shows which are both problematic. On the one hand, there is the scattered large-scale show where the works have to be searched for like a needle in a haystack, leaving the visitor to behave like a pig searching for truffles. The interactivity is limited to map reading; the act of seeing becomes a mere ticking of the checklist. On the other hand, there is the block-buster exhibition which is even more problematic as it attempts to provide a panoptic survey. This always runs the risk of appearing to be pretentious as it does not take into account that an exhibition is one 'truth which is surrounded by many other truths which are worth being explored'. (Marcel Broodthaers) The third option is the large-scale exhibition as a promenadology (neologism from the French *promenade*, referring here to *spaziergangswissenschaften* – the science of walking which was founded by Lucius Burckhardt as a new field of research).

Migrateurs[1]: This series of exhibitions which I organise for the Musée d'Art Moderne de la Ville de Paris, is an attempt to create a mobile platform within a large institution. Working closely with the museum, artists decide where and how they want to intervene. The whereabouts of the intervention must not be predetermined so that the artists are free to define the public parameters of their interventions. *Migrateurs* is a laboratory. The artists are: Liliana Moro, Eva Marisaldi, Douglas Gordon, Rirkrit Tiravanija, Felix Gonzalez-Torres, Didier Trenet, Steven Pippin, Bas Jan Ader, Koo Jeong-A, Elke Krystufek, Christine Heidemarie, Irène Hohenbüchler, Uri Tzaig, Gabriel Orozco, Lucius Burckhardt & Paul Armand Gette, Ugo Rondinone, Leni Hoffmann, Joseph Grigley, Jeremy Deller. 1996-97 *Migrateurs* are Liza May Post and Mika Vainio.

5 Mobile exhibitions that are not tied to any particular site.

LAST BUT NOT LEAST, THERE WAS HERWARTH WALDEN WHOSE RANGE OF CATALYSTIC ACTIVITES WAS ALSO VERY BROAD – FROM PUBLISHING HIS STURM BOOKS AND A POSTCARD EDITION TO JOURNALISM; FROM HIS OWN ART SCHOOL (*KUNSTSCHULE DER STURM*) TO HIS OWN ART GALLERY (WHICH WORKED AS A LABORATORY FOR THE NEW ART); FROM THE LARGE-SCALE SHOW *ERSTER DEUTSCHER HERBSTSALON* IN 1913 WITH 360 WORKS FROM MORE THAN 80 INTERNATIONAL ARTISTS GATHERING PROTAGONISTS OF EXPRESSIONISM, CONSTRUCTIVISM OR ITALIAN FUTURISM TO AN APPRECIATOR OF THEATRE, MUSIC, POLITICS, SCIENCE AND LITERATURE. IF FENEON DEFINED THE PROLIFIC AND INSATIABLE CURATOR-IMPRESSARIO – THE PEDESTRIAN BRIDGE BETWEEN THE ARTS AND THE PUBLIC – WALDEN'S FUNCTION CAN BE DESCRIBED, AS IN HIS OWN WORDS, AS A 'HAMMER'.

5a The exhibition *Do It* has neither a beginning nor an end.

In 1919 Marcel Du-champ sent instructions from Argentina to his sister in France to execute the 'ready-made *malheureux*'. His interest in this textual genre is reflected in the instructions listed in his notes under the heading of 'Speculations' such as 'to make a picture or a sculpture that will run like a film spool' or 'to buy a dictionary and cross out the words to be crossed out'. About his notes Duchamp says, they 'all have something in common; they are all written in the infinitive. A *l'infinitif* means doing things, finally doing things that I never did'.

In this use of the infinitive, Duchamp created a strategy that runs parallel to the ready-mades. Any notion of artistic taste is thwarted; the ready-mades are to stay in the infinitive as opposed to the aging, object-oriented ready-mades always in the present, where the work can happen.

Moholy-Nagy was the first artist to have a piece realised over the phone. Cage turns scores into a set of instructions open to multiple forms of execution – the work of art is recreated in each performance. Guy Debord lampoons instructions by taking them out of context – the sources are scattered and the concept of an original gives way to an open-ended concept of a work.

The museum version of *Do It* consists of instructions by 12 artists which are carried out at the respective venue but, unlike a drama, neither beginning nor end are marked.

Do It can be presented in several places at once, like a film. Two performances are never identical. By carrying out the instructions, the specific, quotidian, profane surroundings of the respective site stream into the exhibition space. The exhibition occurs in the space between execution and negotiation. The meaning of the instructions depends on how the text is interpreted.

It is important not to reconstruct or copy works whose originals are located elsewhere. *Do It* targets an open-ended model, an exhibition in progress that adapts to local needs but still lives up to international expectations. Every realisation requires not only the respective institution's active participation but also that of local partners and contexts.

Christian Boltanski's instructions create a dialogue with a school, Hans-Peter Feldmann suggests starting with the daily

newspaper in each venue. Maria Eichorn involves a silver-smith. Rirkrit Tiravanija's recipe establishes contact with a local Asian grocery store. Mike Kelley engages a low-tech *bricoleur*. The bonbons prescribed by Felix Gonzalez-Torres are manufactured locally. The first *Do It* realisations have shown that those involved in preparing the exhibition also take part in the events accompanying it. The number of participants is unlimited in cases like Jean-Jacques Ruillier's infinite chain of drawings or the red objects to be accumulated and displayed in the museum upon the wish of Alison Knowles. Meticulous scores generally come with Ilya Kabakov's installations. For *Do It*, Kabakov suggests the score of a textual white cube. Paul-Armand Gette's instructions address the borderline between inside and outside. The objective is to move a square yard of nature into the museum. Bertrand Lavier's instructions consist of a passage from a text written about his work by Bertrand Marcade. *Do It* implies both local necessities and an international appeal. The instructions do not force an exhibition but rather set up a frame that can be filled in various ways. These 12 sets of instructions have been used so far by the Ritter Kunsthalle in Klagenfurt (Austria), the CCA in Glasgow and the FRAC des Pays de Loire (Nantes), by the Municipal Museum in Reykjavik and Zerynthia in Siena, Espace Forde in Geneva and the Helsinki Kunsthall.

5b Further *Do It* versions are in preparation in Bangkok and Uppsala. Instructions for a home version of *Do It*, in conjunction with a *TV-Do It* are planned. Yoko Ono will give singing instructions. Allan Kaprow's contribution will be a dust sculpture for home use. With Franz West's instructions, users will be able to make a broom sculpture. Steven Pippin will suggest converting washing machines into cameras. Annette Messager's instructions will explain how to multiply one's signature. Shere Hite will give instructions on how to embrace a boyfriend or a girlfriend. Lloyd de Mause will invite readers to join in a fantasy analysis. Thomas Schütte will describe a display of flowers, coffee and paint. Leon Golub and Rupert Sheldrake will invite participants to conduct experiments with dogs. Daniel

Dennett will propose a psychoanalysis game. Chris Marker will invite us to try out a New Concept in Mouse-Clicking. Gilbert & George will read their Ten Commandments. And finally, Bruce Sterling will provide instructions for reactivating dead, forgotten media.

5c Bruce Sterling's activation or rather reactivation of forgotten media takes us to Vienna's museum in progress (MIP), where I have curated exhibitions on a regular basis since 1992. MIP is a mobile platform for exhibitions in printed media, on television or on Internet. Artists design their work specifically for the medium in question, thereby creating an exhibition reality in the mass media.

Let me start with printed media. In cooperation with the Austrian Ministry of Education and Culture, MIP has succeeded in securing regular use of pages in the daily *Der Standard*. In addition to individual projects (Nancy Spero was invited to design a series of six double pages), large thematic exhibitions take place in print, for instance, *Vital Use*.

The point of departure is dissatisfaction with existing structures of production and distribution, which is leading more and more artists to work at creating their own more vital structures.

5d *Cieli Alta Quota* is another example of a mobile exhibition. Alighiero Boetti's exhibition for Austrian Airlines is a project that I also organised in conjunction with MIP. Boetti designed six aeroplane puzzles to fit the folding tables on board. The puzzles were handed out free of charge for one year.

5e The large-scale painting in front of the Kunsthalle, Vienna, was one of the projects which I curate for the MIP; it is a 50 metres-long, computer-aided painting. Each year two artists are invited to undertake such a project for the duration of three months. Douglas Gordon's large-scale painting was entitled *Cinema is Dead*, with graffiti stating, 'Raise the Dead' – very neo-gothic and uncanny. Previous large-scale paintings were undertaken by Ed Ruscha, Walter Obholzer and Gerhard Richter.

Note

1 *Migrateurs* is the French word for migration birds. Migration birds move between navigation and orientation. Each bird has his or her own migratory axis. What determines these axes is complex and takes into account the position of the stars and the sun, gravity and magnetic fields, and last but not least, the memory of invisible routes (or Songlines, as Bruce Chatwin used to call them).

OPPOSITE, FROM ABOVE, L to R: Richard Wentworth, Hotel Carlton Palace, Paris, Room 763; Rosemarie Trockel and Carsten Höller, Art & Brain; book cover for Migrateurs by Joseph Grigely; Ugo Rondinone, Migrateurs, Musée d'Art Moderne de la Ville de Paris, 1995; DO IT, Converture du catalogue Islandaii, Municipal Art Museum, Reykjavik, March 1996; Gilbert & George, Nanomuseum (travelling), 1996; book cover for Migrateurs by Douglas Gordon; Olaf Metzel, Home Do It; Richard Wentworth, Hotel Carlton Palace, Paris, Room 763